BANJOS, BARBECUE AND BOILED PEANUTS

BANJOS, BARBECUE AND BOILED PEANUTS

Kirk H. Neely

author of *A Good Mule is Hard to Find*

Illustrations by Krista Jones

Spartanburg • 2011

First printing, October 2011

Hub City editor: Kari Jackson
Book design: Mark Olencki
Proofreaders: Jill McBurney, Ivy McLaurin
Illustrations: Krista Jones
Photographs: Mark Olencki
Printed in Saline, MI, by McNaughton & Gunn Inc.

Hub City Press thanks Ronald M. Fields Jr. who helped underwrite publication of this book.

Library of Congress Cataloging-in-Publication Data

Neely, Kirk H.
 Banjos, barbecue & boiled peanuts / Kirk Neely.
 p. cm.
 ISBN 978-1-891885-81-5 (pbk. : alk. paper)
 1. South Carolina--Social life and customs--Anecdotes. 2. South Carolina--Humor. I. Title. II. Title: Banjos, barbecue, and boiled peanuts.
 F269.6.N44 2011
 975.7--dc23
 2011017835

186 West Main Street
Spartanburg SC 29306
864-577-9349 www.hubcity.org

This book is dedicated to Clare,
the love of my life and my companion in all things;
To our beloved children, who bring us much joy;
To their dear spouses, whom we love as our own children;
And to our precious grandchildren, who are our treasured blessings.
They are the future.

TABLE OF CONTENTS

INTRODUCTION: WRITING SOUTHERN STORIES

Introduction: Writing Southern Stories

For the past six years I have written a regular column for *H-J Weekly*, a publication of the Spartanburg *Herald-Journal*. Writing "By The Way" is one of the most interesting and challenging tasks of my week. Newspaper deadlines roll around each week. Holidays and vacations may mean shifting to an earlier submission time, but nothing cancels the imperative to write. Newspaper editors want columns to be interesting, to come in on time, and to observe the required word count. Readers often ask questions about my column.

"As a pastor, when do you find time to write?"

We all have exactly the same amount of time. We all choose how we spend the time we have. I have good friends who enjoy playing golf. They devote one afternoon each week to playing a game they love. I would rather write than play golf. Most of my writing is done in the early morning. It's something I enjoy.

"Where do you get your ideas for the column?"

I try to cultivate the art of paying attention. I listen to the people around me and frequently jot down what I hear. Every person has a story to tell. Children have a unique perspective on life. They are the little professors among us. Paying attention extends to the behavior of animals, the wrinkles in a landscape, and the shifts in the weather. Life is constantly unfolding before our eyes. There is really no excuse for any alert person to be bored.

"How did you learn to write?"

Most writers would answer, "Read all you can and write all you can." For me there is more. As a pastor, I spend a lot of time reading the human heart. Writing and preaching have several parallels. Both require keeping your finger on the pulse of your constituents. The truth is that I am still learning to write.

"Are all of your columns about the South?"

I am from the South. You can only write what you know. The stories must come from your own experience or from personal encounters with others.

My wife, Clare, and I moved to Cambridge, Massachusetts, with our four young sons in 1980. I had been awarded a Merrill Fellowship to the Harvard Divinity School. Before I left I went by the lumberyard, our family business. My dad told me, "Remember, Harvard don't change the pig any. It just puts a curl in its tail." It was his way of reminding me not to forget where I came from. I met some people at Harvard who had amputated their heritage. They were ashamed of where they came from.

When I left Harvard, I had several opportunities to go to other places. I decided to come back to the very same briar patch where I was born and bred. We live in the house my grandfather built next to the lumberyard he started. This is the place and these are the people I know best. That's why I write about the South.

Perhaps no culture is more susceptible to stereotypes than the southern United States. Those of us who live here tend to cultivate those images. The truth is that we are more like other people, all people, than we are different from them. Being from Dixie is not an excuse for being exclusive. Speaking with a drawl is not an excuse for ignorance. We who are Southerners have much to offer to make the world a better place. Those things are worth writing about.

David Allen Coe recorded the Country and Western hit "You Never Even Called Me by My Name." Coe explains that, when Steve Goodman wrote the lines, Goodman considered it the perfect country song. But Coe told Goodman that it was not the perfect country song because there was nothing about mama, trains, trucks, prison, or getting drunk. In response, Goodman wrote a final verse chock-full of country music clichés:

> Well, I was drunk the day my mom
> got out of prison
> And I went to pick her up in the rain
> But before I could get to the station in
> my pickup truck
> She got runned over by a damned ol' train.

Every writer, especially a Southern writer, knows that resorting to the use of clichés is poor form. For publishers it is a real deal breaker. This book has references to mama, trains, pickup trucks, and

bootleggers. Still, I have tried to avoid stereotypes and clichés. I have tried to tell the stories as I know them.

Following the wonderful reception of *A Good Mule is Hard to Find*, I am thankful for the opportunity to collaborate with the Hub City Writers Project on this new collection, *Banjos, Barbecue and Boiled Peanuts*. More importantly, I cherish the privilege of connecting with those who read my stories.

A professor at Princeton Theological Seminary sent an e-mail saying that he had received a copy of *A Good Mule is Hard to Find* as a gift from a colleague. He read a chapter each day as his daily devotion during Lent. I was astonished and delighted.

Just before Christmas, Clare and I were eating at Wade's Restaurant in Spartanburg. A man I didn't recognize stopped at our booth. "Hey, ain't you that preacher?"

I stood up and shook his hand, "Kirk Neely is my name."

He didn't offer his name but asked, "You got more books coming out anytime soon?"

"I'll have one by this time next year," I said.

"I don't hardly ever read a book, but I have read that mule book all the way through."

"Thank you, Sir," I said.

"Yep, I have it in my bathroom. I read it every day."

He walked away. I sat back down and returned to my supper. Clare grinned at me. "That's why you write," my wife said.

"I reckon so."

Faithfully,
Kirk H. Neely
February 2011

BE WHO YOU IS

A Cast Iron Skillet

I occasionally have breakfast at the Skillet, a hometown restaurant in a narrow shotgun storefront. If the place were empty, you could shoot in the front door and the pellets would go out the backdoor. Tables are close together down one side of the tight aisle from the front all the way to the back. Down the other side is an oxen-yoke shaped counter with swiveling stools.

Skillet customers include professionals in suits as well as blue-collar workers. Retired folks, grandmothers with their grandchildren, joggers, walkers, college students, professors, and pastors are all patrons. Regulars exchange morning greetings and their morning newspapers. Conversation often turns to news and sports, sprinkled with rumor and humor. Waitresses maneuver around the narrow passages serving good food and steaming coffee. Located in downtown Spartanburg, South Carolina, it is a good place to start the day.

When the place is humming, the cooks are busy with their work. When things slow down, they may join in the conversation. One morning last week, at a pause in the action, the lady who had scrambled my eggs, fried my bacon, and stirred my grits spoke to me. Wiping her hands on her apron, she asked if I enjoyed my breakfast. I said that I had enjoyed it very much. Then, since she knows that I am a pastor, she asked if I would pray for her friend who was in the hospital. I promised that I would.

We talked for a few more minutes, then, teasing her, I asked, "Here at the Skillet, do you cook with a skillet?"

"Not here. But I do at home. Cooking in a skillet is the best way, and it's better for you too. It puts iron in your blood."

Her answer struck a chord. I asked, "Tell me about your skillet."

"I got it from my grandma. She cooked in it all the time on a wood burning stove. I remember waking up in the morning smelling

that wood smoke and then smelling that sausage when it hit the frying pan."

"How old is your grandmama's skillet?"

"I guess it's about as old as she was. That pan is seasoned so good it is as smooth as glass. When I wipe it out after I cook, I can almost see my face in the bottom."

A well-seasoned cast iron skillet will have dozens of very thin, hard layers of oil, so many that the pan will appear to be black instead of the silvery gray of raw cast iron. Maintaining a well-seasoned skillet is an art: the best way is to use it.

Cast iron lasts for years when cared for properly. It neither warps nor dents, and it cooks well at a wide range of temperatures. It can be used to fry chicken, catfish, hush puppies, okra, green tomatoes, or onion rings on top of the stove. It can be used to bake corn bread, buttermilk biscuits, apple Betty, or peach cobbler in the oven. Its uniform conductivity makes cast iron ideal for Southern cooking.

There are health benefits. After my mother gave birth to her eighth child she was anemic. Dr. W. A. Wallace, a gentleman physician who followed the old-fashioned custom of making house calls, recommended that, to put more iron in her blood, Mama eat food cooked in a cast iron frying pan.

Cooking with cast iron is an art from a simpler time. Miss Maude, my step-grandmother, lived in an old farmhouse in Barnwell County, South Carolina. She cooked on a wood stove with a cast iron skillet. I remember the aroma of sizzling bacon. Miss Maude put the bacon aside to drain and used the grease to cook chopped onions. Then, she would scramble eggs gathered from her yard hens. The eggs were cooked with the onions and bacon drippings. Her grits were steaming in a big enamel pot and stirred with a long handle wooden spoon. After the eggs and onions were ready, she put them on a plate and

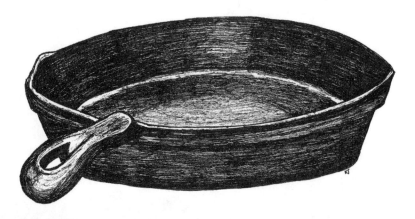

covered them with a pie pan to keep them hot while she added flour, salt, and pepper to the remaining bacon drippings, squeezings to make sawmill gravy. She had made biscuits much earlier in that same old frying pan.

I learned from Miss Maude that the right spatula is important. Hers was steel with a flat edge and rounded corners. I also learned—the hard way—that potholders are necessary. That cast iron handle gets hot!

Miss Maude was a small woman with a bent back. I don't know how she was able to lift that big pan. I never saw her wash the skillet. I know that by noon she had it out again to cook fried chicken, country style steak, or something else good to eat.

I have since learned that cleaning a well-seasoned skillet is unlike cleaning any other kitchen utensil. After cooking it is best to simply wipe it clean with cooking oil and a paper towel. To remove sticky residue, place salt and vinegar or oil in the pan and heat it on low heat for a few minutes, then rub clean. And, for heaven's sake, don't scrub it in soapy water!

This is another thing I learned the hard way. Soon after I started dating Clare, I made a terrible mistake. I was visiting her parents' home in Macon, Georgia. Miz Lib, Clare's mother, had fixed a delicious breakfast of scrambled eggs, crisp bacon, homemade biscuits, and grits. Miz Lib had an early appointment with her beautician, so I volunteered to wash the dishes. I thought it was a good idea that might give me some extra credit with the lady I hoped would one day become my mother-in-law.

I washed all of the dishes in short order until I came to the pan she had used to bake the biscuits. I got a steel wool scrubbing pad and, using a lot of elbow grease, cleaned all of the gunk out of the pan. I was so pleased with myself.

When Clare and her mother returned from the beauty parlor, they were horrified. Miz Lib never said a word. Clare told me later that the favorite pan was never to be put in soapy water and scrubbed.

I have taken that as an excuse to avoid washing dishes ever since.

LIVING BY THE
RAILROAD TRACKS

I am usually able to sleep through the rumble of a passing railroad locomotive. But at 3 a.m. on a Monday morning I was awakened by a loud screeching noise. A boxcar on a southbound freight train had faulty brakes. The grating of steel-on-steel friction was so jarring that, with a nod to Clement Moore, "I sprang from my bed to see what was the matter." It sounded as if the Norfolk Southern engine had jumped the tracks and roared into our backyard. Clare and I live by the railroad tracks. Most of the time we enjoy it. Occasionally, it can be annoying.

I have always been intrigued by the railroad. I can remember the Christmas when I got my first Lionel train set. Dad and I put the track together in a figure-eight pattern on the living room floor. Mama let me keep it there all the way through New Year's Day.

Several years later, my three brothers each got an HO scale model train for Christmas. Dad built an elaborate HO gauge railroad layout in our basement. All three trains could run at the same time over hills, through tunnels, and into a model village without having a train wreck.

My greater interest has been in real locomotives pulling long lines of freight cars along the steel rails that crisscross our country.

My grandfather, Pappy, lost his lumberyard and his home in the Great Depression. Then, as the economy improved, he wanted to start another lumberyard. He bought a strip of land that bordered on the main Southern Railway Line that went from Spartanburg to Columbia. In those days a lumberyard required a railroad siding, since most building materials were transported by trains. Pappy built a lumber shed on one end of the property. On the other end he built a house big enough to accommodate his family of eleven.

Foster's Tavern, a stone's throw from the land Pappy purchased, was constructed in 1807 along the Old Georgia Road. The imposing

home was built of hand-thrown brick made from a nearby clay pit.

In 1937 Pappy built his home in that clay pit. He was told by several people that building a home so close to the railroad tracks was not wise. One fellow told Pappy, "If you build there, every train that comes down the tracks will shake the house. You'll spend a fortune replacing broken windows."

When Pappy dug the footings for the home he went a step further by drilling holes in the clay deep enough to support a telephone pole. When concrete was poured for the foundation, it filled the holes, essentially putting the house on pilings like those used to stabilize buildings along the coast. To this day, when a train passes by, the house vibrates. The old homeplace by the railroad tracks is where Clare and I have made our family home since 1980. When a train passes, we hardly notice the sound or the movement of the house. We simply have gotten used to it.

The Drakensberg Boys Choir visited Spartanburg in 1983. Clare and I hosted two of the South African lads in our home. On the first night they were with us I heard them clambering out of bed in the middle of the night. Getting up to check, I found two frightened boys peering out of the bedroom door. One blurted, "Dr. Neely, did the earthquake do much damage?" The train shaking the house had alarmed them.

I often visited my grandparents' home as a boy. Back then, six months out of the year the screened back porch was used like a spare bedroom. Before air conditioning, sleeping porches were common throughout the South. Spending the night out there in the summer was cooler than sleeping inside the house. In fact, I preferred it in the spring, summer, and fall! Several trains, pulled by coal-burning steam locomotives, passed on the tracks behind the house during the night. In the morning my grandmother, Mammy, scrubbed the coal soot from my face. She made me blow my nose several times to clear it. The thick black gunk was alarming!

The lumberyard, located next to the house, closed at noon on Saturdays. After enjoying a good dinner just past noon Pappy often took me fishing. But, if the cows were lying down, a sure sign the fish weren't biting, Dad and I would go uptown. We stopped to get a treat at Bluebird Ice Cream, and arrived at the Magnolia Street Depot a little before 2 p.m. That was the time when four passenger

trains stopped in Spartanburg. It was a locomotive traffic jam. The two Carolina Special trains, one from Cincinnati and the other from Charleston, met each other at 2 p.m. The two Piedmont Limited trains, one from New York and the other from New Orleans, met at the same hour. Four of the five available tracks were in use at the same time. Many travelers made connections in Spartanburg. My dad and I just wanted to see the trains. Watching four steam-powered engines, passenger cars in tow, arriving and departing within a matter of minutes, was quite a show!

As a boy, the lumberyard was a special place to me. It was where Pappy, my dad, two great uncles, and four uncles worked. I was a frequent visitor. I stood behind a chain link fence at the back of the property watching as the shifter brought boxcars into the lumberyard siding. I was transfixed as the long freight trains rumbled southward loaded with coal and automobiles. The northbound freights hauled pulpwood in gondola cars and petroleum products in tanker cars. From behind that chain link fence I was witness to the passing commerce of a nation.

I wanted to work at the lumberyard when I grew up. My dad said, "Before you work at the lumberyard, you have to learn to work for your mama." Working for my mother was harder than working at the lumberyard. Finally, I got the promotion the summer after I finished the seventh grade. I weighed no more than a hundred and twenty

pounds soaking wet. The very first day I went to work, my dad put me to the task of unloading a boxcar of cement. Nothing was palletized, and the old boxcar had just one door. The cement had to be lifted by hand, one ninety-six pound bag at the time, put on hand trucks, rolled up a ramp, and stacked into a warehouse.

I learned a lot that first summer at the lumberyard. I learned that you don't have to work at a lumberyard very long before you hear the Lord calling you to do something else. I learned that a boxcar looks a whole lot more interesting on the outside than it does on the inside. Still, my fascination with trains did not pale. I came by that honestly. My family has a long standing connection with the railroad.

My great-grandfather, William Morgan Neely, worked as a brakeman on the Nashville, Chattanooga, and St. Louis Railroad. The crew ate meals prepared by a cook in the kitchen in the caboose located at the end of the moving freight train. The aroma of an apple pie baking in the wood stove wafted up to the pagoda of the caboose where the brakeman rode. Tantalized by the fragrance, Billy Neely, my great-grandfather, leaned over the railing, shouting above the clatter of the rumbling train to the cook below, "When will that pie be ready?" Those were his final words.

Somewhere before Tullahoma, Tennessee, at a bend on the mountain grade, Billy Neely was jolted from his perch and dashed to the double tracks below. Unconscious and unnoticed, he was struck and killed by a speeding train headed toward Murfreesboro traveling on the opposite tracks.

Billy Neely was a tall man with dark eyes and a thick, full moustache. The circumstances surrounding his death are somewhat mysterious. Presumably, the swaying motion of the train moving around a mountain curve dislodged him from the roof of the caboose. Some speculated that a hobo threw him from the train and robbed him. Whatever the reason for his demise, by the time his body was found, he had been robbed of everything except his gold railroad pocket watch. The timepiece was given to his oldest son, who became my grandfather.

Billy Neely was buried in the family plot located on his father's farm on Short Creek near Fosterville, Tennessee. His grave is within two hundred yards of the main line of the Nashville, Chattanooga, and St. Louis Railroad.

As a boy, I rode the train to Charlotte one summer to visit my friend, Gordon. But the longest train ride of my life came in 1960 when I was sixteen. I went to the National Boy Scout Jamboree in Colorado Springs, Colorado, with 50,000 other Scouts. The troop from Spartanburg rode in a day car on the Carolina Special through Asheville to Cincinnati. There we joined another train headed to Chicago. In Chicago, our day car was added to a train called the Jamboree Special. Cattle cars with picnic tables down the center served as our dining cars. We were herded into those cars and fed box lunches, preparing us to eat our own cooking once we arrived at the Jamboree.

After two weeks in Colorado we traveled a Southern route through New Mexico and Texas to New Orleans. There we boarded the Southern Crescent for the trip back to Spartanburg. Having seen from my day car window the enormous train yards in Cincinnati and Chicago, and having traveled all those miles listening to the rhythm of the rails, I realized the magnitude of our rail system and something of its importance to our country.

Spartanburg County has long been a locus of intersections, a hub. Several old Indian trails crossed the area east and west, north and south. Both the Catawba and the Cherokee tribes hunted this land. Later those same trails became wagon roads traveled by pioneers. Near Roebuck, the intersection of Blackstock Road and the Old Georgia Road was a main crossroad. United States Highways 176 and 29, and, more recently, Interstate 26 and Interstate 85 paralleled those ancient Indian trails. However, it was the railroads that gave my hometown the nickname Hub City.

Spartanburg's rail service began with a train to Union and Columbia in 1859. In 1873 came the Atlanta & Charlotte Line, now the main track of the Norfolk Southern from Washington to Atlanta and points west. With the completion of the Saluda Grade in 1885, Spartanburg was connected with Asheville. This route became the Southern Railway Line from Cincinnati via Spartanburg to Charleston. Also in 1885, the Charleston & Western Carolina, which ran from Port Royal to Augusta, came to Spartanburg.

A third major line into Spartanburg, The Clinchfield Railroad, is an engineering marvel. The rail runs from Elkhorn City, Kentucky, passing through more than 450 miles of mountains and fifty-four

tunnels along the way. In 1909 it reached its southern terminus of Spartanburg. The Clinchfield, primarily a coal carrying line, had one passenger train daily from Elkhorn City. Spartanburg was the end of the Clinchfield line.

An electric railroad, the Piedmont & Northern, also came to Spartanburg in the winter of 1913-1914 from Greenwood, Anderson, and Greenville.

Some have reported that ninety trains passed daily through Magnolia Street Depot in Spartanburg in the early 1900s. Dr. Lewis P. Jones, former Chairman of the History Department at Wofford College and an avid railroad buff, said, "People exaggerated the number of trains that came through Spartanburg. Some folk counted one train as it arrived and counted it again as another train when it departed ten minutes later."

The Magnolia Street Depot fell into disrepair, and much of it was demolished in 1971. The west end of the structure survived and recently has been refurbished. It now serves as a center of cultural activity. It continues to be used as a railroad station. It also houses an interesting railroad museum. Two Amtrak trains, still called the Southern Crescent, stop each day. But most rail traffic through Spartanburg is freight, carried by two railroad companies formed by multiple mergers, CSX and the Norfolk Southern, the line which passes behind my house.

Clare and I enjoy living by the tracks in the old homeplace built by my grandfather. I am glad to report that Hub City is alive and well. Eleven trains rumble down the rails in back of our house every single day.

Yesterday, one of our grandsons was visiting us. We heard the sound of a lonesome train whistle. We stepped out onto the screened back porch to watch the passing train. I saw in his eyes that enthralled look of a boy watching a train, and I remembered.

ON BEING GRAY

"Dr. Kirk, your hair looks like my dog."
First-graders have a delightful way of speaking the truth! Was I having a bad hair day?

"Do you mean that my hair is oily and matted and crawling with ticks and fleas?"

"No!" the six-year-old giggled. "I mean your hair is the same color as my dog!"

He paused, looking at my hair. "You know what, Dr. Kirk? My dog is very old."

Art Linkletter had it right. Kids do say the darndest things!

One of the joys of being a pastor is visiting children's Sunday School classes. I usually learn as much as the youngsters do. On this occasion I might have quoted Proverbs 16:31: "Gray hair is a crown of glory." Instead, I just chuckled.

Later, I thought about the conversation. There are both blessings and responsibilities that come with gray hair. Perhaps commenting on the Hebrew proverb, actor George Bancroft said, "By common consent, gray hairs are a crown of glory, the only object of respect that can never excite envy."

Gray hair does not always command respect. When twenty-nine-year-old Taylor Hicks first appeared on *American Idol*, grumpy judge Simon Cowell told him he would never win because of his gray hair. The blues and soul singer from Alabama refused to dye his hair. He won in 2006, the fifth season of the competition.

Older people tend to develop gray hair because their hair follicles produce less pigment and the hair becomes colorless. Gray hair is considered to be a characteristic of normal aging. The age at which this occurs varies from person to person. Whether you can detect it

or not, nearly everyone has gray hair by the age of seventy-five, men earlier than women.

The exact age seems to be determined by heredity. Premature graying runs in families. Three generations of our family attended Cooperative School, now E. P. Todd Elementary. My dad remembers a family with four sons who lived near the old school. "All four of those boys were white-headed before they got out of high school," he said.

Gray hair is not actually gray, but it is a combination of the dark and white hair. When our hair starts to turn, we tend to blame a high-pressure job, an illness, or even difficult children. In truth, the link between gray hair and stress is little more than folk wisdom. Numerous scientific studies show no connection.

After his first State of the Union Address there was speculation that the hint of salt-and-pepper above President Obama's temples was the first physical sign of the pressures of his high office after only one year. A more likely explanation is that Mr. Obama started to turn gray for the same reason other people do. He's getting older.

While the arrival of gray hair is relatively predictable according to age and heredity, how and why hair ages this way is not well understood. Beyond mere vanity, unlocking those secrets could have potential for understanding the aging process. Scientists hope that, by identifying the mechanism that kills hair pigment cells, research can develop new treatments for shutting down more troublesome cells like those that cause skin cancer.

Scientists realize that hydrogen peroxide plays a role in the process of diminishing hair pigment. Consider the peroxide blond. The change in color due to aging is an internal process. Every hair cell makes a little hydrogen peroxide, but over time the amount builds up. Scientists have discovered that this accumulation blocks the production of melanin, the natural tint in hair.

As we age, our hair bleaches itself from the inside out.

So what are those of us who have gray hair to do? The Cosmetic, Toiletry, and Fragrance Association estimates that as many as two out of every five American women choose to dye their graying hair. The number of men who dye their hair is smaller but increasing. But hair coloring is a temporary fix. The multi-billion dollar industry in hair color products depends on regular renewing of color. English writer P. G. Wodehouse once wrote that there's only one cure for gray hair.

"It was invented by a Frenchman," he said. "It's called the guillotine."

Short of dyeing by using hair color or dying by losing our heads the French way, there is another alternative. Have you noticed that an increasing number of celebrities are leaving silver highlights as is? Richard Gere and George Clooney have opted to do so. It hasn't hurt their appeal at all.

Singer Emmylou Harris, whose flowing locks turned before she was fifty, is an inspiration for other women. Emmylou says, "I've earned that gray, and I'm not changing it."

Bill Cosby says that he's mighty proud of his dappled crown. He calls it God's graffiti!

My encounter with a first-grader was really an affirmation. I will never be considered a Silver Fox like Sean Connery or Robert Redford. The simple honesty of a child informed me that my hair looked like his dog. It is not all bad when a child sees something about an old codger that reminds him of a beloved pet.

WATERMELON SEASON

Elaine was one of my classmates at Cooperative Elementary School. Her birthday was right after the beginning of the new school year. She invited every student in Mrs. Pearl Fairbetter's fourth grade class to her party.

Even though I was scared of girls, Mama said I had to go to Elaine's party. She was our neighbor. Not going to her party would be rude. Reluctantly, I went. There were thirteen girls there. I was the only boy who attended.

I guess Elaine's daddy felt sorry for me. He told me I could help him cut the watermelon. That was just fine with me. I liked watermelon, and I didn't like girls. Turns out the girls were too prissy to eat watermelon. Elaine's daddy said I would have to eat the whole thing by myself. I ate as much as I could.

I got sick as a dog. I am ashamed to say that I didn't especially like watermelon for a long time after that day. I probably started to like it again about the time I started liking girls.

Summer is watermelon time. Beginning in late June, roadside produce stands have bright green melons prominently displayed, tempting passersby to stop. Watermelon season extends well into September.

A cold slice of watermelon on a muggy summer day hits the spot. It is not uncommon for such an occasion to be followed by a seed spitting contest. My brothers and I used to line up on the back porch and spit watermelon seeds toward a tin can propped up on a concrete block. There were two categories in seed spitting proficiency—distance and accuracy. Even if we missed the can, which was most of the time, we tried to see who could propel the black seed the farthest.

I remember a hike to Dead Horse Canyon with several of my buddies. The garden behind our house included a watermelon patch.

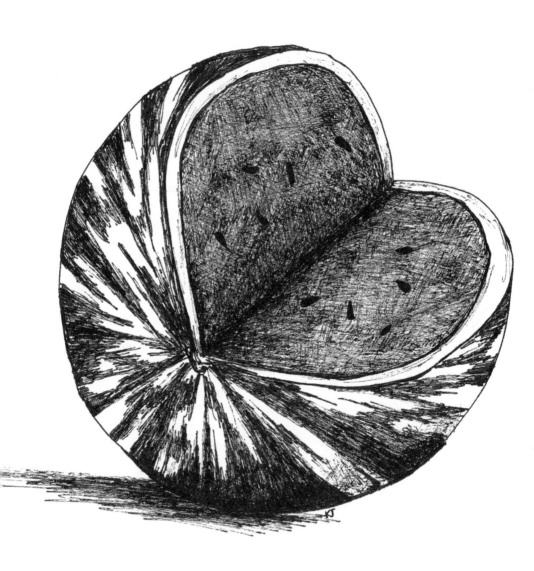

We picked a melon that was ripe. We had to cross a creek on the way to the canyon, actually a red clay gulley. In order to get the melon cool, we floated it in the creek. One of the guys thought it should be submerged all the way under water. Where a wild cherry tree grew on the creek bank, we pried loose a root and pinned the watermelon under the snag beneath the surface of the water. We planned to rest by the creek and feast on the chilled fruit on our return hike back home.

After a hot, messy dirt clod fight in Dead Horse Canyon we stopped by the creek to enjoy our cool watermelon. Boy, were we surprised! Something had eaten holes all through the ripe red fruit. Crawdads were crawling around inside the tunnels made through the flesh. My best guess is that a muskrat had his fill of our watermelon, leaving the rest to the crawdads. We left it floating in the creek. What a disappointment!

Watermelon lovers like to get face-down into a huge slice of the bright red fruit with juice running down their elbows, dripping from their chin onto their bare feet. My father-in-law, Mr. Jack, told the story about a time when his cousin, Davenport Padgett was eating watermelon. Red juice circling his mouth, the lad took the last few bites of a large piece.

"Save me the rind!" Mr. Jack begged.

"Ain't gonna be no rind!" Davenport said. "I'm gonna eat every last bit of it."

Watermelon is as nutritious as it is delicious. Though it is 92 percent water, the red flesh is packed with vitamins and minerals. The deep red varieties of watermelon are loaded with lycopene, an antioxidant that protects the heart and prostate and promotes skin health.

Citrulline is among the phytonutrients found in watermelon. It can help those who need increased blood flow to treat angina, high blood pressure, and other cardiovascular problems. It has the ability to relax blood vessels, much like Viagra does. Sounds like a good bedtime snack!

The inner rind of the watermelon, usually a light green or white color, is commonly pickled in the South. The rind is edible, has a unique flavor, and contains many nutrients. Sometimes used as a vegetable, the rind can be stir-fried or stewed, as well as pickled.

Recipe books have an interesting array of serving ideas.

Watermelon salsa is a summer garnish. A carved watermelon can become a basket for fruit salad or centerpiece for a party. The sweet red juice can be made into watermelon wine.

In the late 1940s Charles Fredric Andrus, a horticulturist at the United States Department of Agriculture Vegetable Breeding Laboratory in Charleston, South Carolina, set out to produce a disease-resistant and wilt-resistant watermelon. In 1954 Andrus reached his goal with the Charleston Gray. Its oblong shape and hard rind made it easy to stack and ship. Its adaptability meant it could be grown successfully in various soil types over most of the South.

Today, U.S. farmers in approximately forty-four states grow watermelon commercially. Almost all varieties available in grocery stores have some Charleston Gray in their lineage.

Carolina Cross, another popular Southern melon, bears large fruit usually weighing between sixty-five and 150 pounds at harvest. Carolina Cross is the variety of watermelon that is grown for contests at state fairs across the South. The current world record, weighing 262 pounds, was grown in 1990 by Bill Carson of Arrington, Tennessee.

My grandfather told about two fellows, both unsuccessful in business, who were out of work. It was early summer, and they needed to find a way to make some money.

"Let's sell watermelons," one suggested. "I have a pickup truck. We can go to Charleston and buy a load of early watermelons. Then we can haul them back up to Spartanburg and sell them before the grocery stores have any."

"Great idea!" his friend said. "I have an uncle in Charleston who can tell us where to buy them."

Off to the Lowcountry they went. They bought a truckload of watermelons at a bargain: two melons for a dollar.

Back in the Upstate, they sold every watermelon at fifty cents apiece.

When they tallied up, one said to the other, "Not counting the cost of gasoline, we broke exactly even."

They thought for a moment.

The other said, "You know what? We've got to get a bigger truck."

VACATION IN A REST AREA

On Saturday morning the bed of my little blue pickup truck was packed with an electric grill, hammocks, beach chairs, and assorted baby equipment for our grandson: all the stuff we take for a week of family vacation at Pawleys Island. Comparisons to the junkyard business on *Sanford and Son* reruns would have been fitting.

I was locking up the house. Clare waited in the truck, arranging things in her nest on the passenger side of the extended cab for our five-hour trek to the beach. Tastefully attired as always, Clare wore a pink linen blouse and her mother's antique pearls.

As she waited, a green pickup pulled into our driveway, this one a battered old Ford with fenders of varying colors. Both taillights and the left headlight were secured with duct tape.

The driver's appearance matched that of his truck. Wearing a tattered grease-stained baseball cap and faded overalls, he approached Clare. His mouth was nearly concealed by his scraggly beard. His broad smile revealed only a few teeth. He was chewing tobacco. The man seemed excited. He motioned for Clare to lower the window. Cautiously, Clare lowered the window about an inch.

"Y'all goin' to the dump?" he asked. "I'm in the arn and met'l business. I'll be glad to haul this stuff fer you 'ns."

Clare answered, "Thank you. We have it loaded. We will be just fine."

With a tip of the baseball cap he released his matted, disheveled hair and dismissed himself.

It was a hilarious beginning to our vacation. We are still laughing.

The house where we stay at the beach is a comfortable old home that underwent significant remodeling after Hurricane Hugo hit in

1989. The house has an understated elegance. Arrogantly shabby is the local description of such a place. We have spent twenty-seven family vacations in that same house, and we love it!

Once we arrive, get everything unloaded, and make the compulsory first trip to the grocery store, I get a glimpse of the ocean. The sound of the waves, the sea breeze in my face, and the fading twilight calm my soul. I can feel the tension and the cares of the mainland drain away.

On Sunday morning I preach, as I have done for many years, at Pawleys Island Chapel. The church is within walking distance of the house where we stay. Like the house, the chapel was renovated after Hugo made his blustery visit. I enjoy leading worship at Pawleys. The sanctuary has some of the most beautiful sacred windows in South Carolina. They are clear glass. They afford a stunning view of the marsh.

Several years ago, while I was preaching, I realized that the entire congregation was focused on the large window behind me. I turned around to see that an osprey had plunged from the sky into the shallow water, snagged a sizeable mullet in her talons, and winged her way back to her nest across the grassy marsh in the top of a tall pine tree. The congregation had a moment of inspiration on that Sunday that I did not plan.

When the Sunday service is over, I return to the beach house for the vacation ritual of dispensing with my watch and my shoes. For a while I can tell time by the tides. My feet and my mind can be completely unencumbered.

When we first went on vacation at Pawleys Island, our five children were young. Beach time was spent building sandcastles, collecting shells and shark's teeth, flying kites, and wading in the surf. In subsequent years, as the children became teens, Frisbees and footballs, sunbathing and swimming, fishing and crabbing occupied our time in the sun. Now, with grandchildren at hand, Clare and I have the joy of seeing our children building sandcastles again. We still enjoy taking walks on the beach after supper.

Among my favorite times at the beach are those hours I spend after dark on a deck close to the ocean. The moon and the stars are bright in a wide sky, my pulse and my breath synchronize with the rhythm of the surf, and I am at peace.

Books have always been part of our vacation. One year Clare and I became closely acquainted with Rabbi David Small, the main character in all seven of the Harry Kimmelman paperbacks. The series of mysteries began with *Friday the Rabbi Slept Late* and was followed by a book for each day of the week. I have enjoyed getting to know Navajo Tribal Policemen Lieutenant Joe Leaphorn and Sergeant Jim Chee in the novels by Tony Hillerman. Clare has read the chronicles of Father Tim and his Mitford community in the volumes by Jan Karon. The Miss Julia books by Ann B. Ross have also been among Clare's favorites. J. K. Rowling, too, has been a part of our family vacation, since we all enjoy Harry Potter books and movies.

We have been delighted to see our children and our grandchildren take up the book habit. Everybody takes a book or two to the beach.

I always take too much to read and too many projects to complete. One of my annual projects is to repair wind chimes. Clare and I enjoy the sound of these simple musical instruments that render their songs unbidden. We have numerous wind chimes at our home in Spartanburg, but, like most things, they break. Before we leave for the beach, I gather the wind chimes that have fallen into disrepair during the year. I take along an old fishing tackle box that is now my wind chime repair kit. Beginning on Sunday afternoon, after I preach at Pawleys Chapel, I settle in to fix broken wind chimes. Sometimes I incorporate driftwood or seashells harvested from walks along the beach into the refurbished chimes. Once mended, I hang them on the screened porch where they catch the ocean breeze. They become an added attraction for the grandchildren and another solace for a weary mind.

I take my laptop computer to Pawleys and write some every day. Last year, with the encouragement of our children, I tried my hand at painting with acrylics. Though I am colorblind, the results were gratifying.

Meals around the table are an important family time at the beach. In our early years, vacations were not much fun for Clare. A week away basically meant moving the regular housekeeping chores to another, but more sandy, venue. I realized that I needed to take some of the burden of meal preparation. The problem was that my world famous peanut butter and jelly sandwiches would only go so far. Over the years I have developed and varied my menu options. Everybody

pitches in with grocery shopping, cleanup, and other tasks.

I cook omelets to order at least one morning during the week. The reason I take my grill on the trip is that, now, I usually prepare the evening meal each day at Pawleys. My specialties are cold boiled shrimp, smothered chicken, sautéed scallops, grilled fish, and, if requested, brats and grilled redneck hamburgers. My children and I team up on a Southern fried meal of chicken, okra, squash, onion rings, and green tomatoes. I am working on several new offerings, including a Lowcountry boil and shrimp and grits with andouille sausage. Though my culinary skills are limited, my family enjoys good victuals.

One of the hazards of pastoral life is that vacations are frequently interrupted. Much to the chagrin of Clare and my family, I have trouble distancing myself from the church. Between the cell phone and the laptop, I am never out of reach. That is my own choice. I feel that I need to be available. I have frequently been called back to Spartanburg to conduct a funeral. Vacation has sometimes been cut short because I had to return for a wedding. I constantly face the relentless return of the Sabbath. We leave Pawleys on Saturday morning. I usually have to preach three times the next day, so by Thursday I am into sermon preparation mode even though we are at the beach.

As the time to leave last year grew closer, I was tired. On Saturday morning we closed down the beach house. Accompanied by jokes about *The Beverly Hillbillies* and a lot of help from our children, I loaded the pickup for the journey back home.

Clare and I enjoyed traveling the back roads for a while. It seems to extend the vacation just a little. But, then we got on the interstate. As we were coming up I-26 just north of Newberry, traffic came to a virtual standstill. Eighteen-wheelers, recreational vehicles, and automobiles loaded with luggage on top and bicycles on the back crept along at a snail's pace. It was hot, and we were tired.

Finally, we saw a sign: Rest Area One Mile. Thirty minutes later, at Clare's strong insistence, we turned onto the ramp into the rest area.

The place was packed. Hordes of weary travelers crammed the parking lot. Every picnic table was occupied. Long lines led to crowded restrooms. Vending machines had run out of cold drinks and snacks. Busy and courteous attendants maintained both order and the facilities. Meanwhile, back on the interstate, traffic was barely moving.

"We are going to be here a while," I said to Clare.

"We might as well enjoy it," she said.

I extracted two beach chairs from the crowded bed of the pickup. I grabbed two apples from the cooler, a library book Clare had been reading, and a new issue of *Garden and Gun* magazine for myself. We sat in the shade, read, and enjoyed our fruit.

We had a ringside seat. Some people were understandably frustrated, but I noticed that gave way to an attitude of calm resignation. Most of us enjoyed an unspoken sense of camaraderie.

A driver of an eighteen-wheeler pulled a football from the cab of his truck. He and his son tossed it back and forth. Four other boys gathered around, joining the game of pass and catch.

At a picnic table closest to us was a family with four energetic little girls who were just glad to be out of their minivan. The mother was clearly exhausted, but she was inventive. "Let's see how many pinecones you can find." Together the dad and his daughters went on a scavenger hunt. They brought armloads of pinecones back to the table. The mother enjoyed a bottle of cold water, guarding the pile as the spiny treasures accumulated. For the children, it was as much fun as an Easter egg hunt.

Pet owners walked dogs of many varieties. The canines, all on leashes, stopped to sniff. The people holding the leashes struck up conversations with each other.

An elderly couple sat under a covered shelter, drinking coffee from a thermos and eating cookies. They were holding hands and talking.

After an hour, interstate traffic started to move again. Some of our number rushed to their vehicles. Drivers cranked up and moved down the ramp, back into the flow of traffic.

"Let's wait here for a while until the congestion thins out," Clare suggested. Our time in the rest area was a refreshing hour, a relaxing end to our vacation.

We were returning home to a busy schedule. Within a short time we would be back into our regular routine—a full day on Sunday and a funeral on Monday.

I still had to unload all that stuff off the truck. And the guy who offered to take it all to the dump at the beginning of our trip was not there to help when we got back home.

THE FIVE-STRING BANJO

Uncle Archie was an eccentric fellow. He drove a Model T Ford, had at least three wives and fourteen or more children, and he played the five-string banjo. I remember Saturday afternoons spent singing on the front porch of the Hutson family homeplace in Barnwell County, South Carolina. Uncle Archie picked the banjo. Cousins Parnell and Billy played guitars. Neighbors came with a mandolin and a fiddle. Uncle Creech was the percussionist alternating between a scrub board and two clacking spoons. Sometimes there would be a harmonica, a jaw harp, or a one-string, broom-handle washtub base. Uncle Archie's brother, Uncle Quincy, would occasionally play a limber handsaw. It was on that front porch in the sand hills that I grew fond of Southern Gospel singing.

I got my first banjo when I was a senior in high school. It is a Gibson extended neck five-string and is pictured on the cover of this book. My banjo is just like the one played by Dave Guard of the Kingston Trio and by the folk singer Pete Seeger. I learned to strum a few chords, but I never have learned to pick the way the best banjo players do.

Jerome Fowler of Clifton taught me to play the guitar. When I showed my banjo to him, he said, "Playing the banjo will drive you crazy!" That must have been what happened to Uncle Archie.

Most people who have tried the five-string agree that, in order to pick the thing, you have to be a little bit addled. If you're not deranged when you begin, that short drone fifth string will drive you batty.

In 1965, when I was a senior at Furman University, I was president of the Pep Club. One of my responsibilities was to organize a campus-wide concert on Friday night before the homecoming football game. I decided to hold an outdoor event in the middle of a big grassy field. I made arrangements to borrow an eighteen-wheel flatbed truck.

I delegated most of the details to other club members, and plans were in place. All but one! The guy who promised me he would secure a band came up empty.

With the event only two weeks away, I decided to call on a fellow from my hometown of Spartanburg. Our band for the event was pure country. I enlisted Don Reno and the Tennessee Cut-Ups.

I wondered how the Furman student body would respond to bluegrass music.

Don Reno and his boys climbed onto the flatbed decked out in cowboy hats and boots. They cranked up the volume and cut loose with a rousing performance. On that cool, sunny afternoon the Furman student body heard one of the best five-string banjo players ever. Using his unique three-finger style of picking, Reno had some students clogging in the grass. Many were toe-tapping and knee-slapping throughout most of the concert.

Don Reno was born in Spartanburg County. His family moved to Heywood County, North Carolina, when he was a boy. He first picked the banjo when he was five years old and was basically self-taught. He became known as one of the best by the time he was a teenager, playing with Arthur Smith and the Crackerjacks. He recorded with Woody Guthrie. He joined Bill Monroe and the Bluegrass Boys, and he played with them for several years.

Later in his career, Reno reunited with Arthur Smith for one recording session. Together they produced "Feuding Banjos," which was later re-titled "Dueling Banjos" for its use in the 1972 film *Deliverance*.

There are two other great banjo pickers from Spartanburg County. Buck Trent was born and raised in Arcadia. He played with Bill Carlisle, Porter Wagoner, and Roy Clark, and he was a regular on the television show *Hee-Haw*.

Bobby Thompson from Converse worked with Carl Story and became one of the best studio musicians in Nashville. He also played in the band on *Hee-Haw*. He was credited with developing the melodic style of five-string banjo picking.

Some have said, incorrectly, that the banjo is the only instrument to originate in this country. By the early 1600s the four-string banjo had been brought to America. Enslaved Africans fashioned instruments like those they knew in their homeland. Early versions were made from

tanned skins stretched over gourds connected to strips of wood. Gut and hemp were used for the strings. Slaves on Southern plantations used African names for these instruments. Called *bangie, banza, banjer,* and *banjar,* it finally became known as the banjo.

Joel Walker Sweeney had a traveling minstrel show with banjo players in the early 1800s. Sweeney added the fifth string to the instrument. So, it is the five-string banjo that is a uniquely American instrument.

The drone fifth string gives the instrument its distinctive sound. Constantly tuned to a high G note, that fifth string is the steel demon that will drive you crazy.

My grandfather, born and raised in middle Tennessee, told me that Uncle Dave Macon from McMinnville, Tennessee, was the best five-string player he knew. Macon was the first star of the Grand Ole Opry. There have been many other notable pickers, from Mark Twain to Steve Martin to Ricky Skaggs. Each person who plays the instrument develops a unique picking style.

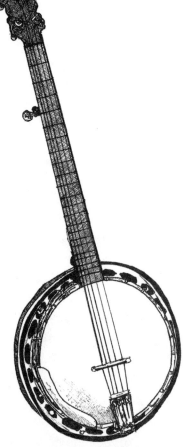

One of the finest is Ralph Stanley, born in Big Spraddle, Virginia. His mother bought him his first banjo when Ralph was fifteen years old. She agreed to pay five dollars for the used instrument. The woman she bought it from took payment in groceries from the small mountain store run by Ralph's mother. His mother, a member of the famous Carter Family, taught Ralph to play using the claw hammer style in which the thumb and the first two fingers move rapidly across the strings.

Stanley and his brother, Carter, formed the Clinch Mountain Boys. Drawing on the minor-key singing style of their Primitive Baptist tradition and the harmonies of the Carter family, the Clinch Mountain Boys found their place in bluegrass music. They were featured in the 2000 movie *O Brother, Where Art*

Thou? Ralph had learned the theme song of the soundtrack "Man of Constant Sorrow" years before from his dad.

Among the banjo players in my acquaintance are some unique people. Ralph Boney not only plays the five-string, but he also picks it left-handed!

Walker Copley, who sells and repairs watches as his day job, plays the banjo on the side.

My brother Lawton is the only person I have seen play the five-string and ride a unicycle at the same time!

But born and raised in Cleveland County, North Carolina, Earl Scruggs is, hands down, the best of all time. When Earl was only four years old, he inherited his dad's banjo. By the age of ten, he had learned the three-finger style that became his trademark. After high school Scruggs joined Bill Monroe's Bluegrass Boys. Lester Flatt was also a member of that band. Flatt and Scruggs started The Foggy Mountain Boys. "The Ballad of Jed Clampett" brought them worldwide fame. Earl has won two Grammys for "Foggy Mountain Breakdown."

In the 1960s my brother Lawton was a student at Gardner-Webb College in Boiling Springs, North Carolina. He joined a folk group called The Joyful Noise. One Monday, the Campus Minister asked the group to sing in chapel. They gladly accepted, but Lawton had left his banjo at home.

A maintenance man at the college loaned his banjo to Lawton. When Lawton returned the impressive old five-string, the generous fellow said, "Thank you for taking care of my banjo. I wouldn't want anything to happen to it. It belongs to my brother."

The maintenance man's name was Horace Scruggs.

His brother's name was Earl!

MAMMY'S POUND CAKE

Fifty-two years ago, my picture appeared in the very first *Stroller Cookbook*, the collection of local recipes published annually by the Spartanburg *Herald-Journal*. Seymour Rosenberg wrote the daily Stroller column and compiled the cookbook.

Inside the front cover of that publication is one of those family pictures that you wish you could avoid when you are almost thirteen and the oldest of eight children. I was embarrassed. In the photograph, taken by B and B Studio, I am standing behind six of my seven younger siblings. My right hand is on my mother's shoulder. My left hand is on the shoulder of my brother Bill.

Mama had submitted a recipe for caramel cake to the Stroller a few days before my youngest sister, Kitty, was born. Seymour Rosenberg called Mama several weeks later to arrange a time for Harry White to take the picture. Kitty was six weeks old. Dad was hospitalized with a serious infection following knee surgery. Mama agreed to the photo but said she had no time to bake a cake.

I rode my bicycle to Community Cash Grocery Store, located at the end of our street on the corner of Lucerne Drive and Union Road. I purchased the out-of-date angel food cake pictured in the photograph, the one Mama is pretending to cover with caramel icing. She was actually spreading Peter Pan peanut butter on the store-bought cake. After the photographer left, we all tasted the cake, but we fed most of it to the dog.

Mama died ten years ago. A part of her legacy is old-fashioned, down-home Southern cooking. With a good bit of motherly cajoling and masterful delegating, she compiled and published her own *Neely Family Cookbook* in 1991. Her goal was to preserve many of the favorite family recipes and the stories behind them in the cooks' own words. Her cookbook has become a collector's item, at least in our family.

"People just do better when they've been fed," was her wise advice.

My culinary repertoire is limited to outdoor grilling, boiled shrimp, made-to-order omelets, bacon, lettuce, and tomato sandwiches with mozzarella cheese, and my world famous peanut butter and jelly sandwich, sometimes with the deluxe banana and mayonnaise addition.

If the old saying "The way to a man's heart is through his stomach" is true, the men in my family may be the best examples.

Mama, a graduate of Winthrop College, majored in home economics. With eight children and forty-five grandchildren, it's a good thing she was an excellent cook!

Dad learned to cook grits in Barnwell County from my step-grandmother, Miss Maude. To this day, Dad makes the best grits I have ever tasted. And his sweet tea—oh, my!

My grandfather was not much of a cook, but he had some of the best culinary advice: "Don't get married and hire a cook; just marry the cook."

Pappy did exactly that. He met my grandmother at a cakewalk at a Methodist church. Mammy was born and reared in the Lowcountry of South Carolina. Pappy traveled to her hometown, twenty miles north of Savannah, to install the electrical wiring for a sawmill. On a Saturday night, Pappy entered the cakewalk. When the music stopped, he won Mammy's pound cake—and Mammy won his heart!

I shared the treasured cakewalk recipe that I inherited from Mammy in a *Stroller Cookbook* several years ago. Her melt-in-your-mouth pound cake is beyond compare.

MAMMY'S POUND CAKE

1 pound sugar
3 tablespoons cream
1 pound butter
3 teaspoons vanilla extract
1 pound flour
1 teaspoon lemon extract
1 pound eggs

All ingredients must be at room temperature. Cream the butter. Gradually add the sugar. Mix alternately small portions of flour and eggs. Add cream, vanilla, and lemon. Beat mixture hard for ten to twenty minutes.

Grease and flour a tube cake pan. One inherited from your grandmother works best.

Pour batter into the pan. Pound the pan on a hard surface twenty to thirty times to remove all bubbles from the batter. Our distressed antique butcher block is the perfect hard surface.

Wham! Wham! Wham! This explains all the dents in the antique pan.

As a child, I thought the name pound cake came because Mammy pounded the cake pan on a wooden cutting board before she put the cake into the oven. The name actually comes from the exact weighing of the principal ingredients on kitchen scales. That includes weighing the eggs. Be sure to weigh them out of the shell.

Put the pan containing the batter into a cold oven. Set the oven to bake at 200 degrees for one hour. Then, increase the heat to 300 degrees and bake for about two hours more or until done.

Check the old-fashioned way, with a broom straw. Pull a straw out of a real straw broom. A plastic broom will not work. When you think the cake is done, stick the straw into the cake. Quickly take the straw out of the cake. If the straw has batter on it, the cake needs more time to bake. If it comes out clean, the cake is done. Turn the cake onto a cooling rack and let the aroma fill the house.

Mammy's pound cake is delicious! It can be served warm. Thin slices toasted and buttered make a delightful breakfast treat. For special occasions, serve a warm chunk of Mammy's pound cake with fresh homemade ice cream.

Mammy's pound cake might change your life. Pappy and Mammy had nine children and thirty-six grandchildren. It all started with her pound cake.

When I got married I took Pappy's advice: I too married a wonderful cook. Clare is a high school history teacher by training, but she is a professional homemaker by vocation. One of the many things I appreciate about my wife is that she has always fed our family well. When our children were small she made peanut butter soup to encourage them to get good protein on cold winter days. She made light fluffy cottage cheese pancakes, insuring that even with whole-grain batter our family would receive the added dairy benefits. While she bakes excellent cakes in the style of her mother, Miz Lib, Clare's specialties are loaded with chocolate. Her hot chocolate chip cookies are so yummy the kids like to eat the dough before she puts it on a cookie sheet. Her double fudge chocolate brownies are to die for.

I am not at all sure my theology is on solid ground when I affirm that I believe heaven will include banana pudding, strawberry short cake, apple pie, peach cobbler, Mammy's pound cake, and Clare's double fudge brownies. We'll just have to wait and see!

The Mockingbird's Song

A lady in our church takes her newspaper and a cup of freshly brewed coffee to her back porch every morning. "I always have my cell phone with me," she explained. "I never know when one of my children might call."

Early one sunny day as she enjoyed her coffee, she heard the familiar ringtone of her cell phone. She took the phone from her pocket. "I thought that the call had been lost. Then I heard the sound again," she said. "It wasn't my phone at all! It was a mockingbird ringing from high up in a sweet gum tree. That bird had heard my ringtone so often that he memorized it!"

The scientific name for the northern mockingbird is *Mimus polyglottos*, which comes from the Greek *mimu*, to mimic, and *polyglottos*, for many-tongued. The mockingbird's song is a medley of the calls of other birds. The mockingbird imitates short units of sound, which it repeats several times before moving on to a new song.

Species with repetitive songs, such as the Carolina wren or the cardinal, are easily copied by the mockingbird. A mockingbird usually has thirty to forty songs in its repertoire. These include other bird songs, the sounds made by insects amphibians, and even the noise of a squeaky gate or a car alarm.

The mockingbird is not only a good mimic, but it is also a loud, vocal bird. Unmated males often sing through the night, especially when the moon is full. These bachelors are singing to woo any available female.

I enjoy sitting in my backyard at night. It is my favorite time to meditate. Eighteen-wheel petroleum trucks groan by on the four-lane in front of our home. Long freight trains rumble along the tracks in back. Dogs bark in the distance. An occasional siren pierces the night, prompting the dogs to howl. I breathe a prayer for whatever family is

involved in the emergency.

When these sounds fade away, I am treated to the symphony of nature. Bullfrogs in the pond and tree frogs in the woods are joined by crickets and cicadas in a chorus. In the spring, whip-poor-wills sing from the meadow near the railroad track. Last week, beneath a bright moon, a mockingbird sang for hours from the top of a pecan tree.

Though called the northern mockingbird, this feathered friend is closely identified with the South, where it is a year-round resident. I know almost no one who calls them northern mockingbirds except exacting ornithologists. It is the state bird of Arkansas, Florida, Mississippi, Tennessee, and Texas. My grandfather, a Tennessee native, told me it was his favorite bird. From him I learned to identify the mockingbird by the distinctive white chevron markings on the wings and the long tail that constantly moves up and down.

By Valentine's Day in the Upstate of South Carolina male mockingbirds stake out their nesting territory. Mockingbirds are usually monogamous. Both males and females are involved in building the nest. While one works on the nest the other perches nearby to watch for predators. In my backyard the nests are frequently located in thick shrubbery up to ten feet above the ground. The mother bird lays and incubates three to five eggs. After the fledglings hatch, both the male and female work constantly to feed them.

Mockingbirds aggressively defend their nest. I have seen a pair harass a red-tailed hawk until the encroacher left the territory. They

have been known to peck bald spots on the rear end of a cat and inflict a wound on a dog that required stitches from a vet. Mockingbirds will even target humans, as my dear wife can attest. Clare walked though a gate into our backyard. Unbeknownst to her, she was too close to a nest. A mockingbird, diving like a kamikaze, struck her on the shoulder.

2010 marked the fiftieth anniversary of *To Kill a Mockingbird*, the Pulitzer Prize-winning novel by Harper Lee. The story's hero, Atticus Finch, gives his children air rifles for Christmas, warning, "It's a sin to kill a mockingbird." A neighbor, Miss Maudie, explains to the children, "Mockingbirds don't do one thing but make music for us to enjoy. They don't eat up people's gardens, don't nest in corncribs, they don't do one thing but sing their hearts out for us."

Many know the song "Listen to the Mockingbird," written by Alice Hawthorne in 1855. My favorite rendition is an instrumental guitar arrangement by Chet Atkins entitled "Hot Mockingbird." In his recording Chet makes his Gretsch Country Gentleman sing like the gray and white bird.

Most parents have sung the "Mockingbird Lullaby" to their children. Carly Simon and James Taylor recorded a version that was a popular success in 1974. One of the joys of being a grandfather is singing to our grandchildren, often lullabies. They provide the only audience that will listen to my warbles without complaining. Recently Clare and I were babysitting for our grandson Ben. After supper and a bath, a fresh diaper, and clean pajamas I took him upstairs to bed. We followed the usual routine: a sip of milk, a favorite book, a little rocking chair time, and a song. I started the lullaby.

> Hush, little baby, don't say a word,
> Papa's going to buy you a mockingbird.

Outside of the bedroom window from the top of a sassafras tree, Ben and I heard the sweet music of a mockingbird. We listened together for a few minutes. I put Ben in his bed. Without a whimper he closed his eyes and went to sleep, serenaded by the mockingbird's song.

ON SPEAKING SOUTHERN

Recently, I had lunch with a delightful group of people at a local eatery. In the course of our table talk one fellow expressed a concern.

"My wife and I have lived here for five years now. We really like the South. We have found it to be much friendlier than Chicago. We are trying to be real Southerners, but people here speak a different language."

"Just be yourself," I said. "You'll probably get some good-natured teasing. Most Southerners would rather know you the way that you are than to have to deal with phoniness. Most folks can spot a fake as quickly as a three-dollar bill."

"See, that's what I mean. The Treasury doesn't print three-dollar bills."

"That's right. They're phony, counterfeit. Most people can spot a fake at twenty paces!"

"Twenty paces? How far is that?"

"About 12-gauge shotgun range!"

He laughed.

Later I thought about his dilemma. What is it about our speech that identifies us as Southerners?

Speaking Southern is more than accent or dialect, more than drawl or pace. It is the turning of a phrase. A conversation takes a little longer because we add extra syllables and words to our speech. Instead of saying *another*, we might say *a whole 'nuther*.

Southern language uses frequent comparisons. If the weather is unusually warm, we say it is hotter than half of Georgia, hotter than a forty-dollar mule, or hotter than goats in a pepper patch.

In Southern vernacular, character traits are described in word pictures. If a woman is frantic, we say she's running around like a

chicken with her head cut off. A stubborn man would argue with a fence post. A person who has been treated badly or abused looks like they've been rode hard and put up wet. An unfortunate fellow got the short end of the stick. An impetuous person goes off half-cocked. An inebriated guest has three sheets in the wind. An upset lady had her feathers ruffled. A person who is snobbish is acting above their raising.

We don't even bat an eye when these expressions are used. It's second nature to us. Many of our Southernisms are self-explanatory. Most anybody can figure out that a person who is counting his chickens before they hatch is being overly optimistic. If a husband and wife are like two peas in a pod, they seem well-suited for each other.

There are times when we use expressions without even knowing where they came from or exactly what they mean. I personally have never butchered hogs, but I know that when a fellow hits his thumb with a hammer he is likely to holler like a stuck pig.

I haven't done extensive research on the life cycle of raccoons, but I know that when something hasn't happened in a coon's age, it has been quite a while since the last occurrence. I do know enough about raccoon hunting to know that when a person is barking up the wrong tree they are misdirected.

In the South we even have expressions for those times when we don't know what to say or we want to avoid saying something rude. Our responses to gossip add nothing to the conversation except to encourage more gossip.

"Aunt Bertha went to the doctor. She's put on another twelve pounds."

"Bless her heart!"

"I heard that Cora Lee ran off with a state trooper."

"You don't say!"

"Jim Bob lost another job. He's drinking hard again."

"Well, I'll declare."

We also have expressions that might or might not signal an end to conversation. "Hush your mouth!" and "Shut my mouth!" are examples. We are probably saying good-bye when we say, "Y'all come," or "What's your rush?"

When Clare and I lived in Kentucky we had neighbors who hailed from the northern side of the Ohio River. These people had trouble saying good-bye. One night after they had thoroughly worn out their

welcome, I said to Clare, "Sugar, we need to go to bed so these folks can go home."

Clare's father, Mr. Jack, used to say to guests who needed to leave, "Don't let the screen door hit you in the back on your way out."

My in-laws were Mr. Jack and Miz Lib. I would never have called them by their first names. Aunts and uncles are always addressed as such. Even older cousins are referred to as Cud'n Emory or Cud'n Myrtis.

My grandfather served in the Navy for four years. As a matter of respect he addressed men as Cap'n. He usually addressed women as Lady. Southerners often give veterans the honorary rank of Colonel. Sometimes we call a person Judge just because they seem to have some authority. A grumpy old codger is referred to as, for example, Old Man Snodgrass.

Mama taught me to say Ma'am and Sir to any person older than I was. To fail to afford that level of respect to my elders was a mouth-washing offense. My dad taught me to say a blessing before meals, even in a restaurant or in a fishing boat.

Our Southern way of speaking takes a little longer. We don't need to expect others to adopt our ways. We all just need to be ourselves.

Mama used to say, "Be who you is, and not who you ain't. Cause if you is who you ain't, you ain't who you is."

THIS SIDE
OF THE KUDZU

Eulogy for
a Groundhog

O ne cool day last fall Clare discovered a dead groundhog. The
animal was near our mailbox next to the four-lane road in
front of our home. Though I am not a Crime Scene Investigator, the
immediate cause of death apparently was a close encounter with a
motorized vehicle of some sort. My best guess is that he was dealt a
blow by a lumber truck.

The plump fellow was flat on his back. His small feet were tucked
into his body. His mouth was open, revealing sharp incisors.

Using a shovel, I scooped the groundhog from the pavement and
carried him to a large field next to the railroad tracks behind our
house. The next day, I noticed several crows and two buzzards circling
his carcass.

Reflecting on this drama, I wondered why our calendars include a
day commemorating the groundhog. Why not have special days named
for other critters? Don't possums and skunks deserve days named for
them? Why is only the groundhog afforded this honor?

On February 2 the Christian holiday of Candlemas is observed. In
the Roman Catholic tradition the day marks the end of the Christmas
and Epiphany season. It is the day Christmas decorations are to be
removed.

> Down with the rosemary, and so
> Down with the bays and mistletoe;
> Down with the holly, ivy, all,
> Wherewith ye dress'd the Christmas Hall.
> —Robert Herrick (1591–1674)
> "Ceremony upon Candlemas Eve"

The name Candlemas refers to the practice of a priest blessing

beeswax candles for use in churches and homes for the year ahead.

Each year on February 2nd, the population of Punxsutawney, Pennsylvania, swells from about 6,000 to well over 10,000. Visitors travel to the small town sixty-five miles northeast of Pittsburgh not for the blessings of candles but to celebrate Groundhog Day.

February 2 is the midpoint of winter, falling halfway between the winter solstice and the vernal equinox. If, on Candlemas, the weather was cloudy and overcast, it was believed that warmer weather was ahead. If, on that day, the weather was bright and sunny, cold weather could be expected for another six weeks. Hence, the rhyme:

> If Candlemas Day is bright and clear,
> There'll be two winters in the year.

Therefore, if a hibernating animal emerging from his den casts a shadow, winter would last another six weeks. If no shadow was seen, according to legend, spring would come early.

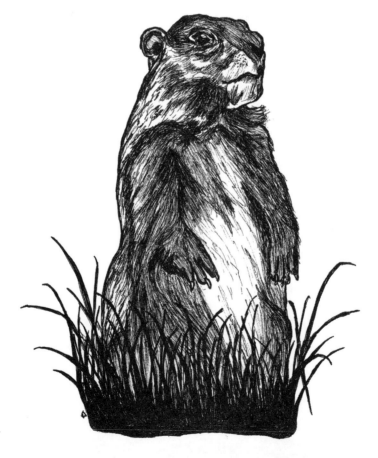

The question remains, why the groundhog? Surely other furry animals cast shadows. Why should the groundhog be singled out for a special day? Maybe this is rodent discrimination. What about gophers, or squirrels, or rats?

Maybe groundhogs were chosen because they are animals that enter a true hibernation period. Maybe it is because they have such a wide range, from Alabama to Alaska. Maybe it is because they are so plentiful, reproducing in numbers similar to rabbits and rats. Indeed, farmers in some areas consider these marmots to be varmints.

Maybe the groundhog received this designation because, when frightened, he holds absolutely still, hesitates, and then scurries into his burrow. This might explain the legend that the groundhog sees his shadow, is afraid, and returns quickly to his den.

The groundhog (*Marmota monax*) is known by several names. The name woodchuck comes from an Algonquian name for the animal, *wuchak*. Woodchuck is the name made popular by a well-known tongue twister.

> How much wood would a woodchuck chuck,
> If a woodchuck would chuck wood?
> A woodchuck would chuck all the wood
> That a woodchuck would chuck,
> If a woodchuck would chuck wood.

Another name for the groundhog is whistle pig. Outside their burrow these furry animals are alert. When driving along the Blue Ridge Parkway, I have often seen several of these critters standing erect on their hind feet, motionless, watching for danger. If alarmed, they use a high-pitched whistle to warn the rest of the colony.

Of course, the one Clare found by our mailbox was also motionless. He apparently didn't hear the warning.

Groundhogs usually live two to three years. Common predators include wolves, coyotes, foxes, bobcats, bears, hawks, and owls. Lumber trucks are also a hazard.

Country folks sometimes eat groundhog for supper. Stews with plenty of onions, garlic, and hot peppers seem to be the preferred recipes.

The groundhog has found his niche. Doc Watson and Pete Seeger

have memorialized him in folksongs. *Groundhog Day* is a 1993 comedy film directed by Harold Ramis, starring Bill Murray and Gaffney's own Andie MacDowell.

On February 2, businessmen wearing top hats and tuxedoes will coax Punxsutawney Phil, the most celebrated of all groundhogs, from his stump. Phil will whisper his prediction to a Punxsutawney Groundhog Club Inner Circle representative. The translator will reveal the forecast to the national news media. Approximately 90 percent of the time, Phil sees his shadow. Phil's ancestors started making predictions in 1887. Residents contend that their groundhog has never been wrong.

Meanwhile in Lilburn, Georgia, Phil's Southern cousin, General Beauregard Lee, will see his shadow or not. He will then give his prediction for the states below the Mason-Dixon Line.

What about the groundhog that died near our mailbox? Did he see his shadow or not? It doesn't matter either way. He sure didn't see the lumber truck that hit him.

SWIMMING WITH SHARKS

Jaws, a 1975 film directed by Steven Spielberg, was based on Peter Benchley's novel of the same name. I saw the movie on television just two days before I went deep sea fishing off the Outer Banks of North Carolina aboard the *Albatross*, a forty-five foot shallow-draw craft. I thought of a memorable line from the movie: "You're gonna need a bigger boat."

Fifteen years earlier, I had been on a similar boat. After two heart attacks and a stroke, driving an automobile was difficult for my grandfather and unsafe for everybody in his path. I got a South Carolina driver's license when I was fourteen. Then I became Pappy's designated driver.

When I was in the tenth grade, Pappy drove his green Oldsmobile to Spartanburg High School. He blew the car horn repeatedly until Dr. Spencer Rice, the principal, came out to see what all the fuss was about. Of course, Dr. Rice knew my grandfather.

"Mr. Neely, is anything wrong?"

"Nothing wrong. Send that boy out here."

"Which boy?" asked Dr. Rice.

"My grandson, Kirk."

Dr. Rice paged me. "Please send Kirk Neely to the office."

That's the announcement every tenth grader dreads. I walked slowly to the principal's office, wondering what I had done wrong.

Dr. Rice explained, "Kirk, your grandfather is here." I was both relieved and worried. I went outside. Dr. Rice followed.

Pappy had moved over into the passenger's seat. "Get in here, boy, and drive me." I got behind the wheel.

"Mr. Neely, are you taking Kirk out of school?" Dr. Rice asked.

"No, I'm not taking him out of school. He needs his education."

"When can we expect him back?"

"In about a week."

"Do you have an excuse?"

"No! No excuse. We're going fishing!"

Pappy turned to me, "Take Highway 56 South toward Augusta."

In the rearview mirror I could see that Dr. Rice was stunned. Pappy stunned a lot of people. My mother told me later that she thought that being with Pappy for a week was an educational experience, more valuable than a week of school. She was right.

We did not talk much. We drove to Daytona Beach, Florida, and we fished for a week.

Pappy's doctor had told him that he could fish only every other day. He chartered a boat. On the off days we drove all over Florida, going to spring training camps for major league baseball teams.

On fishing days we went on the boat to the Gulf Stream, angling for red snapper, bottom-dwelling fish. Our double hook baited with squid, we fished a few turns off the ocean bottom.

Pappy was an excellent fisherman. By the time he got his line to the bottom and cranked it up a few turns he would have a fish. Because his arm was weak, he would hand me his rod and reel, and I would hand him mine. I reeled in the fish while he hooked another. Many times he had two snappers on the double hook.

In three days' fishing we caught red snapper—six-hundred pounds worth, dressed, frozen, and put on ice.

We still had one day of fishing to go. We got to the boat early that last day. Pappy announced, "Cap'n, I want to go trolling today."

We landed several king mackerel. Then we went further out to the Gulf Stream. We stopped moving for lunch. The clear blue water of the Gulf Stream was like glass. We were about twenty miles off the coast of Florida.

When we finished lunch, the second mate, a couple of years older than me, asked, "Wanna go swimming?"

"Go ahead," Pappy said.

I stood on the transom and dived headfirst into the Gulf Stream. I swam in the warm water ten or fifteen minutes before climbing back into the boat.

As we continued trolling, we caught dolphins, some of the most colorful fish in the ocean. These are not porpoises. A dolphin is called mahi-mahi in Hawaii. They fight like a bream. Imagine having a twenty-pound bream on the end of your line.

I hooked a large bull dolphin. The fish darted back and forth. All of a sudden, it started running straight to the boat. I reeled as fast as I could, trying to understand why the fish behaved so oddly.

Then I saw a dorsal fin rise up out of the water. The fish on my line was being chased by a ten-foot-long shark. The shark closed in, and the fish retreated. The shark followed, and the fish fled. I felt a strong thump and then dead weight on my line. The shark had cut the fish in half. I reeled in the head.

It took me a moment to realize; only minutes earlier I had been swimming with the sharks!

Last summer, before our vacation on Pawleys Island, one of our sons asked, "Dad, have you noticed that Shark Week on the Discovery Channel often coincides with our week at the beach?"

One late afternoon, the tide was coming in. I was swimming with our children just beyond the breakers. Riding up on a wave, I saw a mullet jump. The fish was being pursued! And then a dorsal fin arched in the waves just a few yards away. Thankfully, it was a porpoise.

Whether I venture out to the Gulf Stream or swim just beyond the breakers, I think of my trip with Pappy. He loved the ocean, the sun, and the fish. When I leave land and enter the ocean, I am not alone. Not only are there many creatures, large and small, beneath the salt waves, but I also sense that Pappy is somehow close at hand.

KUDZU FOREVER

Clare and I received an invitation to an engagement party. When I called for directions to the home where the party was to be held, the host said, "We live three houses this side of the kudzu." The truth is, in the South, we all live pretty close to the kudzu. As springtime approaches, kudzu begins to once again reach its sinister tendrils across the Southern landscape.

The television documentary "The Amazing Story of Kudzu" was originally broadcast on Alabama Public Television as a part of the weekly series *The Alabama Experience*. It was then distributed to other Public TV stations nationwide. The documentary tells the tale of the kudzu vine and the relationship Southerners have with the insidious green invader.

At the Centennial Exposition in Philadelphia, Pennsylvania, in 1876, exhibitors from around the world were invited to celebrate the one-hundredth birthday of the United States. The Japanese exhibit featured a beautiful garden filled with plants from the Far East. One especially captured the attention of American horticulturalists, among them a nurseryman from Chipley, Florida. The large leaves and the sweet-smelling purple blossoms of kudzu were most appealing. He took a cutting, propagated the plant, and sold it to mail order customers as an ornamental vine. A historical marker near Chipley proudly proclaims "Kudzu Developed Here."

My dad and granddad told stories about how the federal government was responsible for the kudzu takeover in the South. After the Great Depression there was a Civilian Conservation Corps camp in Spartanburg County. "The government actually paid those fellows good money to plant kudzu," Dad remembered. "The federal government has done some crazy things in my time, but that just about takes the cake."

The Soil Conservation Service promoted kudzu for conservation control. By the 1940s farmers were being paid as much as eight dollars an acre to plant fields of the Japanese vine.

Channing Cope of Covington, Georgia, kudzu's most vocal advocate, proclaimed, "Cotton is no longer king of the South. The new king is the miracle vine kudzu." Cope wrote about kudzu in articles for the *Atlanta Journal-Constitution* and talked about its virtues on his daily radio program.

The problem is that the prolific plant grows too well in our Southern climate. The insidious vines can grow as much as a foot every day during the hottest part of the summer. Kudzu will absolutely take over, climbing trees, power poles, and anything else in its path. My grandfather told a story about an old mule that went lame out in the field. "The poor old mule couldn't run. During the night, kudzu vines twined up his legs and strangled him to death before daylight."

The invasive vines can grow up to sixty feet each year. Kudzu can also destroy valuable forests since it prevents trees from getting sunlight. The Forestry Service in Alabama has researched methods for killing kudzu. They have found that many herbicides have little effect. One actually makes kudzu grow faster. Even the most effective herbicides take as long as ten years to kill kudzu.

I see places in our county that are identified as Kudzu Control Sites, an oxymoron, to be sure. I appreciate the efforts of my friend Newt Hardy and others doing the work. Kudzu is a stubborn foe. Newt explains that the persistent vine grows from crowns. Think strawberry plants on steroids. In order to kill kudzu, the crown has to be destroyed.

The Cherokee believe that a weed is a plant for which a use has yet to be discovered. When it comes to kudzu, Southerners are still eagerly searching for a use. Researchers at Tuskegee University successfully raised Angora goats grazing in fields of kudzu. The goats keep the kudzu from spreading further while producing milk and wool products.

Basket makers have found that kudzu vines are excellent for decorative and functional creations. Ruth Duncan of Greenville, Alabama, makes over 200 kudzu baskets each year. She is called the Queen of Kudzu. Regina Hines of Ball Ground, Georgia, has developed unique basket styles that incorporate curled kudzu vines.

She weaves with other vines as well, but she says that kudzu is the most versatile. Nancy Basket of Walhalla, South Carolina, not only makes baskets but also makes paper from kudzu.

Diane Hoots of Dahlonega, Georgia, has developed a company to market her kudzu products, which include kudzu blossom jelly.

Henry Edwards of Rutherfordton, North Carolina, cuts and bales the vines, producing over 1,000 bales of kudzu hay each year on his

Kudzu Cow Farm. The hay is high in nutritive value. Henry's wife, Edith, makes deep-fried kudzu leaves, kudzu quiche, and other kudzu dishes. Yum!

The quest for a suitable use for the green monster has made it to the Ivy League. Research with laboratory animals at Harvard Medical School has revealed that a drug based on a 2,000-year-old Chinese herbal medicine extracted from kudzu root may help in the treatment of alcoholism.

I have my doubts. When I was at Furman University, one dark night, a fraternity brother under the influence stopped by the roadside to relieve himself. He fell into a tangle of kudzu and grappled with the cussed vine for fifteen minutes before he freed himself. He was no less drunk when he finally escaped than he was when he went into the fray.

Ask any Southerners about the vine, and we'll have something to say or a story to tell. Love it or hate it, we can't escape it. James Dickey once said, "Southerners close their windows at night just to keep the kudzu out." Visitors to the South are awestruck by scenic vistas revealing miles of endless vines.

When Clare and I were at the coast last fall, a Canadian tourist asked, "What is that plant that covers so much of the countryside? We noticed the interesting shapes that it makes along the highway."

"That's kudzu," I said. I knew exactly what he meant.

"I have heard of kudzu," he said. "Will it grow in Canada?"

An older gentleman standing nearby offered, "I can tell you how to plant it."

"How's that?" the tourist asked.

"Cut a piece about the size of a pencil. Throw it as far as you can in one direction, and run as fast as you can in the opposite direction," the old man said with a twinkle in his eye.

"Then y'all will have kudzu like we do—forever!"

BURYING GROUND

The most expensive real estate rarely changes hands once the property is occupied. These small tracts of land are burial plots.

A friend of mine worked for a local cemetery. I teased that he ran his business into the ground. Fifteen or more years ago, he made me an offer too good to refuse. The cemetery was planning to develop a new section.

"We're running a special for a limited time only," he said. "I'll sell you two cemetery plots for the price of one."

I talked with my dad, who always keeps an eye out for a good land deal. Each of us purchased two plots in acreage still undeveloped. Several years later, my friend called again. "We've exhumed a body to be reburied in another county. Four adjoining cemetery lots are available near the graves of your grandfather and grandmother. If you and your dad would rather have those plots, we'll swap even."

Occasionally this expensive real estate is sold to a new occupant. My dad and I both agreed to accept the offer. My mother had qualms about being buried in a previously occupied plot. Seeing that there was no future in trying to reason, Dad and I decided that she and Clare could have the new ground and one of us would gladly accept the used grave as our final resting place.

Burying ground has become multipurpose property. When I conduct a funeral at Greenlawn Cemetery in Spartanburg, I often see people walking their dogs or jogging. As student drivers, our children used the narrow roadways of a local cemetery to master the skill of maneuvering an automobile. Negotiating the circular loop around multiple graves hardly prepared our teenagers for interstate driving, but it was relatively safe. Perhaps the setting is a good reminder that driving can be hazardous.

I spend a good bit of time in cemeteries. Funerals are a regular

part of pastoral duties. After forty-five-plus years of ministry I have spoken words of committal in burying grounds all across the South, including Georgia, Kentucky, Tennessee, and the Carolinas. From green mountain graveyards in Cherokee, Weaverville, Seneca, and Spruce Pine, to city cemeteries beside busy thoroughfares in Lincolnton, Greenville, Louisville, and Charlotte, to quiet country churchyards in Anderson, Rock Hill, Saluda, and Hartsville, I have stood with grieving families as they said good-bye to loved ones.

I conducted a graveside service in the churchyard at Zion Baptist Church set in the rolling hills of rural Cleveland County, North Carolina. Following the service, Bob Cabaniss, a lifelong member of the church and the community, said, "Preacher, let me show you something."

He walked with me to a small granite marker that read:

ORAN ASA PRUITT
Fell From Airplane
June 13, 1956

Bob told the story of the fallen man. "I was over yonder on the next hill mowing hay. I heard the plane flying over. I looked up and saw something fall. A fellow was down here digging a grave when this man fell out of the sky and landed right at this spot. He didn't roll or bounce or anything. He just made a sizeable dent in the ground."

"What happened?" I asked.

"Well, he was flying from Winston-Salem to Asheville on a Piedmont twin-engine plane. They say he was drunk and needed to go to the bathroom. He just opened the wrong door and the wind sucked him right out of the plane. The worst thing about it was that he was on his honeymoon."

"Did they bury him here?"

"No, he died when he hit the ground here in the cemetery. The deacons of the church decided to put down the marker. They took the fellow off somewhere else to bury him."

I doubt that I will ever forget that burying ground in the Piedmont just west of Shelby and north of the Broad River.

The oldest cemeteries in my neck of the woods are to be found next to Presbyterian Churches. These were the churches established by the Scots-Irish settlers. Nazareth Presbyterian Church, organized

in 1772, is the oldest in Spartanburg County. After a funeral there I usually linger a few moments reading the names and the epitaphs on the tombstones. Some of the markers are for original settlers in the Upstate born in the 1600s in Ireland. There are graves of Revolutionary War patriots near graves of Confederate soldiers. There near the Tyger River, a part of the history of Spartanburg County is literally etched in stone. I have a particular interest in Fishing Creek Presbyterian Church in Chester County. That graveyard is filled with Neelys. It was there that I started my genealogical research years ago.

On numerous occasions my grandfather Pappy issued the cautionary word about looking too deeply into our genealogy. "Don't dig around trying to find out about your ancestors. You'll turn up a bunch of whores and horse thieves." I did not heed his warning.

In 1985 my great-uncle Hugh said to me, "Kirk, I'd like to go see my cousins one more time before I die. Would you drive me back to Tennessee?"

"Do they know we're coming?" I asked.

"No! You don't tell them you're coming. You just go."

I agreed to drive Uncle Hugh's brand new Buick, just purchased off of Bill Wakefield's car lot. Before the trip, he took a pair of big scissors—cotton mill shears—and cut the seat belts out. "I am not going to die strapped in a car!" he said.

Uncle Hugh was eighty years old. He had three living first cousins, all older than he.

We had no plan at all when we left Spartanburg except to try to find his kinfolks. We found all three: Ruby and Emory Tucker, brother and sister, who lived in Murfreesboro, and Myrtis Swafford Walls, who lived near Bell Buckle.

I listened intently to these four octogenarian grandchildren of my great-great-grandfather as they told family stories and shared memories. I made six hours of tape recordings of this oral history of my family.

Emory Tucker rode with me to find a cemetery at the base of Short Mountain near Fosterville, Tennessee. Emory's grandfather and grandmother were buried in a small family cemetery that had been untended for years. On a gravel road, we crossed a railroad track and stopped at a barbed wire fence. The enclosed land, once a pasture, was overgrown with high weeds.

Eighty-eight-year-old Emory, who walked with a cane, remained at

the car. Spreading the barbed wire with my hands, I climbed through the fence. I searched the ground and found a big stout stick. Using it to clear my path, I made my way through the weeds and insects, toward a grove of oak trees some two-hundred yards away. The grove was a tangled mass of bramble briars and poison ivy.

Wielding the stick, I fought my way into the grove. I hacked away, finally clearing a small spot of ground. I nearly stumbled. At my feet was a pile of bleached bones. After a moment of stunned disbelief, I identified the remains as the skeleton of a horse.

I caught my breath and rejoined the battle against vines and thorns. Suddenly the stick hit something solid, a tombstone engraved with the name WEBB. I tried to shout the news of my discovery to Emory. Alas, he was not only lame but also hard of hearing. Retracing my steps, I walked almost all the way back to the car before I could make him understand what I had uncovered.

"That's it!" he said excitedly. "That's the grave of Cousin Joe Webb. Grandpa and Grandma are buried right next to him."

Using the stick to separate the barbed wire, I helped Cousin Emory through the fence. I made my way back to the grove of trees. Emory followed at his own pace. Returning to Joe Webb's marker, I continued my attack on the enemy twisted vegetation. There were no other tombstones.

Exasperated, I jabbed the stick into the ground. The resulting sound was a clear thud. Using my hands to clear away several inches of earth, I found another stone, and another, and another. This was a true burying ground; even the grave markers were buried!

Clawing with my bare hands, I scraped the dirt away from each fallen stone. Like an eager archeologist, I uncovered the names: M. H. NEELY, N. A. NEELY, and W. M. NEELY. I had discovered the graves of Emory's grandparents, Major Hugh Neely and Nancy Aylor Neely. They were my great-great-grandparents. I had also found the grave of my great-grandfather, William Morgan Neely.

The cemetery has since been reclaimed, fenced in, and is now properly maintained. My genealogical quest led me to an unusual visit at a very special burying ground.

I think I am the one who will be laid to rest in that used grave in Spartanburg. I hope the previous occupant was neither a whore nor a horse thief. I'd hate to be remembered as a preacher who kept bad company!

DANCING DAFFODILS

A dear lady, Helen Babb, lived in the country between Greer and Gowansville. Mrs. Babb loved beautiful flowers. In the late summer, wildflowers covered an area near the old barn. They reseeded each year, multiplying in number and in beauty. In the early spring, Helen Babb's yard featured bright yellow jonquils, the petite relatives of daffodils. They, too, spread each year, flowing like a graceful yellow ribbon down a gentle slope.

After Mrs. Babb's death several years ago her daughter knew that she would have to sell the homeplace. She wanted to save some of the heirloom flowers for her own yard in Spartanburg. In the fall she dug up a box full of the jonquil bulbs, many more than she needed. She shared some with me.

On a rainy, cold November afternoon I planted the bulbs on an embankment near the waterfall in my garden. Every February, the tiny flowers put on a magnificent display. Late winter across the South is the season for narcissus. Both petite jonquils and larger daffodils are members of the narcissus family.

The flowers are named for Narcissus, a character from ancient Greek mythology. He was a sixteen-year-old young man who became infatuated with his own reflection in a

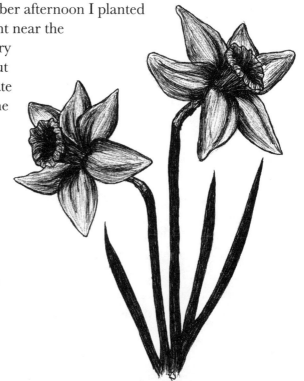

pool of water. He spurned the affection of the beautiful maiden, Echo, until she was finally reduced to nothing more than her sad, pleading voice. Narcissus, meanwhile, was so entranced by his own image in the pool that he was transformed into a flower at the water's edge. The blooming plant that bears his name is commonly known as the daffodil.

Daffodils and their smaller Spanish cousins, jonquils, dance in the wind. Other flowers, like the crocus and the Lenten rose, are welcome sights even in the snow. But once the daffodils bloom, there can be no doubt that the seasons are changing. It is as if the nodding trumpet-shaped flowers herald the arrival of spring.

Several years ago, two of our sons and I took a backpacking trip during spring break along the Foothills Trail in the Dark Corner, the northwestern section of South Carolina. Somewhere between the Toxaway and the Whitewater Rivers, we camped in a clearing. The following morning we were greeted with the stunning sight of hundreds of dancing yellow daffodils. An old homestead had long since deteriorated and was now marked only by a crumbling fieldstone foundation and a collapsed chimney. The flowers that graced the place each spring had survived and naturalized, stretching through a meadow and across the forest floor.

The English poet William Wordsworth immortalized the daffodil in lines penned in 1804:

> I wander'd lonely as a cloud
> That floats on high o'er vales and hills,
> When all at once I saw a crowd,
> A host, of golden daffodils;
> Beside the lake, beneath the trees,
> Fluttering and dancing in the breeze.

When I think of daffodils, Gene comes to mind. Gene was a dear friend who grew up on a farm in Cherokee County, South Carolina. His success with the family business enabled him to build a comfortable home on the family farm within a stone's throw of the old homeplace. The beautiful new house had a wrap-around porch, graced with big rocking chairs. Visitors approached the home by a long driveway, flanked on the left by a horse pasture and a weathered barn. Up a hill

to the right was the foundation of the former home. In the early spring, this hill was covered with bright yellow daffodils. Originally planted by Gene's mother around the old farmhouse, the daffodils naturalized and spread helter-skelter down the hillside. Each year the flowers still bloom from late February through March. The yellow-splotched hill is a sight to behold.

A few years ago, after several months of increasingly serious health problems, it became clear that Gene was quite ill. The diagnosis was a rapidly growing, rare form of cancer. His death came quickly, far sooner than most of us could have ever expected. While anticipated, it was also sudden, making the grief experience jagged and confused.

In mid-March Gene went home from the hospital. On a bright, warm Sunday afternoon, just before he died, Gene asked if he could see the daffodils. Surrounded by his loving wife, children, and several grandchildren, Gene was transported by wheelchair down the driveway near the barn. He sat quietly for a few moments, taking in the sight of the hillside covered in delicate yellow blooms dancing in the breeze. Three days later Gene died.

At the graveside in a country churchyard, the children and grandchildren each placed a daffodil, picked from the hillside, atop the polished wooden casket. Even though yellow daffodils bring to mind bittersweet memories, they will be a perennial symbol of hope for Gene's family.

In his concluding lines in the poem "Daffodils," Wordsworth captures, for all who find in them a signal of hope, the wonder of these spring flowers:

> For oft, when on my couch I lie
> In vacant or in pensive mood,
> They flash upon that inward eye
> Which is the bliss of solitude;
> And then my heart with pleasure fills,
> And dances with the daffodils.

Jesus taught his followers how to deal with worry and anxiety. His counsel was to pay attention to birds and flowers. For Gene's family those flowers will always be daffodils.

ON BEING A
COLORBLIND ARTIST

O ur home is decorated with art, most done by our family. Our
children brought many pieces of art home from school. As
adults, they have continued to express their creativity in multiple
ways, including visual arts.

On Father's Day 2010 they encouraged me to try my hand at
painting.

I have done a lot of painting in my time, most of it on furniture
and walls. I had never before tried to be an artist.

When our children suggested it, I protested. "I can't do that.
I'm colorblind."

They, of course, know that. Through the years they have noticed
my mismatched socks. Our son Erik once quipped that my choices in
neckties harkened back to a time before the invention of color.

"Dad, you ought to try painting," they still encouraged.

My first tentative attempt was on canvas. Our son Kris, the
Assistant Dean of Studio Art at Wofford College, viewed my efforts.

Ever the teacher, he asked, "Are you happy with it?"

"No!" I answered. "It doesn't look a thing like the picture I had
in my mind."

Kris said, "Let's talk about it. Dad, you might try painting on
wood. It's a lot more forgiving."

Forgiveness is not a word I had thought of using in connection with
art. But, looking at my first canvas, I found that the idea of forgiveness
seemed appropriate. I must confess, I felt like a schoolchild presenting
a piece of art, hoping it would be displayed on the refrigerator door.

I've done a lot of painting on wood. I spent most of one summer
trying to paint a fence for my Uncle Wesley. The rough pine boards
drank gallon after gallon of white paint. By the end of the summer, it
looked like a bad whitewash job.

Having grown up on a lumberyard, I know a little bit about wood. I gathered two pieces of Oriented Strand Board I had in my barn. The Strand Board is called OSB by contractors. I am hesitant to use the initials OSB for fear I might get them mixed up and say something I do not intend. To be safe, I just call it strand board.

I assembled a few paints, dragged out an easel our children used when they were preschoolers, scrounged together some old paintbrushes and a forgotten shaving brush, and dared to try.

Our son, Kris, has created a unique opportunity for local artists at his gallery and art studio at Hillcrest Shopping Center in Spartanburg, The Wet Paint Syndrome. On special Pop-up Nights he allows any artist the privilege of displaying two works of art for three hours for a small fee. Amateurs as well as experienced artists accept this unusual invitation. I decided to show my first two pieces at the Pop-up Night. The two paintings I entered were still wet, appropriate for his enterprise. A group of seventeen young artists gathered around my paintings. Most of them offered kind comments. All of them were encouraging, making helpful suggestions.

They, like my children, said, "You need to keep at this."

My first two paintings were of crosses. In itself, the cross is an odd symbol when you think about it. Most of the world's great religions use an object of beauty to identify their faith: the Star of David, the crescent moon, the lotus flower. Christians have chosen the cross, a cruel instrument of execution. It might just as well be a guillotine or an electric chair! Through death by crucifixion the Romans devised a way to inflict severe pain and suffering.

For me, there is a compelling beauty in the cross. It is a reminder of divine love.

So, I paint crosses.

Now that I have embarked on this new venture, I see crosses everywhere—in the shape of a tree, the form of a dragonfly, a constellation in the night sky, and the markings on a hawk. Some crosses are literally in your face. Others are far more subtle.

I am a novice artist, and I am colorblind. Mama was the first to discover my color impairment. She could tell from the drawings I brought home from school. I couldn't distinguish red roses on a green bush.

As a teenager I drove through a town in Georgia one dark night.

A police car tailed me straight down Main Street. Just beyond the city limits, the officer pulled me over.

"Son, are you colorblind?" he asked.

"Yes, sir, I am."

"Colorblind folks have trouble here. When they installed our stop lights, they hung 'em upside down. I followed you all the way through town. You stopped at every green light and went through every red light! I'll warn you this time but don't let it happen again."

In the 1960s, when I was at Furman, Army ROTC was a required class for freshmen and sophomore men. The US Army was preparing all male students to be officers in Vietnam. We were given a routine colorblind test. The Colonel called me aside.

He barked, "Neely, this man's army needs you in reconnaissance!"

Turns out, colorblind people are not easily fooled by camouflage. The life expectancy for a reconnaissance officer in Vietnam was something like two days. I respectfully declined and went to seminary instead.

My children comment on my paintings, "Dad, you have such an unusual use of color, and the colors are so vivid."

I cannot see the colors, but I can read the labels on the tubes of paint. I am having fun! I am like a sixty-something-year-old kindergartener.

THE PACOLET RIVER HORSE

Jason grew up on his family farm in Illinois a few miles south of Chicago. He was visiting a friend in my hometown of Spartanburg. Clare and I invited Jason and his friend to dinner at a local restaurant. We enjoyed a meal of fried green tomatoes and shrimp and grits together. It didn't take long for that Yankee farm boy to get up to his elbows in good Southern victuals.

"Have you been to South Carolina before?" I asked.

Jason told me the story of his one previous foray into the Palmetto State. I was fascinated by his tale.

"I first came to the Carolinas in 2002. March Madness brought me and two other guys from Greenville, Illinois, to Boiling Springs, North Carolina. The women's basketball team from Greenville College traveled to Gardner-Webb University for the National Christian College Athletic Association championship tournament. I was a player on the Greenville Panthers men's team. I was invited to be color commentator for the radio broadcast on WGRN, THE GRIN, back in Northern Illinois.

"Our girls' team played the last game on the first night of the tournament. We arrived at the Gardner-Webb campus late and didn't have time to eat dinner. After the game was over we were all hungry. Everything in Boiling Springs was closed. We decided that, since we had never been to South Carolina, we would drive across the state line to find food.

"At Interstate 85 we saw the signs to Greenville. Since we were from Greenville, Illinois, we thought it would be cool to eat in Greenville, South Carolina."

"It's a good thing you didn't know about Greenville, North Carolina," I interrupted.

"After we ate it was very late. We were all tired. The two other

guys fell asleep. I drove. Somewhere beyond a giant Peach, I got off the Interstate heading back to Gardner-Webb. I must have taken the wrong turn. I got hopelessly lost. I drove forever down a dark country road.

"The black highway was covered with gray mist. I approached a river, traveling downhill. I crossed a bridge shrouded in thick fog, and, suddenly, to my right, I caught a glimpse of a white stallion rearing up out of the water. I swerved to avoid hitting the horse. My friends woke up yelling at me. I spun out, skidding to a stop in front of a big factory of some kind.

"'Did you see that horse?' I shouted. They thought I was crazy. They insisted that I was hallucinating."

Jason swore on a stack of fried green tomatoes that there were no drugs or alcohol involved.

When I heard his story, I laughed out loud.

Jason said, "I have dreamed about that horse galloping through the fog. Every time I have a high fever, I have nightmares about that horse rearing up out of that river."

After our meal I drove Jason to Pacolet Mills to show him the Pacolet River horse.

Jason mused out loud. "It's not as big as it seemed that night. In the fog and mist it looked as big as an Illinois draft horse. Up close in the daylight it looks like it belongs on a merry-go-round."

Jason and his friend took a few pictures of the Pacolet River and the horse perched on its pedestal near the bridge. "This solves a puzzle in my life. Any idea why there is a horse here?" he asked.

I was intrigued by his question and decided to investigate. I started with the internet. I learned that Pacolet is a Cherokee word meaning swift horse. The fleet steed became the logo of Pacolet Manufacturing. The image of the stallion graced the engine of the local train. The horse was the truth mark, the seal of authenticity, stamped on every bale of cloth shipped from the mill. One time a shipment of fabric was returned from China back to the mill. It had been refused because it did not bear the stamp of the horse. So the horse as a symbol has several connections to Pacolet Mills.

After Jason's departure, I wondered: how did the horse get into the river? Several Pacolet residents said I must talk to Worry Kirby.

Maurice Pace arranged a meeting at the T. W. Edwards

Community Center with R. S. Burns and Worry Kirby. My first question seemed obvious. "Where did you get the name Worry?"

"My uncle gave it to me when I was three. He said I worried him to death."

I asked about the horse in the river. Worry and Burns told the story.

In 1953 a new bridge was built over the Pacolet River on Highway 150. The old bridge was demolished except for the large stone piling left standing in the current. The horse, the logo of the mill, was imprinted on every paycheck. The mascot of Pacolet High School was an Indian riding a white horse. Both textile league baseball teams in Pacolet were called the Trojans. Worry and Burns decided they wanted to put a white stallion on the old pillar in the river.

Burns said, "We looked high and low. Of all places, we found it on White Horse Road in Greenville."

Worry explained, "It was fiberglass. Made in California. The fellow who had it for sale wanted $3,000."

"Before we left, Worry had him down to $2,800," Burns said. "We raised most of the cash in three months. Worry can raise money. If he takes a bucket to go blackberry picking, somebody will throw five dollars in the pail before he gets started. His brother chipped in forty dollars before we got back to Pacolet."

Worry said, "We got the horse! I hauled it around in the back of my truck while we got the rest of the money together."

Burns continued the tale, "We borrowed the longest ladder the Pacolet Fire Department had. We lowered that ladder over the bridge, tying it with ropes to the railing. Worry went over the edge, slid down to the top rung, worked his way around to the other side of the ladder, got a good hold, and walked that ladder like a pair of stilts over to the rock column."

Worry explained how he accomplished the acrobatic feat. "I pulled myself up on the pillar. R. S. threw me a broom. Folks had been using it for target practice. The top was littered with rocks and broken bottles. I swept it clean and measured real good. I didn't want to go back over there if I didn't have to."

On July 4, 1996, four men were lifted, one at a time, over to the stanchion in a bucket truck. They ate lunch on top of the pillar just because they could. Using a generator for power, they drilled holes to accommodate the bolts that would fasten the horse in place.

Meanwhile, a fellow who repairs fiberglass boats made the horse watertight. A welder prepared the steel base and the cage that protects the horse. By July 12, 1996, the Pacolet River steed was in place, rearing proudly above the river named for a horse.

The fiberglass steed is definitely a stallion. Several women in the Pacolet Mills community wanted Worry and Burns to turn the horse around facing upstream so his maleness would be less evident.

"I ain't gonna do that!" Worry declared. "If y'all want to put a diaper on him, have at it!"

Burns added, "One preacher tried to get up a petition asking the town council to take our horse down. He thought it was indecent. Nobody would sign the petition. Most people like the horse."

When I told Worry and Burns the story about Jason, they laughed. "He's not the first, and he won't be the last to be surprised by that horse!"

I told them about Jason's nightmares.

Worry grinned, "That stud deserves to have mares of some kind."

HOMEGROWN TOMATOES

My mother was born July 4, 1922. When I was a little boy, I was impressed that everybody took the day off on her birthday. The entire Neely family, as many as fifty-six of us, gathered at the farm for the afternoon. We enjoyed a picnic featuring fried chicken, coleslaw, potato salad, deviled eggs, and blackberry cobbler. We went swimming in the pond. Some tried fishing, but the mosquitoes bit more than the fish. After a supper of leftovers, we watched as our uncles put on a fireworks display.

Because it was Mama's birthday, it took me a while to realize that all of the festivities were not in her honor. Instead, we were celebrating the birth of our nation. For me the best part of the day was eating soggy tomato sandwiches.

July 4 is the date by which gardeners in the Upstate of South Carolina hope to harvest their first ripe tomato. When the first homegrown tomatoes ripen on the vine, I look forward to tomato sandwiches made with Duke's mayonnaise. Many tomato sandwich connoisseurs demand white bread. The less discriminating among us will be perfectly happy with whole wheat or some other variety. For me devouring a soggy tomato sandwich over the kitchen sink is sheer joy.

Long ago, some people thought the tasty red treat was poisonous. Before it was considered fit to eat it was grown only as an ornamental garden plant. The mistaken idea that tomatoes were poisonous probably arose because they belong to the nightshade family. That includes the datura, mandrake, and belladonna, all considered toxic. Close relatives are paprika, chili pepper, potato, tobacco, and petunia. The unpleasant odor of tomato leaves and stems contributed to the idea that the fruits were unfit as food.

Tomatoes originated as wild plants in the tropical foothills of the Andes Mountains of Peru. Gradually, they were carried north into

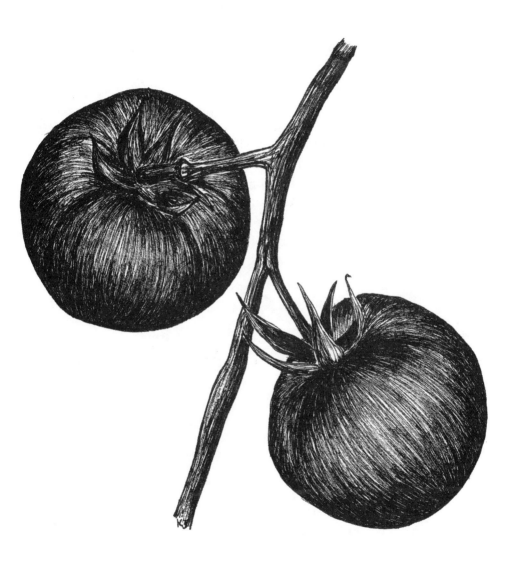

Central America. Mayans used the fruit in their cooking. Tomatoes were cultivated in Mexico by the sixteenth century. The Pueblo people believed that those who ate tomato seeds were blessed with powers of divination. But because of the highly perishable nature of the fruit, the tomato was slow to be adopted as a cultivated plant by Native Americans.

Spanish explorers in the sixteenth century introduced the tomato to European culture. Italians were the first Europeans to grow and eat tomatoes. Later they were grown in English and Spanish gardens, not as food but as a curiosity. The French gave it the name *pomme d'amour*, translated as love apple in English.

The earliest reference to tomatoes being grown in North America is from 1710, when herbalist William Salmon reported seeing them in South Carolina. They may have been introduced to our area from the Caribbean. By the mid-eighteenth century, they were cultivated on many Carolina plantations. Even then, they may have only been of ornamental interest.

Thomas Jefferson had learned of tomatoes in France. The progressive Virginia farmer grew them at Monticello as early as 1781. But in the United States it was not until 1812, in New Orleans, that tomatoes were first grown as food, no doubt because of French influence.

When Clare and I first became homeowners in Kentucky, I worked hard to cultivate a plot of ground that was red clay. Kentucky has plenty of horse manure. I found a riding stable that was glad for me to shovel as much of the stuff as I wanted. I borrowed a pickup truck and hauled three loads of well-rotted manure mixed with composted hay and grass. I was able to grow delicious strawberries, zucchini squash, cabbage, Kentucky pole beans, and tomatoes. We enjoyed that little garden for several years. When we moved to North Carolina, I wished I could take it with me.

While serving my first church I learned quickly that I did not need a garden. As a pastor, I am often asked, "Preacher, do you have a vegetable garden?"

I learned that if I said "yes" I would be able to enjoy whatever I grew. But if I answered "no" we had more vegetables without a garden than we ever had with a garden of our own. Church members kindly share the bounty of their gardens with our household. Sometimes we

know who to thank. At other times, these gifts are left anonymously on our doorstep.

Several years ago, I wrote a poem about homegrown tomatoes and shared it with our congregation. We received so many delicious tomatoes the following week that our son Erik suggested, "Dad, you need to preach a sermon about sweet corn this week."

Tomatoes are the most common garden vegetable in our country. Along with zucchini squash, tomatoes have a reputation for out-producing the needs of the grower. In 1986 Gordon Graham of Edmond, Oklahoma, grew the largest tomato on record. It weighed seven pounds, twelve ounces.

Visitors to Walt Disney World can view the largest tomato plant in the world. Guests along the Living with the Land boat ride at Epcot can see the tomato tree. The vine, a Guinness World Record Holder, grows golf ball-sized tomatoes with a harvest of more than 32,000 tomatoes at a total weight of 1,151.84 pounds. The tomatoes are served at Walt Disney World restaurants.

Although the tomato is technically a fruit, a member of the berry group, it is considered also to be a vegetable. In fact, it is the state vegetable of New Jersey and Arkansas. Health experts say that we need five to ten servings of vegetables and fruits every day. We should all take advantage of local homegrown tomatoes to meet our daily quota.

Tomatoes are regarded as one of the healthiest foods in our diet. Rich in vitamins A and C, tomatoes contain lycopene, an antioxidant that helps reduce the risk of heart disease and cancer. Lycopene is the chemical that gives tomatoes their red color. But as Southerners know, some of the best tomatoes are bright green.

While we were enjoying our family vacation at Pawleys Island, our daughter, Betsy, announced that she had a new recipe for fried green tomatoes. A lifelong devotee of the Southern delicacy, I searched high and low for unripe tomatoes up and down Highway 17. They are not easy to find at roadside stands. In hot weather, even tomatoes that are picked green soon start turning pink. Good fried green tomatoes require the use of bright green fruit that is as hard as a rock. I finally made arrangements with a lady who grew her own vegetables in Andrews to pick several unripe tomatoes early the next morning. I bought them first thing and took them to the beach house. Betsy's recipe was mouth-watering delicious.

Tomatoes are a special favorite in our family. The following verse is an expression of my gratitude.

God is great, God is good.
Let us thank Him for our food.
By His hand we all are fed.
Give us, Lord, our daily bread.

Wholegrain bread, rye, or lite,
A sourdough loaf, or just plain white.
And please, dear Lord, some Duke's mayonnaise.
And homegrown tomatoes for these summer days.

Add lettuce, and bacon, or maybe cheese,
But especially, Lord, I ask you please,
For vine ripe tomatoes, sliced thick and round
To make the best sandwich I've ever found.

On days that grow weary with muggy heat,
A soggy tomato sandwich just can't be beat.
With a tall glass of something cold to drink,
I'll eat my lunch over the kitchen sink.

I'm grateful for corn, that good Silver Queen,
For cantaloupe, peaches, and fresh green beans,
For squash, and okra, and small red potatoes,
but nothing is better than homegrown tomatoes.

God is great, and God is good.
Let us thank Him for our food.
I know His kindness never ends
When given tomatoes by special friends.

STORMY THE GARDEN CAT

I have learned that when Clare senses something is amiss, I need to pay attention to her. While house hunting in Winston-Salem, we visited one picturesque abode. We got no further than the front door when Clare said, "Yuck! The previous family had cats! Many cats!"

Several years ago we were sitting quietly in our den when Clare smelled something burning. I sniffed and detected nothing. Clare insisted that I look around the house with her. Reluctantly, I left my chair to join the search. I could not smell anything burning.

But there was! And it was my fault!

I had come home from work, pulled off my necktie, and flung it toward a chair in our bedroom. One end of the silk tie had flipped over a lampshade and was touching the hot light bulb. The end of the tie was smoldering, just before bursting into flames. Clare's keen olfactory awareness saved us from a more serious problem.

Clare often wears two pairs of glasses. Her prescription lenses are perched on her nose, and a pair of reading glasses is at the ready on top of her head. But her unaided eyesight is amazing. She can spot a dead bug on our basement floor at thirty paces. She can see a stain on my shirt and identify the source before I am even aware of the problem. She carries a laundry stick in her purse, just to keep me presentable.

My wife's hearing is equally as sensitive. Last spring during a booming thunderstorm, Clare thought she heard a baby crying. I, of course, heard nothing. But I have learned to pay attention when Clare senses something strange. As I listened, I heard only rumbling thunder, whistling wind, and pounding rain.

"I hear something that sounds like a baby crying," Clare insisted. I listened more closely, and I heard what she had heard.

I went out into the storm to investigate. Sure enough, Clare was

right! It was a baby crying—a baby kitten.

I reported my find. "Don't bring that cat into this house!" she instructed.

I heeded her warning. I have never regarded myself as a cat person. Dogs are more to my liking. At the same time I felt compelled to provide some comfort for the black and white foundling. The little kitten had obviously become separated from her mother during the storm. I could not be sure how old the kitten was. She was so small I could hold her in the palm of one hand.

Placing an old towel in a garden basket, I made a bed for the tiny trembling stray. Cold, wet, hungry, and frightened, she continued to cry. She even tried to nurse my little finger. That didn't work.

I called a good friend, a retired veterinarian, who gave me sound guidance. At a local pet store I purchased a formula substitute for mother's milk. The little orphan lapped it up and promptly fell asleep in the crook of my arm. I am not really a cat person, but I had become the unexpected caretaker of a kitten.

Our daughter named the cat. "She was delivered to your porch by a thunderstorm. You have to name her Stormy." So Stormy she is.

My veterinarian friend advised me on immunizations and on the proper time to have her spayed. Those health issues were taken care of by the good folks at our local animal shelter.

My responsibilities are relatively few. I make sure Stormy has her regular ration of food, that her water bowl is freshly filled each day, and that she has a routine tick and flea treatment. I also take a little time to scratch her ears. When I sit down on a favorite bench in the yard near the tree of life, Stormy still enjoys climbing into my lap for a snooze. I, who am not really a cat person, enjoy that too.

Stormy has made herself at home in our garden. She quickly found the patch of catnip and enjoys a daily tumble in the fragrant foliage. She has her favorite lookout posts and napping places. She has climbed most of the trees in our garden and knows how to ascend and descend each one.

Early in our relationship, Stormy and I reached an agreement. She is free to stalk and capture any varmint that crosses the estate. However, she is under strict orders to leave the birds alone. So far, Stormy has done pretty well with that contract. We have been gifted with a variety of artifacts at our front door. These have included an

assortment of deceased moles, voles, mice, and chipmunks, and at least three gray squirrel tails. I don't know what she did with the other end of the squirrels. Perhaps there are three tailless squirrels bounding through our tree branches

Late one night, I heard the sounds of a major catfight. Actually, Stormy had cornered a possum. She wasn't quite sure what to do with the critter, so I ran it off with a shovel.

As far as I can tell the bird casualties have been limited to one starling. I reminded Stormy of our bargain, but, honestly, I wasn't a bit upset by the demise of the pesky starling. She is a discerning cat.

In one corner of our garden I have a cast iron chiminea that I bought from a fellow in Commerce, Georgia. Sometimes on cool nights I build a small fire in the rusty stove. Stormy ventures over to check me out. Then, just like she did when she was a little kitten, she will hop on my lap. I am not really a cat person, but I scratch her ears. Stormy purrs, and we enjoy the dying embers together.

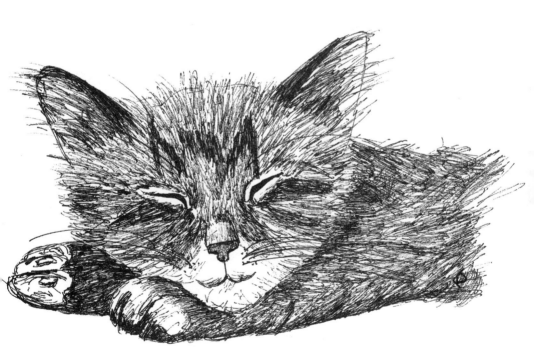

LOOKING FOR DIXIE

I was at the back of the checkout line in the grocery store waiting to pay for a few items Clare had asked me to pick up. An elderly couple hobbled into the store on a cold, windy day and approached the clerk with a request. "Can we post a lost dog flyer in your store window?"

The manager was nearby and offered to put up two of the flyers. Then he said, "Tell me about your dog."

"Dixie is a Cocker Spaniel. She escaped from our yard. I went after her, but I just couldn't keep up with her," the old man said sadly.

"We've looked high and low, and we can't find Dixie anywhere!" said the woman tearfully.

The name Dixie is common in the South. In my high school and college years there were several coeds with the name. In the local Yellow Pages there are a dozen companies claiming the title. Winn-Dixie grocery stores, once prominent in our area, are still part of the Southern economy in the Deep South. When Clare and I lived in Louisville, Kentucky, we discovered that a major traffic artery was named the Dixie Highway.

What is the origin of the name Dixie? According to *A Dictionary of Americanisms on Historical Principles* by Mitford M. Mathews, two theories most commonly attempt to explain the term:

> 1. In the early 1800s ten dollar notes were issued privately by banks in Louisiana. Labeled *Dix*, French for ten, the bill was called a Dixie. The area where the money circulated was called Dixieland. The term eventually broadened to refer to the Southern states.

2. Jeremiah Dixon purportedly said to his surveying partner, Charles Mason, "We've got to draw the line somewhere." The Mason-Dixon Line defined the border between Maryland and Pennsylvania. It became identified as the border between North and South.

Dixie is usually defined as the eleven Southern states that seceded to form the Confederate States of America. They are, in order of secession: South Carolina, Mississippi, Florida, Alabama, Georgia, Louisiana, Texas, Virginia, Arkansas, North Carolina, and Tennessee. In the minds of many Southerners these states represented by the stars on the Confederate battle flag remain the traditional South. Many others believe that Dixie, as a region, includes West Virginia, Virginia, Maryland, North Carolina, South Carolina, Georgia, Florida, Alabama, Tennessee, Mississippi, Arkansas, Texas, Oklahoma, Louisiana, and Kentucky.

When Clare and I were students at Furman University, Kappa Alpha fraternity was the group on campus that preserved Southern traditions. Each year, they held an Old South Ball. Members and guests celebrated their heritage by dressing in Civil War period costumes.

Kappa Alpha Order was originally founded at the end of the Civil War on the campus of Washington and Lee University in Lexington, Virginia. Robert E. Lee, whose ideals of chivalry and gentlemanly conduct inspired the founders, was designated the Spiritual Founder of the Order. The KA fraternity is still popular throughout the South.

When I was Head Cheerleader at Furman, the KAs brought a huge Confederate battle flag to every home football and basketball game. At any particularly exciting point in the contest the Furman band broke into "Dixie," and the KAs waved the flag.

The song has an interesting history. "I Wish I Was in Dixie" is the original title of the tune. Surprisingly, the words were adapted from a letter written before the Civil War began in 1861 by Evelyn Snowden, an African-American woman. The homesick young woman wrote to her father lamenting the loss of her past life in the South.

The Snowdens, a family of African-American musicians, were freemen of color. Another surprise is that "Dixie" was composed by

a Yankee from Ohio, Daniel Emmett.

In 1859 Emmett's minstrel show débuted the song in New York City. It became an immediate hit. As was the custom with other minstrel show numbers, the song was performed by singers in blackface using an exaggerated Southern accent. The popular song became widely known simply as "Dixie." It is most often associated with those parts of the Southern United States where traditions and legacies of the antebellum South linger.

The song became the unofficial anthem of the Confederate States of America during the American Civil War. Today, many perceive the song as racist, while others regard it as a legitimate part of Southern heritage. Interestingly, Abraham Lincoln, upon hearing of the Confederate surrender at Appomattox, asked the Union military band to play "Dixie."

Another song, first recorded by The Band in 1969, was written by Canadian musician Robbie Robertson. "The Night They Drove Old Dixie Down" tells of the last days of the Civil War. Confederate soldier Virgil Caine "served on the Danville train," the main supply line into the Confederate capital of Richmond, Virginia. General Robert E. Lee's army of Northern Virginia was holding the line at the Siege of Petersburg. Union Army General George Stoneman's Calvary "tore up the track again." The siege lasted from June 1864 to April 1865, when both Petersburg and Richmond fell. Lee's troops were starving at the end. "We were hungry, just barely alive." In the lyrics, Virgil Caine mourns the loss of his brother, also a Confederate soldier: "He was just eighteen, proud and brave, but a Yankee laid him in his grave."

In a review in *Rolling Stone* from October 1969 the writer explains why "The Night They Drove Old Dixie Down" has such an impact on listeners:

> Nothing I have read ... has brought home the overwhelming human sense of history that this song does. The only thing I can relate it to at all is *The Red Badge of Courage*. It is a remarkable song, the rhythmic structure, and the voice ... make it seem impossible that this isn't some traditional material handed down from father

to son straight from that winter of 1865 to today.
It has that ring of truth and the whole aura of authenticity.

In a documentary film entitled the *Last Waltz* Robbie Robertson claimed that he had the music to the song in his head but had no idea what it was to be about. "When I first went down South," he said, "I remember that a quite common expression was, 'The South's gonna rise again.' At one point when I heard it I thought it was kind of a funny statement and then I heard it another time and I was really touched by it. I thought, 'God, because I keep hearing this, there's pain here, there is sadness here.'"

That pervasive sadness that Robertson put into his song still haunts some Southerners. When I heard the couple in the store grieving because they had lost their dog, I was not at all surprised at the pet's name. The phrase stuck in my mind: "We can't find Dixie anywhere." It had that same note of sadness that I have heard by people who had not lost a dog but were longing for a Dixie long since passed.

For many Southerners any reminder of War Between the States still elicits mixed emotions. The cartoon caricature of a portly old rebel declaring "Forget, Hell!" does not begin to encapsulate the feelings of most Southerners. Today, most Southerners affirm that slavery was terribly wrong and a horrible injustice. Most would agree that it is best that the Union was preserved. It is also true that even now, four generations since General Robert E. Lee surrendered his sword to Ulysses S. Grant at Appomattox Courthouse, there lingers a pervasive grief for The Lost Cause. It is the deep pathos that is the foundation for Margaret Mitchell's epic work, *Gone with the Wind*. It permeates much of Southern literature and the music of the South.

In 1990 I was walking across campus at the University of Indiana with Charlie Sullivan, an old timer from Durham, North Carolina. I commented on the beauty of the place.

Reflecting the lingering mindset of generations of Southerners, defeated more than a century earlier, Charlie responded, "Yep, it sure pays to have won the war!"

Twenty years ago, a long-time friend and avid Civil War buff gave me a framed copy of "The Conquered Banner," a poem by Father Abram Joseph Ryan who was known as the Poet Laureate of the

Confederacy. The lines lament the defeat of the South. Ryan wrote it soon after the surrender at Appomattox Courthouse. The Roman Catholic priest later told a friend that he had taken the meter from a Gregorian dirge. The last verse reads:

> Furl that banner, softly, slowly!
> Treat it gently—it is holy,
> For it droops above the dead.
> Touch it not—unfold it never,
> Let it droop there, furled forever,
> For its people's hopes are dead!

The friend who gave me the poem requested that "Dixie," the anthem of the Confederacy, be played at his funeral. His family honored his wish. As the coffin departed the church, the organ played softly the strains, "O, I wish I was in the land of cotton."

Some folks spend their whole lives looking for Dixie and never find it. Rather than looking back wistfully to the past, those who cherish the South will look forward. Look closely and you will see that the South did, indeed, rise again!

THE BOXCAR AND
THE BIRD'S NEST

Clare and I are grandparents to seven delightful children. We await in eager anticipation the arrival of additional grandbabies in the months and years ahead. Being a grandfather brings me much joy. My memories of my own grandparents give me much to anticipate with my grandchildren.

Like so many other grandparents, Clare and I experience a double joy whenever we are privileged to be with our grandchildren. The happy time together concludes in blessed relief when the visit ends.

After spending time with our interesting third-generation family members I pause to reflect on how they are growing and what they are learning. I ponder too how I am changing and what I am learning. In families, education is always a two-way path.

An old Jewish proverb puts it well, "Blessed is the family where the elderly listen to the young, for it follows that in such a family the young will also listen to the elderly." Indeed, children are the little professors that grace our lives. How else could we learn the similarities and differences between mud and peanut butter?

After a recent visit with a grandson I was reminded that tending a toddler cannot be done sitting down. Everything is an adventure! Though we have done our best to childproof our home, there are hazards at every turn. Caring for a child requires quality time.

I remembered something that I learned from this child's daddy years ago. Scott is our third child. At the time of this story he was a Cub Scout. He needed to take a five-mile, in-town hike in order to complete the requirements for an achievement award. I was required to hike with him, not by the Boy Scouts of America but by Clare, his mother and my wife. I had promised to hike with Scott, but my schedule for the week had become an avalanche of unfinished tasks. Finally, on Friday afternoon, I threw in the towel, shucked my coat and

tie, and put on khaki pants, a plaid shirt, and hiking boots for a five-mile stroll with nine-year-old Scott.

The gleam in his blue eyes and the smile on his face told me I had made a good decision. We were off together, Dad and son, leaving behind Mom and the four other children. Children in large families often are treated as one member in a covey. This was Scott's special, private time with me, and my time with him.

We started walking along the sidewalk away from our home. As if borrowing a line from Shel Silverstein's children's book, we came to the place where the sidewalk ends, just beyond the lumberyard at a railroad crossing. It had been years since I had walked a railroad track. Scott and I followed the shiny steel rails. The railroad ties were too close together for my steps and too far apart for his. We both had to adjust our stride. I kept a sharp eye and ear out for any train that might need to use our walkway.

Walking with a child requires a slower pace. A child sees things that adults miss: an old bottle cap, a shiny piece of quartz, a frog in a drainage ditch, a butterfly drinking from a wildflower. I could soon see that this hike was more than a Cub Scout requirement. I needed this late afternoon journey too.

After a mile or so we came to a place where a sidetrack veered off the main railroad line. Together we followed the spur as it disappeared into a grove of pine trees. As the railroad siding went further and further into the woods, pine saplings grew between the rails. Wild daisies were blooming in the spaces between the crossties, a clear indication that no locomotive had rumbled along these rusty rails in quite some time.

Down in the grove of pines Scott and I came upon an old Southern lady, an abandoned Southern Railway boxcar. We examined the vintage railroad car. I walked around one side, and Scott went around the other side. When we met at the rear, Scott looked at me and said, "Dad, this train has been here a long time."

I thought, "How brilliant of my Cub Scout son to recognize that this boxcar has been here a long time." In my daddy/teacher style I asked, "Scott, how do you know it has been here a long time?" I thought he would mention the plants growing between the rails or the accumulated rust on the tracks and wheels. Instead, he surprised me.

He pointed up to the ladder on the rear of the boxcar. "Dad, look

on the ladder. There's a bird's nest. Dad, a bird can't build a nest on a moving train."

Scott and I completed our hike, walking a little more slowly. Later that night, I shared the story of the boxcar and the bird's nest with Clare. We agreed that just as a bird can't build a nest on a moving train, neither could we build a family if we were always on the go.

Healthy relationships simply require time together at a slower pace. It is a lesson that I have needed to relearn often. Scott's son has reminded me yet again.

By the way, I have also learned that the very best thing about being a grandfather is getting to hug grandma!

Autumn Colors

I have officiated at many weddings over the last forty-five years. I have seen the mother of the bride go all out to decorate the church for her daughter's wedding. One particularly zealous mother spent thousands of dollars to have three florists adorn the sanctuary for a wedding that lasted about forty minutes. Of course, it was beautiful, and the wedding pictures were stunning.

At the reception the father of the bride handed out cards that were the size of business cards. The inscription read:

> Hello. I am the father of the bride.
> You probably haven't noticed me since
> early in the wedding service.
> But I can assure you that
> three bankers, three florists, and a caterer
> are watching me very closely.

Sadly, this expensive wedding was for a couple who were divorced three years later.

Maybe the most beautiful wedding I have been a part of was for my nephew, Edward, and his bride in October at Camp Greenville. Perched high above the Blue Ridge escarpment is Symmes Chapel, owned by the YMCA of Greenville County, South Carolina. The views from the open air chapel are spectacular. Known as Pretty Place, it is a popular site for weddings.

While I have performed other weddings at Pretty Place, the one for Edward and Jennifer was special. They had flowers provided by a florist. The arrangements and bouquets were designed to blend with autumn colors. The sky was a clear deep blue, and the mountains were in their full autumn attire. Midway through the ceremony a pair of

ravens soared up from the valley below and glided along the face of the mountains before disappearing over a ridge. For that wedding there was striking beauty that money cannot buy.

In the fall the Blue Ridge Mountains and surrounding foothills are decked out for their annual autumn display. Peak fall colors in our area occur from mid-October through early November. Though the mountains are home to more than one hundred species of trees, the most colorful foliage comes courtesy of sugar maples, scarlet oaks, sweetgums, red maples, and hickory trees.

Those of us who live in the Piedmont are fortunate to enjoy a changing climate. As days shorten and night air becomes crisp, the soothing green canvas of summer foliage is transformed into a breathtaking autumn palette of color. Before settling down into winter's deep sleep Mother Nature has one last fling, an amazing fashion show, when mountain foliage turns radiant shades of crimson, red, orange, yellow, and purple.

The Cherokee Indians have a legend that explains why the leaves change color. It is the tale of a mighty bear that roamed the countryside wreaking havoc. The beast would charge into their villages, eat all their food, destroy their homes, stampede their animals, and frighten the women and children.

Tribal elders held a council and selected the bravest hunters to put an end to the bear. The warriors set out with their dogs and weapons to stalk the marauder. The beast fled; the Indians gave chase. One hunter came close enough to shoot, and an arrow nicked the bear. The injury was not serious, but the culprit ran so fast he escaped up into the sky. The determined hunters, in their zeal, ran into the heavens in hot pursuit.

Use your imagination, and you can see the bear depicted in the four stars in the bowl of the Big Dipper. The three stars in the handle of the dipper represent the hunters chasing the bear. The stalkers and their prey go around and around in the northern night sky. Every autumn, the Big Dipper comes low to the horizon. It is then that the bear's wound leaks a few drops of blood. According to the legend, the blood of the bear changes the colors of the leaves on the trees.

Four factors influence autumn leaf color: leaf pigment, length of daylight and darkness, rainfall, and temperature. The timing of color change is primarily regulated by the increasing length of night hours.

As days grow shorter and nights grow longer and cooler, chemical processes in the leaves begin to paint the autumn landscape.

During the growing season chlorophyll makes leaves appear green. As night length increases in the autumn, chlorophyll production slows down and then stops. The pigments that are present in the leaf are then unmasked, and the trees show their fall colors.

The timing of the color change also varies by species of trees. Sourwood and tulip poplars in southern forests can become a vivid yellow in late summer while all other species are still green. Oaks put on their colors long after other species have already shed their leaves.

The brilliance of the colors that develop in any particular autumn season are related to weather conditions that occur before and during the time the chlorophyll in the leaves is dwindling. Temperature and moisture are the main influences.

Mythical Jack Frost supposedly brings reds and purples to the forest by pinching the leaves with his icy fingers. The hues of yellow, gold, and brown are mixed in his paint box and applied with quick, broad strokes of his brush as he silently moves among the trees decorating them.

But, frost does not bring autumn hues; it actually turns the leaves brown. The most spectacular color displays are brought on by a succession of warm, sunny days and cool, but not freezing, nights. During these days sugars are produced in the leaf. The cool nights and the gradual closing of veins going into the leaf prevent these sugars from moving out. The combination of sugar and light spurs production of brilliant pigments in the leaves.

The amount of moisture in the soil also affects autumn colors. Like the weather, soil moisture varies greatly from year to year. The countless combinations of these two highly variable factors assure that no two autumns will be exactly alike. A late spring or a severe summer drought can delay the onset of fall color. A warm, wet spring, favorable summer weather, and warm, sunny fall days with cool nights produce the most brilliant autumn colors.

The vivid change of color starts in late September in New England and moves southward, reaching the Blue Ridge Mountains by early November. The trees in cooler, higher elevations will change color before their relatives in the valleys.

A couple in the church that I serve said, "We're skipping your

sermon today. We are driving to the mountains to see the color."

You know, I really couldn't blame them. Clare and I enjoy cruising Highway 11 in any season but especially in the fall of the year.

George Schrieffer, a minister friend, came up with a short rhyme for the fall season. He was concerned that folks would be tempted to skip church on Sunday to drive to the mountains to see the display. George's lines of poetry are dear to any pastor's heart.

> The leaves reach their peak
> In the middle of the week!

THE APPALACHIAN TRAIL

My good friend David White has hiked the entire Appalachian Trail, from Georgia to Maine. For ten years he used ten days of vacation time in the late summer to backpack a 100-mile section of the wilderness trail. After those ten years he had walked about half of the lengthy route. Recently retired, David decided to take on the challenge he had long considered: to hike the entire 2,200 miles in a single year. On a day in late winter he began the trek at Springer Mountain, Georgia. On a beautiful fall day, he arrived at the trail's northern terminus on Mount Katahdin in Maine. Congratulations, David!

In an article published in the *Journal of the American Institute of Architects* in 1921 Benton McKaye first suggested an Appalachian Trail. The dream of a wilderness footpath that would stretch the entire length of the Appalachian Mountains from Georgia to Maine was realized in 1937, only sixteen years after McKay's original idea. While McKay was the father of the Appalachian Trail, Myron Avery was the organizer who put together the volunteers necessary to complete the trail.

The year our son Scott graduated from Wofford College, he and his good friend John Faris hiked the AT together. In mid-summer I drove to a trail head near Gettysburg, Pennsylvania, to meet Scott and John. They had just completed a forty-five mile stretch of the hike that takes backpackers through parts of four states. I got a motel room in Harper's Ferry, West Virginia, so that Scott and John could take hot showers. Believe me, they needed showers. Then I took them to Cracker Barrel and told them to order whatever they wanted. They ate well! The best part of our time together was listening to tales of their escapades. After a little rest they were soon back on the trail together. Buddies since kindergarten, Scott and John are now brothers-in-law. Bonds forged since childhood were made stronger on the high

mountain path. One of our treasured photos is of Scott and John together on top of Mount Katahdin. What an adventure!

The Appalachian Trail is marked with white blazes painted on rocks and trees along the entire course. There is almost always a marking in sight, but hikers have to be alert to changes in direction.

I have hiked the southern fourth of the Appalachian Trail, almost all of it in twenty-five to thirty mile segments over the span of forty-five years. I have had many adventures on the Trail. On one rainy three-day trek in Virginia, I took refuge in a picnic shelter in a campground in Cherokee National Forest. I rolled out my sleeping bag and slept beneath the dry roof. Early in the morning, well before daylight, I was awakened by the headlights of a truck. A man wearing a helmet equipped with a bright miner's headlamp got out of the truck carrying a white cloth bag and a long stick with a hooked metal tip. My curiosity got the best of me. I pulled on my boots and my poncho. I caught up with the fellow just as he started along the AT.

"What's going on?" I asked.

"Follow me, and I'll show you," he quipped.

Just beyond the campground the trail follows a narrow gauge railroad bed through Laurel Fork Gorge. The steel rails have been removed, and the winding path follows the Laurel Fork River through a virgin stand of hemlock trees. We walked together maybe fifty yards. In the light of the beam from his headlamp, I spied a huge timber rattler. I stopped in my tracks. The other fellow did not. He walked to the snake, lifted him with the stick, and deposited the docile reptile into the bag.

"What are you going to do with that rattler?" I asked.

"I'm getting him off the trail. Come daylight, hikers will come along here."

We walked a few more yards and

there in the trail were three more timber rattlers and a copperhead. Using his stick, the strange man picked up each one, in turn dropping it in the bag. By dawn he had captured more than twenty of the serpents. I thought he must be a member of a Pentecostal snake handling church. But he wasn't. Neither was he protecting hikers. He was a conservationist protecting the vipers. We turned around to walk back toward the campground. Along the way the man turned off the trail, climbed up the side of the mountain to the craggy rocks above the AT, and released all of the snakes.

I hardly knew what to say. I bade the man, "Good-bye."

He was matter of fact: "Have a good one." He got in his truck and left.

I ate breakfast, packed up my gear, and continued my hike along the AT, walking very carefully through Laurel Fork Gorge.

Another time, I had one experience on the AT that was especially frightening.

I had arranged to take a group of young people from our church in North Carolina on a thirty-mile hike on the Appalachian Trail in Virginia. I spent time preparing these young people for the hike. This included a how-to session giving instructions on the proper way to load their backpack, to care for their feet, to choose proper clothing, to select food, to provide pure water, to insure sanitation, to hike as a group, and what to do if they got separated from the group. We checked equipment, bought food, and made all the necessary preparations. I provided each person with a map. I gave them careful instructions about the section of the AT we were planning to hike.

At the last minute three boys who had not been to any of the planning sessions wanted to join the hike. I was reluctant, but their parents assured me that they had hiked the Trail numerous times and knew what they were doing. I consented and invited them to come along.

We arrived at the trail head early in the morning in heavy fog, a common phenomenon in the mountains just after dawn. After a quick review of procedures we were off on our hike. There were three adults and nine young people.

We hiked in groups of four. I was, as usual, at the back. I am a slow hiker. We were to regroup three miles up the trail at a shelter. When I arrived with my group at the shelter, the three boys who had signed

on at the last minute were nowhere in sight. I asked their group leader about them. He said, "They got tired of waiting and said they were going ahead. I couldn't stop them."

The fog never lifted. All day long, we hiked. The boys were nowhere in sight. My assumption was that these three were fast hikers, that in their impatience they had gone ahead and would stop at the place we had designated as our campsite for the night. As the day wore on and the trail became steeper, my doubts increased. These young experienced hikers could very well be behind me. One or more of them might be hurt. Throughout the day I used a prearranged signal, three blasts on a whistle, to see if I could get a response from them. There was none.

Just before dark, the fog lifted slightly, and rain began to fall. We arrived at our campsite with no sign of the three missing boys. We set up camp. I packed a few emergency supplies in a daypack and headed back down the trail, flashlight in hand. As I backtracked, I used a roll of reflector tape to mark the campsite and to mark the trail between the white blazes. By nine o'clock I was out of reflector tape. I returned to the campsite about ten o'clock to devise another plan.

As I considered what to do, I heard a whistling sound. The three boys had seen the reflector tape and had followed it to the campsite. They were whistling the "Colonel Boogie March" from *The Bridge over the River Kwai*. I was both relieved and upset. I held my tongue. After I was calm I asked, "What happened?"

Their simple answer was, "We forgot that the AT was marked with the white blazes, and we took a blue blaze trail."

To this day, I tease them about going to blue blazes.

SOUTHERN BARBECUE

Clare and I were invited to attend a cookout at a beautiful lakeside home in the mountains. We stood on the patio with a group of friends, enjoying the view across the water to the hills beyond. Our host was basting a Boston butt, a cut of pork that comes from the upper part of the pig's shoulder.

"What are you grilling?" a lady asked.

"Please don't call it grilling," the cook requested emphatically. "This separates hard-core barbecue enthusiasts from the uneducated novice. Think of the difference in romantic terms. Grilling is a quick, hot fling with a hamburger or a hot dog. Barbecuing is a long-term relationship. You have to spend a lot of time rubbing spices into a rack of ribs or a pork shoulder. Then you spend hours over a smoky wood fire. It's a lot like making love. The real experts take it slow and easy!"

Blushing, the lady said, "My ex only knew how to grill. Maybe my next husband will be good at barbecue!"

Our host's description gave us a new appreciation for the fine art of preparing genuine Southern barbecue.

Those who are connoisseurs of barbecue know that the various types share a rich history. The Spanish first introduced the pig into the Americas and to the American Indians. The Indians, in turn, introduced the Spanish to cooking with smoke in a pit.

The first colony on the American mainland was in what is now South Carolina. Spanish adventurers were Conquistadores in search of gold. Spanish colonists came later in the early 1500s. They named their colony Santa Helena. It was established in the area that we now call Port Royal in Beaufort County. The colony lasted almost twenty years. In that first American colony Europeans learned to prepare and to eat slow-cooked pork.

The name barbecue derives from the word *barabicu* found in the

language of both the Timucua of Florida and the Taíno people of the Caribbean. The word means sacred fire pit.

Although barbecue is rooted in Dixie, most Americans do not have a clue about Southern barbecue. Lake E. High, Jr., President of the South Carolina Barbecue Association, makes a clear distinction between grilled food and genuine barbecue. High goes further to explain that many kinds of meat can be barbecued. Barbecued chicken, barbecued beef, barbecued turkey, barbecued mutton, and even barbecued possum are among the possibilities. Don't even think about the barbecue Big George made out of Frank Bennett in the novel and movie *Fried Green Tomatoes at the Whistle Stop Café* by Fanny Flagg.

High explains that, because of its origins, barbecue as a stand-alone noun can only be used properly to designate pork. Westerners enjoy barbecued beef, but it cannot rightly be referred to as barbecue. It must be called barbecued beef. To use barbecue as a noun can only mean pork.

Lewis Grizzard, the late columnist for the *Atlanta Journal-Constitution*, had open heart surgery to replace a coronary valve. The surgeon inserted a valve from a pig's heart.

"Doesn't it bother you to think that you have a pig's valve in your heart?" Grizzard was asked.

"Not really," he said, "but every time I drive past a barbecue place, my eyes water."

Grizzard must have shed many a tear in his travels across the South.

Barbecue, barbeque, bar-b-q, BBQ: there are as many spellings as there are kinds of barbecue. Purists insist that genuine barbecue be cooked in an open pit or a wood or charcoal smoker. They are adamant that neither lighter fluid nor aluminum foil ever be a part of the barbecue process. They want their pork cooked the way their ancestors did.

High, a certified barbecue judge, says that each cook develops a recipe for the rub used to prepare the meat. It is the sauce that distinguishes between the four varieties. South Carolina is home to all four. All Southern barbecue falls into one of these four categories: vinegar, mustard, light tomato, heavy red.

Slaves brought with them from the Caribbean a taste for red

peppers. In the Southern colonies barbecue sauce became part of the cuisine when spices and peppers were combined with vinegar. In eastern North Carolina pork seasoned with vinegar and peppers is a favorite. When we visit my brother Bill and his wife, Wanda, we enjoy a barbecue plate at B's Barbecue in Greenville, North Carolina. B serves fine vinegar-based pulled pork. The Scottish families who settled the Lowcountry were the South Carolinians who used vinegar and pepper barbecue sauce adapted from the slaves. Dr. Walter Edgar told me that he traveled fifty miles to speak to a Camden Garden Club because he was promised five pounds of McCabe's barbecue as his honorarium.

As for the origin of the mustard variety, German immigrants settled in the Midlands of South Carolina, especially in the Dutch Fork area. Those families received land grants on the Broad, Congaree, Saluda, and Santee Rivers. They brought with them their Lutheran faith and their taste for spicy mustard, which soon found its way into barbecue sauce. Many people know Maurice Bessinger. His sauce is a staple in Southern grocery stores. Clare and I frequently return to her birthplace, Leesville, South Carolina. There we enjoy Shealy's buffet and Jackie Hite's pulled pork. As we travel to our family vacation on Pawleys Island, we often stop at Wise in Newberry County and take a supply of their barbecue in an ice chest to the beach.

The third type is light tomato sauce made from vinegar and pepper with tomato ketchup added. It is the sauce famous in the Piedmont region of North Carolina. Lexington, North Carolina, is the acknowledged center for light tomato sauce. North Carolina has declared the month of October as Barbecue Month. In the final two weeks of the month the town of Lexington hosts the Barbecue Festival. The last two Saturdays feature an annual North Carolina Championship Pork Cook-Off. Last year an estimated crowd of 150,000 attended the event. The popularity of light tomato barbecue has spread into the Pee Dee region of South Carolina.

The fourth variety is heavy red sauce featured by John White's Beacon Drive-In located in my hometown of Spartanburg. I was in the place recently and witnessed two fellows from Pennsylvania reading the formidable menu. Dazed and confused by the array of choices, one asked me, "What are you having?"

"My favorite is an outside." My answer didn't help. They were more baffled than before. I showed it to them on the menu

and explained.

"An outside is a barbecue sandwich. The meat is pulled from the outside of the pork shoulder, the part that has been basted and cooked to a mouth watering crust. They put a little coleslaw on top and add heavy red sauce. If you don't have gallbladder trouble, get an outside-a-plenty. They'll cover up the sandwich with French fries and onion rings."

"Is it really good?" he asked.

I noticed his Penn State sweatshirt. "You'll be whistling 'Dixie' all the way back to Happy Valley."

When Spartanburg native William Ball was Secretary of the Navy, he asked John White to cater a meal for 300 sailors onboard a naval destroyer in the Mediterranean Sea. Beacon Barbecue was transported by helicopter to the ship.

The Beacon hosted the Inaugural Luncheon for Governor Donald Russell, a Spartanburg native, at the Governor's Mansion in Columbia in 1963. Southern barbecue has been served to numerous Presidential candidates visiting the Beacon and to military personnel around the world. *Southern Living, Sandlapper*, and *Gourmet* are among the magazines to feature Beacon barbecue. Charles Kuralt broadcast a segment on the Beacon in his *On the Road* television series.

The popularity of heavy red sauce has spread throughout the nation because of the insatiable sweet tooth of the modern American. Heavy red is featured at Neely's Barbecue in Memphis, Tennessee. Pat and Gina Neely have one of the most successful barbecue restaurants in the South. Their television program, *Down Home with the Neelys*, is broadcast on the Food Channel. Pat happens to be African-American. My brother Bill visited the Memphis restaurant, and he and Pat figured out that we are all distant cousins.

When it comes to barbecue, most Southerners have an impassioned preference. Joe Crook, owner of Pig Out in Spartanburg County, offers his customers both a mustard-based and a tomato-based sauce. Harold Jennings, owner of Bull Hawg's, has developed his own special sauce that combines vinegar and tomato with other spices.

Preparing good Southern barbecue is a labor-intensive endeavor. One characteristic of the best barbecue restaurants is that the owner can almost always be found on location. Sarah Shealy still stands at her cash register in Leesville checking out customers one by one, just as

John White did for so many years at the Beacon in Spartanburg. Jackie Hite, Joe Crook, and Harold Jennings take a hands-on approach to cooking the barbecue they serve. Clare and I have been impressed at the time, effort, and loving care these master chefs put into their work.

While good barbecue places are in high demand, some folks prefer to prepare and cook their own meat at home. Maurice Pace has a large homemade wood-burning cooker. On holidays he fires it up with split oak and hickory logs.

Last November he issued an invitation. "Why don't you come down the day before Thanksgiving, and we'll smoke a few turkeys and barbecue some ribs?"

"I have a problem smoking turkeys," I said.

"What's the problem?"

"I can't figure out which end to light!"

Surprised by a Black Snake

For the first six years of my life our family lived in a four-room house on Kentucky Avenue in Spartanburg. In the kitchen a two-eyed laundry heater stoked with firewood provided heat. Smoke was vented through a stovepipe. The heater, our source of hot water, provided warmth for our home and served as a cooking surface.

Early one morning when I was five years old, I heard my mother calling my name with distress in her voice. She was cooking breakfast when she discovered a large black snake coiled behind the heater. The slinky critter had found a warm place to spend the night.

My mother gave me instructions. "Go out the front door. Come around to the back and hold the door open for me!"

"Yes, ma'am!"

My mother, pregnant with her fourth child, herded the snake out of her kitchen with a straw broom. The shiny black serpent wiggled past me. His presence in the house was most unwelcome. My admiration for my mother's courage and my respect for the black snake's ingenuity increased.

The southeastern United States is home to at least forty-five species of snakes. Only six of those are poisonous. Among black snakes there are several species, including the ring-necked snake, the pine snake, the eastern indigo snake, and the Southern black racer. The eastern hog-nosed snake is sometimes black. The venomous cottonmouth moccasin is usually black but lives only below the fall line in South Carolina. Snakes are often killed

by humans as a result of misinformation or misidentification. "The only good snake is a dead snake!" is something I have heard many times. In our area many people think that every snake is a copperhead.

The black rat snake, also called pilot snake, is the most common snake in the Southeast. It is also the largest snake in our area, sometimes reaching eight feet in length. Black rat snakes are found in forests, fields, marshes, and farmland. They are skillful climbers. They can ascend the trunk of large trees and climb into the rafters of barns. They swim quite well.

I was fishing with a group of Cub Scouts near Burrell's Ford on the Chattooga River. I noticed a humongous granddaddy black snake slithering down the opposite bank of the river, the Georgia side. He proceeded to swim through the swift current straight toward the covey of young boys.

In an attempt to prevent widespread panic I met the long snake on the South Carolina side, quickly grabbing him behind the head. The large constrictor threw three coils around my arm. His strength was impressive.

The Cubs shouted, "Dr. Kirk, what are you going to do with him?"
"Can I hold him?"
"Can I take him home with me?"

I retreated to a pine tree to release the powerful snake. Just as I let him go, he whipped his head around, giving me a hard bite on my right thumb. Having declared his displeasure with me, he scaled the tree in no time flat. I washed my bleeding thumb in alcohol from a first aid kit, explaining to the boys that we had invaded the snake's territory.

Black rat snakes are active during the day in the cooler months of spring and fall; in the summer they spend the day in the shade and move around at night. When alarmed, the sleek reptiles hold perfectly still. If the threat persists, the snakes wrinkle into a series of kinks. If they feel further danger, they coil and strike. They are quick! I have been bitten twice! As a last resort they slither away. Black snakes sometimes vibrate their tails in dead leaves, making a sound like a rattlesnake. They also produce a foul smell that they release onto a predator. I have had the unpleasant odor on my hands. It took several scrubbings and a little lemon juice to get rid of the stink.

This species is a constrictor, coiling around its prey and tightening its grip until the victim suffocates. Then the predator swallows its

meal whole. True to its name, black rat snakes consume mice and rats. They will also hunt other snakes, as well as chipmunks, squirrels, bats, birds, and bird eggs.

My mother apparently had radar for black snakes. The ten people in our family were enjoying a fine dinner together one Sunday after church. Mama saw something amiss through the screen door. "I think there is a snake going up the wall in the garage," she said.

Sure enough, there was a hungry black snake making its way to a wren's nest in the rafters. My dad quickly dispatched the intruder to the field across the fence.

Though they have few natural foes, I have witnessed a full-grown black snake dangling helplessly from the clenched talons of a red-tailed hawk. Humans are their most common enemies. Black snakes are frequent road kill victims. They are also in danger of being slain by frightened people.

Black snakes are beneficial to humans because they prey on rodents. Several years ago, I released a black snake into my barn for that very reason. I haven't seen him since.

Even those who understand the value of these beneficial reptiles don't always respect them. Once a man offered to build a tool shed for his brother-in-law. The property owner had seen a large black snake on his land. He cautioned, "If you see a black snake, leave him alone. Black snakes are our friends."

Later that day the owner returned to see how the project was progressing. He was aghast to see a large black snake dead, draped over a fence. He chided his brother-in-law.

"I told you not to kill a black snake. Those are our friends," he said.

"When I sit down to eat my lunch, I don't appreciate being surprised by your friend."

THE DARK CORNER

My ancestors were Scots-Irish. Samuel Neely followed the Carolina Wagon Road from Bucks County, Pennsylvania, to Fishing Creek in Chester County, South Carolina. Learning a little of the history of these sturdy people has been important to the understanding of my heritage.

The first European settlers in the Southern Appalachian Mountains were primarily Scots-Irish, granted their lands from the King of England before the Revolutionary War. When these people immigrated to the American colonies, they already had an ax to grind with Great Britain. Originally from Scotland, they were transplanted to Northern Ireland. It became known as the Irish Plantation or the Plantation of Ulster. Land owned by Irish chieftains was confiscated and used to settle the colonists. King James I of England began the official plantation in 1609. The British required that the colonists be English-speaking and Protestant. The Scottish colonists of Ulster were mostly Presbyterian.

When these families, the Neelys among them, came to America, they brought with them a fierce independence. They hated British taxation. The British colonists along the coastal plain encouraged the king to grant land to the Scots-Irish along the mountains and rivers of the frontier. This was to use the Scots-Irish as a buffer against the Indians.

The plan worked. The Scots-Irish learned to fight the way the Indians fought. When the Declaration of Independence was signed, the mountain people were prepared to fight. Some historians contend that the American Revolutionary War was won in the South. At the Battle of King's Mountain in 1780 and the Battle of Cowpens in 1781, these volunteers, known as over-the-mountain men, carried the day.

The Upstate of South Carolina was inhabited by Scots-Irish

families. Descendants of many of those early pioneers still reside in the area, living on the original tracts of land. Many of them retain to this day a strong, stubborn independent streak. That is especially true in the region known as the Dark Corner.

Dean Stuart Campbell is known as the Squire of Dark Corner. An author, lecturer, photographer, storyteller, and tour guide, Dean Campbell has the perspective of a native son whose maternal and paternal ancestors were early settlers. Campbell was the first to delineate the Dark Corner, the infamous mountain region in northern Greenville County, in his book, *His Eyes to the Hills—A Photographic Odyssey of the Dark Corner.*

For years the Dark Corner was difficult to pinpoint. When local folks were asked the location of Dark Corner, the usual answer was, "Just a little piece further down the road."

Over time the entire northwest corner of South Carolina became known as the Dark Corner.

Campbell's Dark Corner is much more specific, confined entirely within the boundaries of Greenville County. It includes rolling foothills and the rugged Blue Ridge escarpment, called the Blue Wall by the Cherokee.

The Dark Corner was so named because there were few roads in and out. The land was densely forested. Farmsteads were away from the roads, hidden by the trees. The people who lived in Dark Corner were good, hard-working people. Making and selling liquor was a legal way of earning money. Many residents of Dark Corner have made their own alcoholic beverages for generations, turning their grain crops into whiskey. They reasoned that they could get a better price for their corn and rye if they distilled them into white lightning and sold it to flatlanders. Besides, they reasoned, it was by their own sweat and toil that the crops were grown. It was nobody's business what they did with it. They certainly did not expect their brew to be taxed!

President George Washington was the first to appoint high sheriffs to collect taxes on homemade liquor. These officers were called Revenuers. The first sheriff dispatched to Dark Corner was shot and killed.

The people of Dark Corner felt that the government was unreasonable for imposing such laws. Government agents charged with enforcement of taxes and, later, prohibition, were looked on as

enemies. Strangers who entered Dark Corner were regarded with suspicion.

Ed Martin was my dad's college roommate and a lifelong friend. In the late 1930s they attended North Greenville Junior College in Tigerville, South Carolina. Just off campus was an old country store. The store owner was also a deputy sheriff. On the wall of his establishment was a map of the Dark Corner. He hired students from the college to scout the surrounding area at night and look for the telltale smoke of moonshine stills. If a student found a still that led to a successful raid, the storekeeper paid the student spy five dollars for the information.

The proprietor of the store had a pretty daughter. Ed was not interested in finding stills, but he was always interested in a pretty girl. He made arrangements to date the storekeeper's daughter. After the date Ed was walking back to campus. On that moonless night a grizzled mountaineer stepped from behind an old barn, pointing a double barrel shotgun at Ed.

"Where you'ns been?" he demanded.

Shaking in his shoes, Ed blurted, "I have been dating a girl over yonder!"

"What's her name?"

For the life of him, Ed couldn't remember. "She's too ugly to remember."

"I ought 'er shoot you'ns. You go up to that college and tell them others the snooping around is over. If I catch any of you'ns out after nightfall, there'll be no talk'n, just shoot'n."

That ended the spying days for North Greenville students, and Ed never dated the storekeeper's daughter again.

An intruder in the Dark Corner literally took his life into his own hands. Folks who operated the stills, hidden in the laurel thickets, hollows, and coves along mountain streams, looked on Revenuers as fair game.

Sometime after the turn of the century, in the early 1900s, Troy Alverson lived on Von's Creek near the old road that went from Tryon through Dark Corner. One day a wagon and seven men stopped at the Alverson cabin. The wagon was loaded with axes, picks, and guns. They asked Mr. Alverson if this was the road to Dark Corner.

"Do you fellers know anyone there?" he asked.

"No," they answered.

They were advised that it was dangerous to go prowling around if they didn't know anyone in the area.

One of the men spoke up, "We'll take our chances. We're Revenue Officers."

Mr. Alverson shook his head. "Good luck, fellows."

The seven men were never heard from again.

In his book *Smokin' Shootin' Irons in Dark Corner*, James Walton Lawrence gives a detailed account of a raid on an illicit whiskey still. The episode occurred beside the headwaters of the South Pacolet River at the base of Hogback Mountain on January 31, 1924.

Reuben Gosnell, a Governor's constable with nineteen years experience, led a team of officers. The group included Constable Holland Howard, a lifelong resident of the Dark Corner.

The raiding party approached the suspected site by following a stream up through a mountain cove. They met brothers W. P. and Alexander Plumley coming from the direction of the still. The experienced officers could tell by the condition of the brothers' clothing they had been working at a still. They searched the two and found a pistol. The Plumleys were placed under arrest and incarcerated in a small log corn crib about a half-mile below the still site.

Gosnell and Howard left officers guarding the corn crib. The guards soon came under rifle fire coming from a cave 100 yards away across the South Pacolet River, a lookout post protecting the approach to the still.

Gosnell crept around to the head of the cove to cut off escape. Howard ran upstream toward the still to flush the moonshiners. Gosnell heard cursing. Several shots rang out. He saw two men run from the still, one going west and one going east. He went after the man going west. After a 400-yard chase he caught the culprit. Holland Pittman tried to draw a pistol on Gosnell, but the constable got the drop on him.

Gosnell returned to the distillery and found Howard dead. Gosnell was fired upon from an ambush as he tried to leave the scene. Pittman was placed in Greenville County jail. His father, Alexander Pittman, later surrendered in Greenville. Both father and son were charged with murder. The folk song "The Ballad of Holland Howard"

memorialized the event, concluding:

> They brought the Pittmans into court,
> It was on one Thursday morn.
> Alex Pittman said, "I'm an innocent man;
> I was at home shucking corn."
>
> They brought the Pittmans back to court,
> Both father and son were there.
> Judge Mauldin said, "You two men
> Will die in the electric chair.
>
> On the twenty-seventh day of June,
> Nineteen hundred and twenty-four,
> You will both pay the penalty
> for killing Howard,
> You'll make no liquor anymore."

Dark Corner is among the most intriguing places in Upstate South Carolina. Its reputation has improved. Once viewed as an area of outlaws that rivaled the Old West for its gunfights and knife fights, these 150 square miles of rugged mountain country surrounding Glassy Mountain are now known as a beautiful place to visit. Now, tourism has replaced bootlegging as the strongest economic influence. Visitors and retirees flock to the Dark Corner to play golf on some of the finest courses in the Southeast. From Pretty Place at Camp Greenville to the Greenville Watershed, from Campbell's Covered Bridge to the Poinsett Bridge, the Dark Corner is rich in wonders to behold.

Dean Campbell says there are still moonshiners in the area. I know for a fact that Ruben Gosnell was kin to some of my family. If you go to the Dark Corner, be careful! If you meet a Neely, he may be packing heat!

A WILDWOOD FLOWER

To walk a mountain trail through the woods or to pay attention to the roadside is to see the beauty of wildflowers. These delicate blooms are certainly a part of the joy of nature. To spy a stately jack-in-the-pulpit or a regal trillium is a feast for the eyes. So too are the less conspicuous bloodroot and May apple blossoms. Even the tiny fleabane daisy or the lowly wild ginger offers a special treat to those who are willing to take the time and look.

Flowering trees and shrubs also lend their beauty to the mountains. The flame azalea and the cucumber magnolia are wild mountain cousins to their hybrid lowland relatives. The wild magnolia is sometimes called the Wahoo tree. The name puzzled me until I heard about Alice Lloyd College in Pippa Passes, Kentucky. Alice Lloyd was a prim and proper lady who began a community center in Caney Creek in 1923. While Miss Lloyd was alive and in charge, verbal or physical contact between boys and girls at the school was forbidden. The boys would climb the wild magnolia trees outside the girls' dormitory until they were parallel with the windows. Then the boys and girls could whisper and pass notes to each other. This courting from the limb of a tree was known as wahooing.

The story illustrates that the real beauty of the mountains comes, not so much from plants, but from people. Just looking at a road map will reveal the personality of these people. One of my favorite place names is Hell-for-Certain, Kentucky. It is said that, when they arrived, the first pioneers knew that they were in hell for certain.

Mountain people have interesting names for themselves, too. To be called a hillbilly is not offensive but is instead an honor among mountain people. One of the most interesting wildwood flowers I have ever known was a man named Flowers.

I was near Banner Elk, North Carolina, leading a retreat. I had

Saturday afternoon off. I stopped by a local store to see if there was a place nearby where I could fish for trout. The owner of the store gave me directions that involved three left turns and one right turn and a trip down a long, winding dirt road to a river bottom between the mountains.

"You will come to a wide open area," the shopkeeper said. "Just stop there. An old man will show you where you can fish."

Though the directions were strange I was determined to fish, so I carried out my instructions. Sure enough, after about an hour's driving, I came to the wide place in the dirt road. I stopped my car. A man smoking a pipe, wearing overalls and an old felt hat, walked out of the woods. He came over to my car.

"Hello," I said.

He looked me over before he spoke. "Howdy. What's your business?"

I explained that I wanted to fish and that I was told if I came here I might be able to do so. I told him my name and offered to shake hands.

"Flowers," he said. I did not know whether it was his first name or his last name.

He looked me over again and then said, "You're a preacher, ain't you?"

I said that I was.

"Do you believe the Old Bible?"

I knew that if I wanted to fish, there was only one answer.

"Yes," I said.

"Do you think the earth is flat or round?" he asked.

I thought for a moment. "Well, the Old Bible says that God put an angel on the four corners of the earth."

"You got that right!" he said, "Ain't nothing round got four corners."

"Do you believe the earth is flat?"

He looked up at the tall green mountains. "Not around here it ain't."

Then he said what I wanted to hear, "Let's go fishing."

I got my rod and reel out of the car. He told me I would not need any bait, but I took a small box of spinners anyway. We went down to the river where there was a bench. He sat down and watched as I tied on a spinner.

"You ain't gonna catch any fish with that blue line."

No sooner had he said it than a trout took my spinner. I reeled the fish in, put him on a stringer, and plopped him back down in the water.

"Tell me about that blue line," Mr. Flowers said.

I explained that the fish could not see the line under water, that it looked blue to us but not to the fish. In a few minutes, I had caught a second trout.

"Where can I get some of that blue line?" he asked.

"I've got a roll of it in the car I'll give to you," I promised.

I did not catch any more fish. Flowers and I spent the rest of the afternoon together. Mr. Flowers was a wildwood flower if I have ever seen one, a man as colorful, bright, and delightful to be with as any I have known.

When I left him, I gave him the spool of blue fishing line and the two trout.

"Keep on preaching that Old Bible," he chuckled.

Ralph Waldo Emerson said, "The earth laughs in flowers." On the Saturday afternoon that I met a mountain man named Flowers it was the gospel truth.

BLUEBIRDS OF HOPE

O ne day last week, as I left my driveway, a bright bluebird flew directly in front of me. When I arrived at the church, a pair of bluebirds was perched atop one of the nesting boxes placed along the road leading to the parking lot. The day began with a blessing of bluebirds.

One of the perennial joys of spring and summer is the visitation of bluebirds. The sight of these beauties lifts my spirits.

The first movie I can remember seeing was Walt Disney's *Song of the South*. That movie has now been removed from circulation because it is no longer considered politically correct. In my mind's eye I can still see Uncle Remus and the animations of Br'er Rabbit, Br'er Fox, and Br'er Bear. In one of my favorite scenes Uncle Remus is depicted with an animated bluebird perched first on one shoulder, and then on the other, as he sings "Zip-A-Dee-Doo-Dah." The lyrics are: "Mr. Bluebird on my shoulder. It's the truth. It's actch'll. Everything is satisfactch'll."

Bluebirds are associated with happiness. In the movie *The Wizard of Oz* Judy Garland's Dorothy sang of bluebirds that fly over the rainbow. The lyrics to a song from the World War II era proclaimed, "There'll be bluebirds over the white cliffs of Dover," as a harbinger of peace.

Though songs about bluebirds abound, there was a time when the bluebird was an endangered species. *Sialia sialis,* the Eastern Bluebird, primarily feeds on insects. Crickets, grasshoppers, caterpillars, and Japanese beetles are all part of a bluebird's diet. Because they are insect eaters, the native population of bluebirds was reduced to critically low numbers by the overuse of pesticides. Through conservation efforts the species has made a remarkable recovery.

Bluebirds are found in South Carolina year-round. When insect populations decrease with frost and cold weather, the bluebirds expand their menu to include berries, mistletoe, Virginia creeper, red cedar,

hollies, and dogwoods. In a single season a nesting pair will rear two broods of four or five fledglings each. Though the birds will nest in any cavity, bluebird boxes, mounted four or five feet above the ground and facing south over an open area, are almost sure to attract a mated pair.

The Cherokee Indians call the bluebird the "bird that carries the sky on its back." The bright blue feathers, accented with chestnut throat and white belly, make this winged visitor a welcome addition to any backyard.

As I was working in my garden last week, I saw a pair of bluebirds making their second nest of the season in one of the several nesting boxes I provide. Since the fall of 2000, bluebirds have become, for us, a sign of grace.

November in South Carolina is usually a mild month. Not until after Thanksgiving does the weather begin to feel like winter. On November 19, 2000, we had an accumulation of snow in the Upstate. It was the day of our twenty-seven-year-old son's funeral.

Erik died on November 15, 2000, at his home in Charleston. Temperatures in the Lowcountry were normal. The day we returned from Charleston to our home in Spartanburg, the sky was bright and sunny. Sunday morning, the day of the funeral, dawned grey, cold, and damp. Temperatures continued to fall through the day. By the time we arrived at the church for the funeral light snow was falling. When we went to the cemetery for the committal service, the ground was covered with snow.

Some of our friends expressed regret that the weather was inclement on the day of our son's service. In our imagination we thought that Erik had put in a request to the Almighty. Something like, "Lord, you know this will be a hard day for my family. Could you do something to surprise them?"

In my first sermon after Erik's death I interpreted the snow as a gentle touch from God, a gift of grace in our grief, and a symbol of hope. Many of the Christmas cards and presents we received that year included a snow theme. That year, we decided to decorate our Christmas tree only with snowflakes and snowmen ornaments. Hand-cut snowflakes adorned our windows.

As spring approached, Clare and I knew we needed a symbol of hope for the warmer months. In late February I conducted a funeral for a church member at Greenlawn Memorial Gardens, the same

cemetery where Erik's grave is located.

At the conclusion of the service I stopped the car near our son's newly-placed tombstone. I could see an eastern bluebird perched atop Erik's marker. I called Clare on the cell phone just as the bird flew away.

"I think I have found a new symbol for spring and summer," I said when she answered. "It's a bluebird that has just flown away."

"Just wait a minute or two. Maybe he will come back," Clare said.

Sure enough, the bluebird returned. He perched on Erik's gravestone and was joined by his mate, giving us our new symbol of hope.

Nesting boxes in our yard invite bluebirds to make their home near ours. Every spring since Erik's death we have enjoyed two or three winged families as visitors in our yard.

They are, indeed, a symbol of hope and a touch of grace.

BACKPACKING
JOCASSEE GORGES

I was surprised when two of our sons announced that, instead of going to the beach for spring break, they wanted to go backpacking in the mountains of South Carolina. And they wanted me to go with them!

As an Eagle Scout I had hiked the trails and fished the streams of the Upstate. I had enjoyed fresh trout cooked over hot coals. I had found arrowheads along the riverbanks.

In 1995 when Scott and Kris, two of our four Eagle Scout sons, invited me to join them on a forty-mile hike on the Foothills Trail, I was delighted. Both were high school students. Scott, a senior, sought a Thoreau-like retreat into the woods. Kris, a sophomore, wanted an artistic venture. The photographs he took of the trip were black and white, in the manner of Ansel Adams.

Twisting and turning through steep mountains, the seventy-six-mile Foothills Trail stretches from Table Rock State Park to Oconee State Park. The path meanders through an area known as Jocassee Gorges. Here in the northwest corner of the Palmetto State the crystal clear waters of Lake Jocassee splash against the base of the Blue Ridge Escarpment. Forested slopes drop sharply in elevation by 2,000 feet. From Virginia to the Carolinas to Georgia, the Blue Ridge range marks the delineation between mountains and foothills.

Around Lake Jocassee, however, a series of steep-sided gorges carrying surging mountain rivers have dramatically cut the sloping face of the Escarpment. Streams named Saluda, Eastatoe, Laurel Fork, Toxaway, Horsepasture, Bearcamp, Thompson, Whitewater, Devils Fork, and Chattooga carved these rugged gorges. Waterfalls too numerous to count spill over ledges through the area. An annual rainfall of more than seventy-five inches keeps the streams flowing and the vegetation lush. Known as the Jocassee Gorges, this part

of the Upstate is unique among mountain settings in the eastern United States.

When Scott and Kris invited me to share their spring break trip in 1995, I knew what was ahead. I had hiked some of these trails before as a much younger man. Hiking the Gorges is strenuous. Backpacking can be brutal. Still, I was up for the adventure.

I examined a detailed trail guide and topographical map. Our four-day backpacking trip would take us through the heart of the Jocassee Gorges. The trail loops around the northern part of Lake Jocassee. Here, the ancient Appalachian Mountains rise from the Piedmont in sheer granite cliffs known by the Cherokee as the Blue Wall. We would cross five major rivers creating their unique kind of mountain music as they plunged over boulders. These forests are filled with wonders. Plant life ranges from the tiny, rare Oconee Bells to towering poplar trees. Wildflowers and wildlife abound. Trillium, bloodroot, and lady slipper orchids, both pink and yellow, are to be found here. The woods are home to wild boar, black bear, and white-tailed deer. Birds of prey—bald eagles, osprey, hawks, and owls—all thrive here. The place is spectacular!

We walked west, starting at Rocky Bottom, and followed Laurel Fork Creek. Our morning stroll was easy. Scott and Kris were delighted to have exchanged their book bags for backpacks. I was just glad to be with them. Before noon we moved through a thicket to refill our water bottles for our lunch break. Whoa! On a flat rock above a small waterfall we spied a coiled timber rattler basking in the sun. Leaving the velvet-tailed rattlesnake undisturbed, we found water further along. After lunch the trail descended, following the Laurel Fork River. Once, this beautiful stream was a good place for trout fishing—but not on this trip. A logging operation had created runoffs. The river was muddy with silt. I grew up on a lumberyard, so I know the importance of logging. I was sad that the Laurel Fork had been contaminated through carelessness. That night we camped above Laurel Fork Falls. After a supper of hot soup and cornbread we slept serenaded by the rhythm of the cascade.

On the second day I awoke before daylight and before Scott and Kris. Crawling out of my sleeping bag, I became painfully aware that every muscle in my body was sore. I fixed hot granola and coffee for breakfast and took pain reliever to help with my aching muscles.

Sunrise presented a stunning view of Lake Jocassee. The name Jocassee comes from the legend of a Cherokee maiden. The Oconee tribe, the Brown Vipers, led by Chief Attakullakulla, inhabited the west side of the Whitewater River, while a rival tribe, the Eastatoe or the Green Birds, lived on the east. Legend says that a young Green Bird warrior, Nagoochee, was not afraid to enter Brown Viper hunting grounds. On one occasion he fell and broke his leg. Jocassee, Attakullakulla's daughter, brought him back to her father's lodge and nursed him back to health. Jocassee and Nagoochee fell in love. Later, in battle, Jocassee's brother killed Nagoochee. Legend has it that Jocassee went into the water and did not sink but walked across the water to meet the ghost of Nagoochee. The name Jocassee means "place of the lost one."

The Jocassee Gorges area was once home to part of the Cherokee Nation. Keowee, once the southernmost village of the Cherokee, was a major hub along the Cherokee Path. Keowee now lies 300 feet beneath the surface of the lake, near the Toxaway River.

As Scott, Kris, and I hoisted our backpacks for the second day's walk, a shaft of sunlight penetrated the forest canopy. Flitting in and out of the light were scores of yellow swallowtail butterflies. Scott held out his hand to provide a momentary perch for one. I looked to see what was attracting so many butterflies. In the middle of the trail was a substantial deposit of horse manure covered with bright yellow swallowtails. Scott paused to wash his hands.

The second day was exhausting. At first we laughed, and then we became exasperated with the printed trail guide. I smile at the indelible memory of Kris standing with a full backpack, holding the trail guide, and reading the description "steady incline." With that he turned and looked at the trail ahead as it ascended straight up the side of Heart Attack Hill at a steep angle.

Scott and Kris scaled the sharp incline as if they were climbing the stairs in our home. My tired, sore legs finally made it to the top. My sons were waiting patiently for me. My panting must have alarmed them.

"Dad, are you okay?"

"Just give me a minute to catch my breath."

After a few minutes we started the long trek down the other side toward the Toxaway River. Hiking here is what backpackers call a

toe jammer. A steep descent may be harder on old legs than a rugged ascent.

We took a break for lunch at the suspension bridge over the Toxaway River. I took some more ibuprofen and watched a fisherman catch several rainbow trout in the cold water. I had neither fishing tackle nor a North Carolina fishing license with a trout tag. But I was ready to stop, soak my burning feet in cold water, and take a nap. The boys reminded me that we still had miles to go before we slept. We pressed on under the warm spring sun.

In the late afternoon the trail moved close to the north shore of Lake Jocassee and flattened out. Walking this stretch was easier. Kris took pictures of the lake with mountains rising in the background. Scott stopped, bent down, and lifted from the path one of the largest feathers I have ever seen. I thought at first that it might be a buzzard feather. Scott and I agreed that it was the tail feather of a bald eagle. Confirmation came from the tall pine tree towering beside the lake above the spot where the feather had fallen. In the top branches of the pine we could see the massive nest, the eagle's eyrie.

We stopped for the night in a previously used camping spot. We didn't take the time to pitch my tarp tent, choosing instead to sleep under the stars. The cleared space had a fire ring made from stones. We built a small fire and cooked supper. Scott knew from his Boy Scout training that it is a federal offense to possess an eagle feather. He ceremoniously placed the prize of the day on the glowing embers of the dying fire. I put all of our food in a bear bag and hung it from a high limb in a nearby beech tree. It was a good thing I did. Off and on all through the night we heard a bear digging for grubs from a rotten log. He didn't bother us.

When I woke up on the third morning, it was already daylight. As I cleared the sleep from my eyes and put on my glasses, I looked high in the sky through the clearing in the canopy of trees. Circling in the sunlight were two bald eagles. I roused Scott and Kris so they could see the large birds. It was an exhilarating way to begin our day.

As we crawled out of our sleeping bags, we realized that we had camped near an old homestead. Though the house was gone, the moss-covered stone foundation was still in place. Petite golden jonquils, planted years before by a mountain family, danced in the morning breeze. It was another small, tender mercy for the beginning of a new day.

Hiking on the third day was not as hard for me. I still took a couple of ibuprofen, but my backpack didn't seem as heavy and my legs weren't quite as sore. The trail was no less demanding, but I knew we had passed the halfway point of our journey. Up and down we went, making good time. We stopped at Horsepasture River for lunch. Call it a swim or a bath, all of us got into the cold water. We felt renewed after our crossing. By the late afternoon my feet and legs were aching again. The boys moved along the trail like mountain goats. I plodded along like an old mule. I was tired and sore. We camped for the night at a spot aptly named Misery Mountain. We set up the tarp tent as a precaution against the thickening clouds. Throughout the night a pair of great horned owls carried on a debate near our campsite. As far as I know, they never did figure out the answer to their repeated question, "Who?"

The morning of our final day was cold and cloudy. Rain seemed likely. I knew this would be the most difficult day on the trail. We hurried through breakfast and started the last leg of our trip at daybreak. We crossed Bearcamp Creek. Further along, the trail joined the Whitewater River, following it for several miles. At the crossing we discovered a flash flood had washed away the steel bridge. We had to somehow get to the other side of the raging current. What to do!

Further upstream I saw a fallen tree spanning the whitewater. We made a difficult detour through a bramble thicket of rhododendron and greenbriers. The log became our footbridge as we carefully forded the roaring river. I took off my backpack and used my walking stick jammed into the rocks in the current below to stabilize myself on the log. Scott and Kris removed their backpacks as well. Holding my arm, Scott made the first passage successfully. Kris passed the three packs to me one at a time, and I relayed them to Scott. Then Kris took my arm, as Scott had, to safely reach the other side. As I held the trusty walking stick against the rocks, my sons reached out together and pulled their old man over to solid ground.

Our final ascent was the steepest climb of the entire trek. Though the trail was slightly improved, it was still treacherous. The thunder of Whitewater Falls added to the sense of adventure. Hugging the side of the mountain, grasping trees and roots at every opportunity, we made our way slowly and carefully out of the Jocassee Gorges.

We still talk about the trip. Recently, we gathered to reminisce.

Kris, a visual artist, said, "I remember most of all the vivid colors."

Scott, who hiked the entire Appalachian Trail in the summer of 2001, said, "It was the best spring break I have ever had."

For me the trek will remain a treasured memory. I was privileged to be in an intriguing place with two of the most fascinating people I know. I love the place; I love the people.

THE BOYKIN SPANIEL

Carl Bostick is a good friend. He is a surveyor from Irmo, South Carolina, and an Admiral in the Lake Murray Navy. Whenever we get together, swapping stories is our favorite pastime. Recently, Carl related a story that bears repeating.

Near the beginning of the twentieth century a hunt club in Boykin, South Carolina, had a serious problem. Duck hunters plied the tributaries of the Wateree Basin in small skiffs. The boats were fine for duck hunting, but they were not big enough to accommodate a large dog such as a Labrador retriever. Frequent mishaps occurred when large dogs leapt from the small boats, tumbling unsteady hunters overboard into the cold, cold water. Allen Jones Boykin, Carl's great-grandfather, and L. Whitaker Boykin, Carl's great-uncle, determined that a smaller retriever would be far more suitable. They set about the task of developing a smaller breed.

Alexander L. White, a Spartanburg banker and avid sportsman, frequently traveled to Kershaw County to hunt with the Boykin family. He had been the victim of several unfortunate spills into the Wateree River, the unwelcome result of a large retriever rocking the boat. In 1911, as he departed Sunday morning worship, Mr. White, a member of a local Methodist congregation, found a stray dog begging for food near the church door. He took the bedraggled brown pup home with him and named him Dumpy. He soon discovered that Dumpy was intelligent and had quite an aptitude for hunting.

Alexander White was eager to correspond with Whit Boykin to tell him about Dumpy. Arrangements were made for White to travel with the little brown dog to Kershaw County. Mr. White and Dumpy boarded the train at Magnolia Station in Spartanburg and were met in Camden by Boykin. Alexander gave the dog to Boykin. Dumpy, a male, was penned with a female Water Spaniel named Singo. The

result of that breeding was the first litter of Boykin Spaniels.

The Boykin Spaniel has a typical spaniel face with smaller, higher set ears and a straighter muzzle. He sports a brown coat with generally wavy hair, natural camouflage for a hunting dog. The tail is docked to prevent the typical enthusiastic wagging from alarming game birds during the hunt. The yellow amber eyes are a trademark of the Boykin Spaniel. Though each dog has his or her own personality, the breed is known as pleasant and obedient, loyal and intelligent.

The Boykin Spaniel excels as a hunting dog. His keen nose and eagerness in the field make him an exceptional retriever of upland birds as well as waterfowl. He loves water and is an excellent swimmer. His versatile hunting ability has made the Boykin Spaniel a popular companion among sportsmen in the Southern states. Originally bred to be a small retriever, the Boykin Spaniel stands about sixteen inches tall and weighs about thirty pounds. He is known as the dog that does not rock the boat.

Sixty-five years after Alexander White and Whit Boykin brought Dumpy and Singo together, the Boykin Spaniel Society was formed.

In July 2005 the American Kennel Club named the Boykin Spaniel Society the Official Parent Club of the Boykin Spaniel.

In 1985 Act No. 31 of the State Legislature designated the Boykin Spaniel as the official dog of the State of South Carolina because it is the only dog that was originally bred for South Carolina hunters by South Carolinians.

Years ago, three Presbyterian ministers from the Upstate planned to duck hunt in the Wateree Basin. Because they were unfamiliar with the area they decided to hire a suitable guide. A fellow pastor from Kershaw County suggested a member of his church. The pastors arrived and spoke with the guide. When they learned his fee, the ministers were hesitant. The guide said that he could reduce the fee if they were willing to hunt with an inexperienced dog, a newly trained Boykin Spaniel. Agreed.

After several days of hunting, during which they bagged their limit of ducks, the ministers complimented the guide on his retriever. The spaniel had performed beautifully. The guide offered to let the Presbyterian clergymen name the dog. They dubbed him Elder.

Each year at the same time the ministers scheduled a hunt with the guide. They always requested Elder as their retriever.

Then one year the Presbyterian Church scheduled a required conference that conflicted with the planned hunt. Because the three Presbyterians did not want to relinquish their annual hunting slot they offered their reservation to three Baptist pastors. The Baptists accepted.

The following year, the Presbyterians returned for their regular week of hunting. When they arrived, they immediately noticed that Elder was not with the guide. The clergymen insisted, "We want Elder as our retriever."

"No," said the guide, "You don't ever want to use that dog again!"

"Why not?" the ministers asked in dismay.

"Well, you fellows sent those Baptists down here last year, and they messed up that spaniel."

"But how?" they asked.

"Those Baptists didn't like the name Elder so they changed his name to Deacon. Now all he'll do is sit on his tail and holler."

Even a fine Boykin Spaniel can be ruined if he runs with the wrong crowd.

In Reverent Tones

THE CYPRESS KNEE MAN

Which resident of the Lowcountry is tall, bald, and has knobby knees?

When I first heard the riddle, my Aunt Gladys Hutson Sowers came to mind. She lived with her husband and eight children in a cabin on the edge of the Okefenokee Swamp in south Georgia. Her hair loss probably came from raising those children. Maybe it was the frequent visits by alligators that crawled out of the swamp into her backyard, enticed by her chickens.

You can probably think of several acquaintances who fit the riddle's description. But the correct answer is not a person at all. It is one of Aunt Gladys's close neighbors, the bald cypress tree.

The Good Book says that, on the third day of creation, the Almighty created all the plants and trees, everything that bears fruit with seeds. Among these was the bald cypress tree, a Lowcountry native with knobby knees.

The coastal plain of the Southeast is heavily populated with cypress trees. The bald cypress is closely related to the sequoias of California. The tree is called bald because, though a conifer, its leaves are shed in the fall. This interesting evergreen grows best in the rich, wet soil along riverbanks, on the margin of wetlands, or in the middle of swamps. It can grow to a great age and large size, sometimes 150 feet high and 17 feet in diameter. Its durable wood is often called the wood eternal.

Cypress lumber resists insects and chemical corrosion as well as decay. It has a fragrance resembling that of cedar. It is a close-grained yellow or reddish wood, so resinous that it resists rotting even after prolonged submersion in water. Cypress products include coffins, acid tanks, docks, pilings, poles, and railroad ties. There even is a Biblical connection that usually goes unnoticed. The King James translation reports that God told Noah to build the ark of gopher wood. The

New International Version translates the text, "Make an ark of cypress wood" (Genesis 6:14).

The massive trunk of the stately tree tapers upward from its wide, flaring base, where roots entangle to form supporting buttresses. The roots of cypress trees form knees that protrude above the surface of the water. Scientists believe that these knobs provide aeration for the roots that are otherwise completely submerged in water. They also give balance to the tall trees that might topple over under their own weight in the soggy soil.

Though the trees grow throughout the Deep South, the largest remaining old-growth stand of bald cypress is at Corkscrew Swamp Sanctuary near Naples, Florida. Some of those trees are around 500 years of age.

My family and I have been privileged to spend a week at Pawleys Island each summer. One hot Saturday while on vacation there I met Thomas, a big man, standing tall and stately like a cypress tree. He had large hands, callused from years of hard work. His skin, the color of ebony, glistened in the heat and humidity of the Lowcountry like wood

with a coat of high gloss varnish. His voice was quiet and gentle, and he spoke in reverent tones.

Thomas began his life on a farm. Now an elderly gentleman, he still does some farming. "But," he said, "years ago the Lord called me into the swamp and showed me the beauty of cypress knees."

Between McClellanville and Georgetown, along Highway 17, Thomas is known as the Cypress Knee Man. Several days a week, Thomas puts on a pair of high-water boots and wades into the swamp, chainsaw in hand, to harvest these unusual root formations. "I cut them above the waterline," he said. "That way the trees won't die. They just make more knees."

I met Thomas along the highway at Pawleys Island. His vintage Ford pickup was parked next to a hardware store. On a small island of grass between two palm trees he displayed the fruits of his labor. He had some cypress knees with the bark still attached and others that had been stripped and polished. Thomas had cypress knee lamps and cypress knee tables. He had a full display of walking sticks and walking canes, many crafted of oak, sweetgum, dogwood, or tupelo, as well as a few from cypress.

Thomas is an Associate Pastor at a Holiness Church in McClellanville. The following Sunday he was to preach about a third of the three-hour service. The Lord who called him into the swamp also called him into the pulpit. God speaks to him, he says, nearly every day.

"Just look at these cypress knees," he said, motioning toward a hundred or so spread out on the grass. "You can see the hand of God in every one of them. Each one is different. I've seen cypress knees that look like the Lord kneeling in prayer or the Mother Mary. I've seen cypress knees that look like angels. Each one is different, and each one is a sermon."

On that hot Saturday at Pawleys Island I felt that I had been led to worship. The preacher was a man called Thomas. The text was cypress knees. The message was that if you pay close attention, you'll see a creative hand at work in the world around you, maybe in cypress knees, but especially in people like Thomas.

THE OLD GRIST MILL

Twenty-five or so years ago, I stood with Dr. Lewis Jones on the bank of the North Tyger River. The beloved professor of history at Wofford College pointed to Anderson Mill. "This place is living history," he said. "It needs to be preserved."

I looked at the old building covered with corrugated metal, marred by graffiti. Wisteria and honeysuckle vines were creeping up the old stone foundation. The two water wheels were rusted. My unspoken question was, *why in the world would anyone want to save this old place?*

I remembered as a boy coming to this place to picnic with a church group on a hot summer day. On a big flat rock across from the old mill we spread gingham tablecloths, ate ham sandwiches, and drank sweet tea. Then we slid on the rocks in the river rapids. In the 1950s this place was our water park. Little did I realize then the significance of the place.

Grist mills were an important part of everyday life in South Carolina during eighteenth and nineteenth centuries. Corn and wheat were ground by hand before the invention of these early machines.

Power for the mills was provided by fast moving streams. Where water rushed over a rocky shoal a water wheel could harness the river's force. The energy was transferred inside the mill where it turned a large, grooved grinding stone. Rotating over a stationary millstone, grain could be ground into grits, cornmeal, or flour.

Only a few of these grist mills survive in South Carolina; fewer still have been renovated and preserved. Anderson Mill is the oldest mill in South Carolina standing on its original foundation. The site was originally known as Nichol's Fort, then as Nichol's Mill, and later as Tanner's Mill. The mill gets its current name from Tyger Jim Anderson who acquired the mill in 1831.

The fact that the old mill still survives is a near miracle. Fires were

a constant threat. Highly flammable grain was stored on the upper level. Gears turned the grinding stones. Millers would put animal fat on the gears to avoid sparks caused by friction. The old mill was constructed at the rapids on the Tyger River before the Revolutionary War. The Old Georgia Road, a wagon and stage route, crossed the shallow river immediately above the shoals. The fieldstone foundation and some of the supporting timbers remain from the original building. The current building was constructed on the old foundation after floods in the early 1900s caused heavy damage.

Anderson Mill last operated commercially in the 1960s. However, in the late 1980s Mr. Sellers, a former mill operator, gave demonstrations to history buffs and school groups. South Carolina Educational Television did a special program featuring Mr. Sellers. I took a Boy Scout troop to see the old mill. Mr. Sellers gave his demonstration, using the old stones to grind corn into grits. "Do you like grits for breakfast?" Mr. Sellers asked the boys.

Most agreed that they did. "What do you put on your grits?" the older man asked.

Some Scouts said butter and salt, some said cheese. Then one Scout chimed in, "My grandfather likes grits so much he calls them Georgia ice cream."

Mr. Sellers replied, "Without the grist mill there would be no grits in South Carolina and no ice cream in Georgia!"

The living history that Dr. Jones had in mind would be reason enough to save the mill. For those of us who call Spartanburg County home there is further motivation. In 1762 John Thomas Sr. received a land grant on Fairforest Creek. The homestead was located in what is now Croft State Park. The Upstate would soon see an influx of Scots-Irish settlers.

In 1775 William Henry Drayton traveled into the backcountry. Drayton, who within a year would be appointed the state's Chief Justice, was on a mission to recruit patriots to fight the British. He was introduced to John Thomas at a meeting at Nazareth Presbyterian Church. Thomas became the leader of a patriot militia. The new colonel was fifty-seven years old.

Colonel Thomas commanded a unit of 200 patriot soldiers. The English had placed these Scots-Irish on the frontier to serve as a buffer against the Indians. They were tough and used to fighting. They fought

with such valor that it was said "they fought like Spartans." The name stuck. They became known as the Spartan Regiment.

The Spartan Regiment is believed to have been part of numerous skirmishes with loyalists in late 1775. Colonel Thomas and his men earned their reputation for fierce fighting in several conflicts in which they opposed combined forces of English and Cherokee.

John Thomas Sr. and the Spartan Regiment, locally known as the Spartan Rifles, later would fight under General Thomas Sumter. The regiment was reorganized after Colonel Thomas was taken prisoner. John Thomas Jr. took over as colonel and commander of the militia.

It was the younger Colonel Thomas who led the Spartan Rifles in several skirmishes in this area. The area saw six engagements in four weeks, beginning in July with the First Battle of Cedar Spring near Kelsey Creek, just north of the Thomas homestead on Fairforest Creek. In quick secession there followed the battles of Gowen's Fort, Earle's Ford, and Fort Prince. Then came the Second Battle of Cedar Spring and the Battle of Musgrove Mill. These battles set the stage for two decisive engagements. Nearly two months later, Patriot forces assembled from several states scored a major victory at the nearby Battle of Kings Mountain.

Three months after Kings Mountain the conflict returned in full fury to the Spartanburg area, when General Daniel Morgan defeated British Colonel Banastre Tarleton at the Battle of Cowpens. The Spartan Rifles fought in that decisive battle. General George Washington would later call these Scots-Irish militia units the backbone of his army.

So what does a Revolutionary War militia unit have to do with a grist mill? Following the war, the newly formed United States of America and the thirteen new states had to create local governmental structures in order to preserve the peace. In South Carolina, districts were formed. On the third Monday of June 1785 the first court in our district met to organize. The meeting was held at a location every person would have known well: a big flat rock where the wagon road crossed the North Tyger River across from the local grist mill. The first clerk of court was a man widely known and respected, Colonel John Thomas Jr. The first order of business was to name the new district. It was only natural that those gathered named it for the militia unit that had protected them so valiantly. The Spartan District, later

Spartanburg County, was born.

The historic event happened across the river from what is now Anderson Mill. The site was listed in the National Register of Historic Places in 1978.

On a warm summer morning I drove over the North Tyger River bridge on the Old Georgia Road. I stopped my pickup truck to look at the old grist mill. I remembered Dr. Jones' hope that the place might be preserved. The big rock where Spartanburg County was formed and where we had our church picnic is no different than it has been for years. The rushing water that powered the mill in times past still flows over the rocks where we slid as kids. There was a time when pollution dumped in the river upstream made the water so alkaline that it burned the skin and bleached the blue jeans of those who tried the rapids. Now, the river has been cleaned. As I looked at the flowing water on that warm afternoon, I considered sliding on the rocks again. Then I had a better idea. I drove to the Beacon, ordered a bowl of grits with butter and salt, and enjoyed my Georgia ice cream!

THE LEGEND OF STONE SOUP

South Carolina boasts an interesting array of local festivals. Charleston is host to Spoleto. The town of Salley is home to the Chitlin' Strut. Leesville has a Poultry Festival. Pickens sponsors the Whipperstompers Weekend. Irmo features the Okra Strut; Pageland, a Watermelon Festival; Gaffney, both a Peach Festival and the Broad River Antique Plow Day. Whitmire pitches a Party in the Pines. Canadys promotes the Edisto Riverfest. Cowpens celebrates the Mighty Moo Reunion. Greenville throws the Crawdad Boil. From Daufuskie Day south of Hilton Head to Quilt Day in Landrum the Palmetto State offers a party of some sort nearly every weekend of the year.

The same is true of other Southern states as well. The title of this book, *Banjos, Barbecue and Boiled Peanuts,* suggests three. The Smoky Mountain Banjo Academy convenes each spring in Gatlinburg, Tennessee. The Annual Barbecue Festival in Lexington, North Carolina, is held each October. On Labor Day weekend Luverne, Alabama, hosts the Boiled Peanut Festival.

And, each spring, the town of Woodruff is home to the Stone Soup Storytelling Festival. Billed as the official storytelling festival of South Carolina, it is a two-day event celebrating the oral tradition of storytelling. It has been my privilege to attend the event as a featured storyteller.

"Stone Soup" was originally a Grimm Brothers' tale in which conniving strangers trick a starving town into giving them some food. There are many variations of the story. In the Portuguese version the lone traveler is a priest. In a French version the three travelers are soldiers returning home from the Napoleonic wars. In her children's book, *Stone Soup,* Marcia Brown retells the old French version. Her book won a Caldecott Medal in 1947.

In some older European versions of the story villagers are tricked

into preparing a feast for strangers. The fable is a lesson in deception. Most American versions of the tale center on cooperation within a community.

During the Great Depression in the United States many families were unable to put food on the table every day. It became a practice to place a large and porous rock in the bottom of the stockpot. On days when there was food the stone would absorb some of the flavor. On days when there was no food the stone was boiled, and the flavor was released into the water, producing a weak soup.

In some variations the stone is replaced with other inedible objects. In these forms the story might be called button soup, wood soup, nail soup, or axe soup.

Clare and I recently enjoyed a delicious meal at the delightful Stone Soup Restaurant in Landrum. Inside the menu we found yet another version of the legend. It reflects the culture of the Blue Ridge Mountains. Allow me to share an Upstate version of the folktale.

Once upon a time, a long time ago, when it wasn't my time and wasn't your time, but it was a long time ago, there was a village in the Southern mountains. The people had endured a severe drought. Crops had failed. Every family was impoverished and suffering from deprivation.

An old woman lived on a mountainside. She was the best cook in the entire county. One day the old woman hitched her skinny donkey to a wooden cart. She lifted a large cast iron pot onto the cart and made her way down a winding, narrow road to the village. Along the way she picked up fallen branches and sticks and stacked them beside the pot. As she crossed a dry creek bed, she selected one large round stone and added it to her load.

Finally, she came to the center of town. She arranged the sticks to build a fire and put her cooking pot in place. She drew water from the well, pouring bucket after bucket into the cast iron vessel. Into the water she plopped the stone! She lit the fire and sat down in the shade of a tree to wait. People gathered around, curious to see what the old woman was up to.

"What are you doing?"

"I'm making soup," she said.

The people noticed that the only thing in the pot of water was the large rock.

"What kind of soup are you making?" someone asked.

"I'm making a delicious stone soup," she said.

One neighbor asked, "How could it be delicious? There is no seasoning."

"I have no seasoning. I have only a stone."

"I have garlic cloves and sprigs of rosemary that survived the drought. I'll add those to the pot," one said.

Soon the simmering water captured the aroma of the herbs. More people came in curiosity.

"I have some beets that I can contribute," offered another.

Then the soup began to turn red!

A man brought a few potatoes. One had two onions. A woman gave a bunch of carrots. Someone threw in corn. Before long every person in the village, bringing what little they had, contributed to the pot of simmering soup. An old man killed and plucked his only chicken and put it in the pot. Before long the entire village had gathered, savoring the pleasant aroma and looking forward to the delicious soup.

Finally, the old woman said, "I think the soup is ready. If each person will bring a spoon and a bowl, I have a ladle. We will all have supper together."

That night every person in the village ate well. Bowls of soup were delivered to invalids in their homes. Everyone agreed it was the best soup ever!

That is the legend—and the miracle—of stone soup.

At the Woodruff Stone Soup Storytelling Festival there is a meal of soup and cornbread. But the festival takes the name Stone Soup because everybody shares a story, thus contributing to the cultural heritage of the community. My experience in Woodruff is that everybody was certainly well fed. But we were also enriched through our stories.

FLYING FLOWERS

In my backyard I have a volunteer sunflower, now taller than I. It sprang up when a sunflower seed escaped a birdfeeder and landed in a flowerbed. Out of curiosity I decided to let it grow. Recently, I have noticed that several of the leaves have been chewed to a pulp. I have yet to see the caterpillar responsible for the damage. I imagine his eating binge occurs after dark.

Caterpillars have been rightly called eating machines. They can devour the foliage of plants seemingly overnight. Some cause great destruction and do millions of dollars in damage to agricultural crops each year. There are literally millions of species in the biological order *Lepidoptera*. Every one of them has a larval stage we know best as caterpillars. There are both Jekyll and Hyde varieties. The boll weevil has wreaked havoc in cotton crops across the South. Armyworms attack cotton and soybean crops. Every vegetable gardener knows to be on the lookout for cabbage worms and tomato hornworms. Earlier this summer I noticed a webbed tent, the characteristic abode of tent caterpillars, on the branch of a pecan tree.

Some caterpillars are desirable. Every fisherman knows that the delicate purple blossoms of the catalpa tree attract moths that lay eggs. When the eggs hatch, catalpa worms start eating the large green leaves of their host plant. Bream fishermen treasure these tiny worms because bluegills consider them to be such a delicacy.

Other caterpillars are raised because of their economic importance. The silkworm is perhaps the best example. The minute threads secreted by the silkworm are used to make valuable cloth to be fashioned into fine garments.

By late summer my garden is aflutter with flying flowers, butterflies of all varieties. Once they take wing they are drawn to flowering plants that provide a feast of nectar. Creating a butterfly garden requires

a little planning and some maintenance. It is well worth the effort. Among butterfly favorites are ageratum, aster, butterfly bush, bee balm, black-eyed Susan, catmint, coneflower, coreopsis, cosmos, goldenrods, honeysuckle, hyssop, lantana, marigold, phlox, salvia, sedum, verbena, yarrow, and zinnia.

Butterflies are difficult to count because they are constantly on the move. One sunny afternoon last month, I drove into our driveway and paused to look at the lantana. There were no fewer than thirty on, above, and around the lantana. There were several varieties, including majestic monarchs, deep orange fritillaries, and an American painted lady. The lantana, attended by a bevy of flittering guests, created quite a display.

In my garden I have planted bronze fennel. The dark green plants make a nice backdrop with their lacy leaves. Its fragrance reminds me of licorice. I have fennel in my garden because it is a favorite host plant for a particular kind of caterpillar: the larvae of swallowtail butterflies.

Near the back of my property grows a patch of wildflowers. There is some goldenrod, but, more importantly, there is milkweed. The orange blossoms of the milkweed plant attract monarch butterflies. They lay their eggs on the leaves.

All butterflies begin life as caterpillars. After a time of chewing on leaves they hang upside down and enfold themselves in the silken case they spin. In this chrysalis stage they resemble a dead leaf until the moment comes when they emerge from their cocoon. Spreading their newly-formed wings they fly away, gloriously transformed.

This metamorphosis has made butterflies a symbol for new life. Sometimes butterflies are released at weddings, just as the bride and groom are pronounced

husband and wife, to mark the beginning of their new life together. Early Christians saw in the butterfly an apt symbol for the resurrection.

I shall never forget the funeral service for a woman who loved butterflies. She had decorated her home with a butterfly theme. She tended a special garden in her backyard designed to attract her flying flowers.

After her death, following an extended illness, it was only natural at her memorial service to emphasize her enjoyment of butterflies. Flower arrangements sent by friends and family members included silk butterflies.

At the cemetery on a mountainside the crowning touch to her service came as a complete surprise. As I finished reading the scripture, a monarch butterfly fluttered into the funeral tent and descended upon the Bible I held in my hands. The tiny orange and black creature perched like a bookmark between the opened pages. For a few silent seconds we marveled in amazement. The choreography in that service was beyond anything I could have scripted.

Monarchs are among the most regal and the most amazing of all butterflies. These orange and black beauties are migratory, flying 3,000 miles each fall to spend winter in the high mountains of central Mexico. Those who intentionally set out to attract butterflies usually find special satisfaction when they are graced with a visit from a monarch.

I sat with a man who was dying of lung cancer. We were in his backyard next to his butterfly garden, which included several varieties of buddleia, the butterfly bush. The afternoon was pleasant; the air was still. The garden was alive with flying flowers. Spicebush, swallowtails, monarchs, buckeyes, and mourning cloaks all sipped nectar from the array of blooms.

We sat in silence for a time before he spoke.

"They're beautiful, aren't they?"

"Yes," I agreed. "You know the butterfly is a symbol of resurrection."

After a long pause he said, "No wonder I enjoy them so much."

TEARS IN A BOTTLE

Late one fall afternoon a fifteen-year-old girl stood in the church office sobbing, waiting to see me. We sat down together. I handed her a box of tissues.

"Tell me about your tears," I urged.

Barely able to speak beyond her deep hurt, she explained that she had not been selected as a cheerleader at her school. More were not selected than were chosen, but her plight was different. Her mother and all three of her older sisters had been cheerleaders at the same high school she now attended. From the time she was a little girl she had gone to football games with her parents and watched her older sisters lead cheers. She had looked forward to the day when she would follow in their footsteps. Alas, it was not to be.

As I talked with her, a concept came to mind that had never occurred to me before. The world has plenty of cheerleaders but precious few grief leaders. I suggested that she befriend the others who had not been selected. In doing so she discovered that, out of her own disappointment, she could make a difference in the lives of other students who also felt left out.

Over the years I watched as this young woman grew into maturity. She has become a person who gives encouragement, bringing comfort and strength to others, often sharing their tears.

The world needs grief leaders, people of compassion and sensitivity who can guide sorrowing people along the path of bereavement. Grief leaders are those who are not afraid of tears, those of others or their own. They understand that tears are a gift of grace.

I sat in the cafeteria of a local hospital having coffee with three physicians. I have learned that even in difficult emotional circumstances physicians tend to be clinical. One of them had recently suffered a deep loss, the death of his wife following an extended illness.

He commented, "I know now why we are equipped with tear ducts. They are intended to be used."

Another doctor at the table sipped his coffee and added, "I read a study that indicated that if we don't cry enough, we develop sinus problems."

After a moment of silence I asked, "Have you ever heard Rosie Grier, former NFL player for the Rams, sing that song on *Sesame Street*, "It's All Right to Cry?"

The third physician commented, "They don't teach us that in medical school."

The psalmist turns a remarkable phrase to convey the notion that tears are to be treasured: "You put my tears in a bottle" (Psalm 56:8). The verse implies that God values our tears so much that he keeps them in a bottle.

Following our son Erik's death ten years ago, Clare gave a necklace to our newly widowed daughter-in-law, June. A small antique bottle, a lachrymatory, was fastened as a pendant on a chain. The lachrymatory was an appropriate present. The word lachrymatory is derived from the Latin *lacrima*, meaning tear. These small vessels of terra cotta or glass have been found in Roman and Greek tombs. They were bottles into which mourners dropped their tears. The bottles are shaped like a flask with a long, small neck and a body in the form of a bulb.

During the Civil War, women from both the North and the South were said to have cried into tear bottles and saved them until their boyfriends and husbands returned from battle. Their collected tears would show the soldiers how much they were adored and missed.

Lachrymatories have once again become popular. They are created by artists who work in glass in many different cultures. References to the power of the tear bottle occur even in contemporary literature. An explanation of the gift of a lachrymatory is found in Rebecca Wells' book *The Divine Secrets of the Ya-Ya Sisterhood*: "In olden days it was one of the greatest gifts you could give someone. It meant you loved them, that you shared a grief that brought you together."

When Clare gave the lachrymatory to June, they agreed that the only problem with the tiny bottle was that it was simply not large enough.

I continue to be astonished when well-meaning people instruct grieving people not to cry. If we cannot cry at the time of deep sorrow,

then when? In the early stages of grief there are times when tears flow uncontrollably. At other times we are better able to monitor our crying and can even choose our own time and place to weep. This is not to say that our tears should be postponed indefinitely. The truth is that sometimes it is just inconvenient to cry. Clare gave up wearing mascara after Erik died.

When Erik died, we gladly opened our home to many visitors. We found ourselves sometimes working very hard to help others know what to say. We also quickly learned that as a family we needed a place that was off limits to all people other than immediate family.

There is a level of grief that is for family only. There are expressions of hurt that belong in the context of family intimacy where nothing is unspeakable. Our place of seclusion was the second floor of our home. Even our closest friends respected our need to get away from the crowd. As family members, we took turns greeting people and then retreating to our upstairs privacy to weep and console each other.

My wife, Clare, has been my companion in both joy and sorrow. Her clear insight and her honest wit put things into a perspective that I appreciate. On the issue of choosing a time and place to weep Clare said to friends, "I cry in the shower. Somehow being in the flow of warm water gives me permission to cry. It's the best place to really cry alone. It's just not as messy as crying any other time."

Though we may not keep them in bottles, our tears are a gift to be treasured.

Wedding Surprises

Weddings are joyful occasions, but they can be full of surprises. Rarely have I seen a wedding proceed exactly the way it has been rehearsed. Tensions are high, many people are involved, and there are numerous opportunities for things to go wrong.

Clare and I were married on a hot, humid summer day at the Methodist Church in Leesville, South Carolina. My three brothers and Clare's brother, Ben, were the groomsmen. The wedding went along as we had rehearsed. I said my vows. The minister asked Clare to repeat her vows. Before she could respond there was a loud crash!

Ben had been sick with a fever all night. He told no one. Standing next to a bank of candles in that very warm church, Ben fainted. His mouth hit the altar rail, knocking out a front tooth. Blood gushed everywhere. My brothers picked up his limp body and hauled him, his arms and legs dangling, out of the sanctuary. Clare's dad jumped from his seat and went out with his wounded son. After about five minutes the father of the bride returned. Clare, shaken by the entire episode, spoke her vows to me.

I think that Clare had an advantage. When she repeated "for better or worse," she at least had an inkling about what those words means.

Fainting at weddings is commonplace. I'll never forget the day that I pitched a doubleheader. Before the vows a groomsman passed out. After the vows a bridesmaid swooned. The wedding was at high noon, and both attendants had refused to eat anything before the ceremony.

Some years ago I conducted an entire wedding service with the bride and groom seated together on the front pew. As the bride came down the aisle, the groom became pale and unsteady. I had them sit so that the groom would not faint. I'm not sure how their wedding pictures turned out, but at least when they left the sanctuary they were married.

Young couples often want to include in their own ceremony everything they have ever seen in other weddings. One couple, both musicians, overloaded their service with too much music. Their five-year-old ring bearer grew so fatigued during the long ceremony that he put his little pillow down on the steps and stretched out to take a nap.

Unthinking groomsmen, forgetting that a wedding is a worship service, are given to practical jokes. The worst in my experience was a time when the bride and groom had planned to take communion together. Someone put Tabasco Sauce on the bread and put vinegar in the chalice. Ever since that day I give what wedding directors have come to call my fear of the Lord speech. I include the stern warning at the rehearsal, reminding those who are a part of the ceremony, and especially the groomsmen, that we all are worship leaders.

At the rehearsal of a debutante bride and her groom, a football player from the hills of Tennessee, I gave my speech as usual. The fraternity brothers serving as ushers and groomsmen exchanged knowing looks as they listened to my admonition.

The day of the wedding they were polite and well-behaved all the way through the wedding. As the new bride and groom processed from the sanctuary, a commotion arose in the vestibule. The groomsmen padlocked one end of a logging chain around the neck of the groom. The other end of the massive chain was padlocked to the wrist of the bride.

The bride and groom were literally in chains for the remainder of their wedding pictures and for their first dance. The pranksters finally turned the key over to the bride late in the reception. One of the groomsmen explained to me, "Preacher, in East Tennessee we usually chain them up before the wedding, but after you put the fear of God in us last night, we decided to wait."

In forty-six years of ministry I have seen numerous wedding mishaps. Some are the result of poor judgment. Others are completely accidental. One bride fell flat on her face as she was ascending the platform stairs because she stepped on the inside of her dress. At other times mishaps are narrowly avoided.

A couple, both dog breeders, requested that two of their award-winning German Shepherds serve as ring bearers. I suggested that the dogs seemed more important to them than having me officiate. They got married without the dogs. The German Shepherds were present

at the outdoor reception. That was not at the church. Those big dogs made some of the wedding guests uneasy.

Weddings are occasions of gladness, fraught with opportunities for things to go wrong. Above all else a wedding is a worship service, a time of reverence and joy. If candles go out, ferns topple over, or knees buckle, the wedding can still be a meaningful experience.

I have officiated at weddings in churches and in private homes, on Blue Ridge mountainsides and on sandy beaches next to the Atlantic Ocean.

A wedding I recall fondly took place in the hospital. The bride, a terminal cancer patient, was dressed in a white gown. The groom stood at her bedside. Rarely have I been a part of a more joyful occasion.

Their vows were witnessed by family members, nurses, and a caring physician. "To have and to hold from this day forward, for better or worse, for richer or poorer, in sickness or in health, 'til death do us part."

Both the bride and the groom knew full well what their vows meant.

One week later, I conducted the funeral service for the bride.

What's That Humming Sound?

When I take a few minutes to sit quietly, I invariably notice a humming sound. It might be emanating from my car. The source may be my computer. The sound could come from a home appliance. Humming sounds can be natural occurrences. Whales and dolphins beneath the ocean, many varieties of insects, and even the pulsating of heavenly bodies can produce distinctive hums. Some people hear a constant hum caused by the flow of their own blood in the small vessels of their inner ear.

We might well ask, "What is that humming sound?" This time of year it could be a hummingbird.

The first week of September brought blessed relief from the oppressive heat and humidity of our dog day afternoons. On Monday I enjoyed a delicious summer lunch with a gathering of friends on a screened back porch overlooking a well-tended flower garden. Hummingbirds provided the entertainment for our midday meal. The tiny, feathered creatures put on quite an aerial display as they competed for the sweet nectar of the flowers and the sugar water in a feeder.

At the end of the day, as the sun was setting, Clare and I sat on our own back porch. We were treated to an amazing air show. As we enjoyed our supper, we witnessed an incredible display of aerobatics. Agile flying machines were buzzing around our yard, staging mid-air combat maneuvers that would impress even Air Force top guns.

Hummingbirds are always interesting to watch. Their activity increases as the summer days grow shorter. From late August through much of September the tiny hummers become frantic in their feeding habits and combative toward all competitors. They put on quite a performance as they prepare for their long migration to Central and South America.

Their excited pace and almost perpetual motion is at once fascinating and wearying to the observer. Earlier in the spring and summer, two or three hummingbirds might share the same feeder, but in early autumn they become territorial and will attack any intruder, even fellow hummers. Like feisty siblings quarreling over dessert, the petite birds quarrel with each other over which one will have the next turn at their sugar water treat.

A hummingbird in flight can be easily mistaken for a large stinging insect. The hummingbird's tiny wings move so rapidly they make a buzzing sound. This flight pattern, filmed in slow motion, reveals their remarkable ability to speed forward, to pause, and to reverse directions. Hovering, darting, and diving in their heightened frenzy, the aerial gymnastics performed by the humming creatures with tiny wings provide a constant show. It can also be disarming.

A friend who welcomes hummingbirds to her garden with feeders and flowers wanted to put fresh flowers in an arrangement for a dinner party at her home. She cut several late-blooming red gladioli from her

cottage garden. As she did, what she thought was a large buzzing insect began to bother her. The pest attacked from the rear, moving up her neck underneath the tresses of her new hairdo. The well-mannered lady ran, clutching gladioli tightly in one hand, swatting wildly with the other.

She stopped when the buzzing nuisance confronted her at eye level. It was a hummingbird, clearly annoyed that the lady had cut the flowers from which it had been feeding. The woman held the red gladioli at arm's length, as if making a peace offering. The hummer moved from one blossom to the next in the handheld bouquet, drinking its fill, before flying off without further conflict.

Hummingbirds are attracted to a variety of blooms. Fiery red salvias, cup-shaped hibiscus, and even the common trumpet vine provide nourishment to these tiny creatures that are constantly in search of a meal. Their frenetic activity demands a continual supply of sugary food. They sip nectar and can be enticed into view with feeders filled with fresh sugar water. A mixture of one part sugar and four parts of water meets the dietary requirements of these small birds. It is best for the health of hummers if we do not add red food coloring.

Accounts of close encounters between humans and hummers abound. The tiny birds are frequently trapped in garages and on screened porches, usually drawn into these unfriendly confines by something bright red in color. A red toolbox or a red fire extinguisher can lure a hummingbird into an open garage. One was even seen attempting to extract nectar from a red plastic bicycle horn.

Several years ago, a ruby-throated hummingbird, attracted by an artificial flower arrangement, entered a large sunroom in a nursing facility. The patients all suffered from dementia or Alzheimer's disease. Most of the patients were in the final stage of the illness, sometimes known as the living death. The nursing staff was unaware of the hummingbird's presence until they noticed something they rarely saw. Several of the patients were smiling, some for the first time in months. With the aid of a towel, a nurse was able to capture the tiny bird and release it outdoors. The bird flew away, but not before bestowing a gentle blessing on a room full of people who needed a small tender mercy.

THE OUTER BANKS

When we lived in Winston-Salem, North Carolina, our good friends Chip and Peggy invited us to join them for a week of vacation each June. For seven summers Clare and I traveled with our growing family to the Outer Banks of North Carolina. Though the margin between sandy dunes and salty surf looks similar to other real estate along the Southern Atlantic shoreline, vacationing on the Outer Banks is not your typical beach experience.

This 200-mile-long string of narrow islands off the coast of North Carolina begins at the Virginia state line, continuing southeast to Hatteras Point, and then southwest to Cape Lookout. These barrier islands, some as far as thirty miles from the mainland, cover more than half of the North Carolina coastline. Much of the area is protected as the Cape Hatteras National Seashore.

The Outer Banks are in a constant state of flux. Tides, waves, and currents provide daily, subtle changes. Storms can dramatically alter the islands. Offshore, two major ocean currents collide. The cold Labrador Current moves southward along the coast. Further out, the warm Gulf Stream carries clear blue water northward from the Caribbean.

The confluence of these two currents forms sandbars far out into the Atlantic. A charter boat captain explained to me that the bottom of the ocean off of Cape Hatteras is like a giant scrub board with ridges and deep valleys. This makes the coast especially susceptible to riptides. It is also the reason the waters are so dangerous for ships to navigate. Diamond Shoals is the name given to the treacherous, ever-shifting shallow, underwater sandbars extending over ten miles out from Cape Hatteras.

The first known vessel to wreck here was *The Tiger*, a British ship of Sir Richard Grenville's expedition to Roanoke Island, in June 1585. Since record keeping began, more than two thousand vessels and untold numbers of human lives have been lost in these waters.

No wonder it is called the Graveyard of the Atlantic!

The ocean off the coast of the Outer Banks is like a fickle woman. She can be well-behaved and placid or she can be enraged, unleashing her fury on any passing vessel. On a bright June day I stood on Coquina Beach looking out over the calm surf pondering capricious Lady Atlantic. Here near Oregon Inlet on another June day in 1921, a Nor'easter wrecked the *Laura A. Barnes.* I watched our children climb over the remains of the 120-foot wooden four-masted schooner out of Camden, Maine. She set sail from New York, heading to South Carolina and foundered in a dense fog on Diamond Shoals. The entire crew was rescued from the raging sea by the men at the Bodie Island Coast Guard Station. The sand and the surf have reduced the once magnificent tall ship to a driftwood skeleton, a testament to the power of the wind and the sea. The thick oak ribs and spine of the vessel made an entertaining jungle gym for the boys.

These beaches are not the best places to swim. The water can drop to depths of eight to ten feet within just yards of the beach. These deep troughs attract big fish, including large sharks. While the surf fishing is the best I have ever experienced, it is not safe for those who want to swim in the sea.

Once I was fishing with Chip at Hatteras Point. The ocean may be its roughest at the Point. Waves crash together forming tall watery haystacks. We watched a slight young man try to swim in the treacherous surf. A wave knocked him down and tumbled him as if he were trapped in a washing machine. Chip tossed him a small ice chest to use as a flotation device. Clinging to the cooler for dear life, the man made it to safety.

The islanders of the Outer Banks are survivors. These shores were first settled by the English, many of whom have descendants still living on the islands to this day. Before bridges were built in the 1930s, the only form of transport between or off the islands was by boat, which allowed for the islands to stay isolated from much of the rest of the mainland. This helped to preserve the maritime culture and the Outer Banks brogue. The dialect is most pronounced the further south one travels on the Outer Banks. The distinctive accent is thickest on Ocracoke Island.

Ocracoke is the island that our family enjoyed the most. It is home to herds of wild horses, sometimes called banker ponies. According to

local legend, the ponies are descended from Spanish Mustangs washed ashore centuries ago in shipwrecks. Ocracoke is also a great place to look for seashells. It is one of only two places where I have found the rare Scotch Bonnet, the state shell of North Carolina.

Ocracoke was the harbor of the feared pirate Edward Teach, better known as Blackbeard. It is also where Blackbeard was killed. The Visitor's Center on Ocracoke has a pirate museum that was perfect for our young family one rainy day.

One prominent family on Ocracoke is the Oden clan. There is an interesting story connected to the name. The winter of 1856 was especially difficult along the islands of the Outer Banks. The temperatures remained below freezing day after day until Pamlico Sound, separating the islands from the mainland, was completely frozen. Boats were unable to bring supplies out to the islanders. By March they were beginning to suffer from deprivation and longed for the taste of something besides dried fish.

On Sunday morning the preacher in the local church prayed that if God had in mind wrecking a ship along the coast, which the preacher certainly hoped God did not have in mind, that the ship would have on board some pork. And that the pork might wash ashore to feed the hungry islanders.

Within the week a barkentine vessel named the *Mary Varney* had wrecked on Diamond Shoals and was beginning to break apart. As pieces of the ship began to wash ashore, the expectant islanders saw bobbing up and down in the stormy sea a very large pork barrel. With each swell the huge white-capped waves pushed the cask closer to the shore. The preacher reminded those along the beach that just four days before he had prayed that God would provide. When the pork barrel entered the thundering breakers, a large wave picked it up and brought it crashing onto the beach. The islanders rushed to rescue the barrel when something even more unexpected happened. The top of the barrel popped off and out crawled Herbert Oden. As his ship had been breaking up, this enterprising young seaman had emptied the pork barrel and converted it to a life raft. The islanders continued to eat dried fish until the thaw. Herbert Oden never went to sea again. The preacher disappeared and was never heard from again.

Vessels in distress have been regarded by some inhabitants of the Outer Banks as a source of provision from the sea. Nags Head earned

its name when, on dark nights, local residents tied lanterns around the necks of their horses. They walked the animals along the dunes. From the vantage point of ships at sea the lights along the coast appeared to be boats bobbing in a harbor. If an unsuspecting vessel tried to sail into the faux haven, it wrecked on Diamond Shoals. As the ship broke up and the cargo floated ashore, the deceptive land pirates reaped the rewards.

Chicanery was not the mindset of most of the bankers. On numerous trips to the Outer Banks I have enjoyed visiting the picturesque Lifesaving Station at Chicamicomico. Built in 1878, the rugged old structure is a symbol of the heroic lore of the Outer Banks. Seven such stations became part of the United States Lifesaving Service, formed in 1848. These stations operated much like volunteer fire departments function now. Islanders were trained as surf men to respond to sailors in peril at sea.

It was in December of 1884 that a shipwreck on Diamond Shoals gave the courageous men of the United States Lifesaving Service what many consider to be their most severe test.

A merchant ship named the *Ephraim Williams*, her decks loaded with lumber, was traveling north past Cape Hatteras. Through his telescope, Captain Benjamin Dailey, keeper of the Cape Hatteras Lifesaving Station, could see the ship five miles out to sea.

By the morning of December 21 the temperature had dropped to twenty-three degrees. A gale was blowing, and sleet was falling. The ship was laboring against the wind and the sea.

A beach patrol reported cargo washing ashore. The six-man crew of the ship sent a signal of distress. Captain Pat Ethridge brought his crew from the Creeds Hill Lifesaving Station and joined the Hatteras crew north of the Cape Hatteras Lighthouse.

Four strong oarsmen were selected to accompany Captain Dailey and Captain Ethridge into the Atlantic. In surging waves awash with floating timber they rowed five miles to the schooner. They hauled all six crew members of the *Ephraim Williams* into their boat and rowed the five miles back to shore.

His hands were so swollen and blistered by the ordeal that it was nine days before Captain Dailey could write his report. These six surf men were the first to be given the Congressional Medal of Honor for Lifesaving.

Lighthouses along the Outer Banks are designed to warn passing ships of dangerous waters. Each of the lighthouses is unique. At Hatteras Light, the tallest on the Eastern seaboard, there is a museum dedicated to the exploits of the first lifesavers along these shores. Jutting out into the Atlantic, as the Outer Banks do, makes this the area most vulnerable to hurricanes north of Florida. When President Woodrow Wilson signed the Act to Create the Coast Guard in 1915, the United States Lifesaving Service became the United States Coast Guard. The Graveyard of the Atlantic Museum is located in Hatteras Village near the United States Coast Guard facility and Hatteras ferry.

So, if the Outer Banks is not a typical destination for a beach vacation, why would Clare and I go there with our children for seven summers? One reason, of course, is that we enjoyed being with our friends. Their children and ours were about the same age. Clare and Peggy loved each other's company. Chip and I enjoyed fishing. There is no better place than Hatteras for either surf or deep sea fishing. In the waters off Hatteras Chip and I hooked one-hundred-plus pound blue fin tunas at the same time. We fought those fish for nearly an hour. They both got away. It was here that I saw a blue marlin tail dance for the first time. The four hundred pound fish was on the end of Chip's line. The marlin was released to dance again.

The Outer Banks is a stunning place to learn about nature. The Pea Island National Wildlife Refuge is a sanctuary to large concentrations of ducks, geese, swans, wading birds, shore birds, and raptors. But, for our children, wading in Pamlico Sound was a favorite activity.

Pamlico Sound is teeming with life. At least once each summer, we went sound slogging. Armed with dip nets, lanterns, and a five-gallon plastic bucket, Chip and I took our boys wading waist deep in the sound. We collected all sorts of sea life. Back at the beach house, we stocked a saltwater aquarium with the specimens from the bucket: hermit crabs, sea horses, pipe fish, starfish, urchins, sea cucumbers, tiny fish, and blue-eyed scallops. On the final day of the vacation we released all of the critters back into the sound.

One night after slogging in the sound with all of the boys, we began wading back to shore. Suddenly the water became murky, a sure sign that something had stirred the sand on the sound's floor. We stopped and waited until the water cleared. Less than two feet in front

of us was a large stingray. Chip and I separated, each taking our own boys with us, giving the threatening ray a wide berth. Nobody got hurt in our close encounter with a stingray, but I still get the willies when I think about it.

The thin ribbon of sand that is the Outer Banks is rich in history. Clare and I especially wanted our children to know the story of the Wright Brothers. Orville and Wilbur made their first successful airplane flight on December 17, 1903, at Kill Devil Hills near the seafront town of Kitty Hawk. At Jockey's Ridge State Park near Nags Head, qualified hang glider pilots catch the updraft that lifts them above the highest sand dune on the east coast of the United States. Our children were more impressed with the gliders than they were with the Wright Brothers.

The same ocean winds that aid hang gliders can quickly become a tempest. Weather on the Outer Banks is notoriously unpredictable. My dad and I still talk about a fishing trip we took one year in early September. With our good friend, John, we drove twelve hours from Spartanburg to Nags Head. We were scheduled to go deep sea fishing the following day with a charter boat captain out of Oregon Inlet. We got to the Outer Banks in time to visit the docks and see what was being caught. As usual, the boats had much to show for their day in the Gulf Stream. Fishermen unloaded yellowfin tuna, king mackerel, wahoo, and several white marlin. We were excited about our prospects for the following day.

As we enjoyed a fresh seafood dinner at a restaurant on Pamlico Sound, I noticed mullet by the hundreds leaping out of the water. Then I saw the reason. A fast-moving cold front was pushing in from the northwest. In a matter of minutes the temperature dropped fifteen degrees, the wind blew a gale, and the rain pelted down at a forty-five degree angle. The storm raged all night. The next morning all boats were confined to the dock. The wind was blowing straight in from the ocean so even surf fishing was impossible. Without ever putting a line in the water, John, Dad, and I drove twelve hours back to Spartanburg. Back at home my brother Bob asked, "How was the fishing trip?"

I told him the story. Bob quipped, "I did just as good as you did, and I didn't even go fishing!"

Even so, one of my favorite places on earth is the Outer Banks of North Carolina.

THE MYSTERIES
OF PARIS MOUNTAIN

Earlier this spring, I was teaching a storytelling class at Furman University. As I was leaving the picturesque campus of my *alma mater* nestled at the foot of Paris Mountain, I recalled a brutal afternoon I spent on the mountain.

As difficult as it may be to believe, when I was a student at Furman and many pounds lighter, I was on the track and the cross-country teams. I was a long-distance runner. One day at cross-country practice, Coach Jimmy Carnes said that he thought we might play a game of basketball. "But first," he said with a smile on his face, "I want you to warm up. Run from campus to the top of Paris Mountain and back down the other side."

We thought he was kidding. He was not.

We ran the entire eighteen mile loop. Then we played basketball.

My legs have never been the same. I developed a crippling case of shin splints and was on crutches for several weeks.

Now forty-six years have passed since I panted and plodded up and down the twisting road that crosses Paris Mountain. On my recent visit I decided to drive to the top of that ancient peak.

As I enjoyed the view from the summit, several questions came to mind. Why does this mountain sit alone as if alienated from its Blue Ridge cousins? Why is there a state park all but hidden at the bottom of the mountain? Why would a mountain in Greenville County be named for the capital city of France?

I spent the next several hours learning the answers to my own questions. My quest took me to Paris Mountain State Park.

Paris Mountain is a monadnock located north of Greenville. Monadnock is originally a Native American term for a lone mountain that stands above the surrounding area. In the Carolinas these only occur in the Piedmont. Other examples are Pilot Mountain, Kings Mountain, and Table Rock. These mountains have survived erosion.

They tower above the rolling hills. Paris Mountain is a single giant rock of hard basalt that rises about 1,800 feet above sea level.

The first water system for Greenville was created by the Paris Mountain Water Company. They built numerous dams and lakes on the Mountain between 1889 and 1918. The City of Greenville purchased the company and operated the system until a new reservoir at Table Rock was filled. In 1935 the City of Greenville donated the land on Paris Mountain for use as a state park.

Photographs displayed on the walls of the old lodge at the State Park tell the story of the construction project. Following the Great Depression, The Civilian Conservation Corps developed the park, building many of the facilities that are still in use. The original stone and timber construction takes visitors back in time. When I visited the park I was amazed at the fine stonework. It reminded me of similar work done by the C.C.C. on the Blue Ridge Parkway.

Archaeologists have found evidence that confirms Native American activity on the mountain as early as 11,000 years ago. The area was part of the Cherokee hunting grounds. The tribe ceded these lands to South Carolina in 1777. The Indians remained in their mountain homeland for several years after signing the treaty.

The first settler is commemorated on an historical marker at Reedy River Falls Historic Park. The inscription reads:

> Richard Pearis, Greenville's first white settler, was an Irish adventurer who had settled in Virginia with his wife and family by the middle of the eighteenth century. He developed good trade relationships with the Cherokee Indians, had a son by an Indian woman, and in 1770 acquired title to 100,000 acres of Indian land in what is now Greenville County. He set up his Great Plains Plantation with a trading post and grist mill on the banks of the Reedy River. Pearis was wooed by both Patriots and Tories when the American Revolution began. When he went with the British, Patriots burned his home, mill, and store. He fled to the Bahamas and never returned to Greenville. Paris Mountain is named for him.

In her book, *Hidden History of Greenville County*, Alexia Jones Helsley tells the rest of the story. In 1786 the South Carolina Legislature created Greenville County. Lemuel James Alston offered land for the new courthouse. Alston had been a delegate in 1788 to the South Carolina Convention to ratify the Constitution of the United States of America. Lemuel Alston acquired the former site of Richard Pearis's Great Plains Plantation. With the courthouse location set, Alston laid out the plan for the village of Pleasantburg.

The new town sat on hills just below the falls of the Reedy River. By 1805 the town had still not developed as Alston had envisioned. After serving two terms in the United States House of Representatives Alston was defeated, and he became discouraged.

In 1815 he sold the village of Pleasantburg to Vardry McBee, a successful, self-made businessman from Lincolnton, North Carolina. McBee is known as the father of Greenville.

A place as rich in history and in lore as this mountain certainly must have a ghost story. Indeed, according to some local folks, there are ghosts on Paris Mountain. The old Hopewell Tuberculosis Sanatorium was located nearby on Piney Mountain Road. After it was no longer a TB sanitarium the 40,000 square foot building was used to house the criminally insane. It was later abandoned and became known by some as Devil's Castle after reports of weird noises coming from the place. On November 19, 2002, it burned to the ground. The only thing to survive was the boiler room, basement, and morgue.

Legend has it that at twilight the sound of trudging footsteps can be heard, and fleeting shadows can be seen moving across the mountain in the fading light.

I have it on good authority that all that commotion is just an exhausted Furman sophomore whose legs are hurting. He's struggling to keep up with his teammates and get back to campus before dark.

An Acquired Taste

THE ANT FARM

When my mother-in-law, Miz Lib, died, we had the daunting task of cleaning out her house. Miz Lib did not throw anything away. She saved the cardboard tubes out of paper towel and toilet paper rolls. In a kitchen drawer she stashed the cotton out of medicine bottles. She stored stacks of empty egg cartons and big, round oatmeal boxes. She said, "You just never know when somebody is going to do a school project and need this stuff." And she was right.

When we were cleaning out the house, we looked under the kitchen sink. There must have been thirty-five or forty empty Duke's mayonnaise jars, with lids.

I asked, "What in the world did she think we would ever do with these?"

One of our children said, "Dad, she always had a mayonnaise jar for us if we wanted to catch lightning bugs."

I am not sure his grandmother saved mayonnaise jars, but Milton Levine was like a lot of kids. He liked to catch bugs of all kinds. He especially enjoyed catching ants and putting them in a glass jar with sand. He called it his antarium.

When he was an adult, Milton and his brother-in-law, E. J. Cossman, were at a Fourth of July family picnic. There were ants about. Milton suggested a plan, "We ought to make an antarium and see if there would be a market for it."

Milton and E. J. invented Uncle Milton's Ant Farm. Perhaps you remember their invention. It had a green plastic silhouette farm scene and frame with clear plastic panels. Sand was provided, but ants had to be ordered. The ants were red harvester ants from the Mohave Desert. Milton and E.J. hired people to work as ant harvesters, and paid a penny apiece for the insects. The ants were mailed in a glass tube to be added to the farm.

The educational toy was an instant hit. The product has remained essentially unchanged over the decades. Uncle Milton Industries sold more than twenty million ant farms, giving millions of children a sneak peek into the underground life of the tiny insects.

I had an ant farm on three different occasions. My ants kept dying. It was not until recently that I found out why there was such a high death rate. When the farms were first produced the glue that held the containers together was toxic to the ants. If worker ants ate morsels of glue, the whole colony died. That happened twice to my ants.

The third time it was not the glue that killed the ants. I am not exactly sure what happened, but one day I noticed that a plastic panel had cracked. With seven younger brothers and sisters, anything is possible! Many of the ants had escaped the farm. They were crawling across the top of my dresser. They were down in the drawers where I kept socks and underwear. They were all over the bedroom that my brother Bob and I shared. We got a vacuum cleaner and tried to suck up the prodigals. It was several weeks before we were rid of the tiny pests.

Even with the mishaps the ants were fascinating to watch. I saw the colony build tunnels and create pathways through the sand. In a 2002 interview with the *Los Angeles Times*, Milton Levine said, "Humanity can learn a lot from ants."

He mentioned three lessons in particular:

1. Ants are diligent workers day and night.
2. Ants never procrastinate.
3. Ants work together for the common good.

Eva Jeslyn McCall, better known in our family as Nanoo, was my Granny's first cousin, my mother's second cousin, and my third cousin twice removed. When she thought her younger second cousins were yielding to idleness and being lazy, Cousin Nanoo quoted Proverbs 6:6. "Go to the ant, thou sluggard; consider her ways and be wise!" The wisdom of the Bible gives two more lessons to be learned from the ant:

1. Ants need no supervision.
2. Ants store food for later use.

Milton Levine died on January 16, 2011, at ninety-seven years of age. Uncle Milton's Ant Farm has been recognized as one of the Top 100 Toys of the Twentieth Century by the Toy Industry Association.

In the 2002 interview Uncle Milton was asked what he considered so amazing about ants.

He said with a grin, "They put my three children through college."

If I had known ants would do that, I would have taken better care of my ant farm.

LEARNING TO LIVE
WITH LESS

"I've been thinking about it," he said. "If I miss one payment on my riding lawn mower, one payment on my plasma television, and one payment on my four-wheeler, I'll have enough money to make a down payment on a new bass boat."

Sound familiar? It has come to be known as the great American way to achieve the great American dream. The result is the great American recession. Recently I was asked if I think we will learn anything as we go through this economic downturn. The story of my grandparents came to mind.

Pappy and Mammy had eight children when the Great Depression hit. Pappy was running what he called a one-horse lumberyard on East Henry Street. They owned a beautiful brick home on the Greenville Highway. It was located right where it became a dirt road before crossing Fairforest Creek.

One of the things that gets hit the hardest at the beginning of a real downturn is construction. That is an area that is very close to my heart. Construction suffers early. It is also true that building is one of the last things to recover. When the country suffers an economic downturn, people put off building homes and even home repairs.

Pappy and Mammy tried to make ends meet. The older children worked. "Times were hard and things were bad," to quote Johnny Cash. Pappy tried desperately to save the lumberyard. In 1923 he had poured all of his money into the business just to get it started. Soon he mortgaged the lumberyard and then mortgaged his home to put more money into the company. Politicians kept saying that prosperity was just around the corner. People kept trying to hang on. Finally, Pappy lost the lumberyard and his family's home.

The family rented a house. It is still standing right across from the South Carolina School for the Deaf and Blind at Cedar Springs

on Highway 56. The gray Victorian home, ornamented with white gingerbread work around the outside, looks much today as it did then. Mammy gave birth to her ninth child, my Uncle Wesley, while they were living there. Pappy bought a battered and emaciated old mule from the county chain gang. He farmed the land where Mountainview Nursing Home is now in Spartanburg County.

They survived by the sweat of their brows. A cow and two goats provided milk and butter. They had a big garden, and Mammy canned fruits and vegetables in the summer and fall. Pappy plowed with the old mule and raised bountiful crops of sweet potatoes. As a young teenager my dad raised turkeys. Many of the sweet potatoes and all of the turkeys were sold to the state school across the road.

As the economy recovered, the family needed a place to live that would more comfortably accommodate their nine children. Pappy bought a tract of land on Union Road with no collateral except his word of honor. He, along with my Uncle Asbury, built a lumber shed on one end of the land and a home for his family on the other in 1937. The house was constructed in the way most homes were built in the '30s in the South. The framing was yellow pine, and the floors were white oak. The house had few luxuries, but it was solidly built.

Mammy wanted a parlor in their new home. The parlor was a throwback to the plantation home she knew as a child in Lena, South Carolina. It was a small room on the front of the house. There was a large window on one end. An oak mantel surrounded the fireplace, which was originally intended to burn coal. When my grandparents lived in the house, the room was furnished simply with two chairs, a small table, a settee, and a family Bible.

Mammy's parlor was a place to pray. It was not a luxury. It was an absolute necessity. Every night before bedtime my grandparents sat in the small room. Pappy read a chapter from the Bible. Following the scripture, Mammy and Pappy knelt to pray.

When I was with them I heard the prayers they offered for their children and grandchildren. In that parlor, they interceded for missionaries and pastors. In that parlor, before I was born, they prayed for four soldiers, three of their sons and a son-in-law, throughout the duration of World War II. Prayers of blessing for families, for churches, for this country, and for the world still permeate the walls and linger in the ether of Mammy's parlor.

After Pappy started the new lumberyard every day was a struggle. As long as the family could remember, up until about two years before he died, Pappy always carried bank notes in his pocket. At the first of the week he would pull out the notes and shuffle through them. He would say to his sons and his brothers who were working in the business with him, "We have to pay this note off by Friday." They would work all week long to make enough money to pay off that note. The next week, there would be another one to pay off. Pappy kept paying and paying, trying to keep his head above water, trying to make ends meet.

When I was in the tenth grade, I was out at the lumberyard one day. Pappy said, "Kirk, come here. I want to show you something."

I went into his office. He had written a check for $500 to a lumber supplier down in Georgia. He was getting ready to put it in the mail. He said, "This is my last debt from the Depression."

He finally got all the debts paid. It took just about his whole life. The last two years of his life, he was completely out of debt.

One of the things we need to learn is that living on credit, on money we do not have, leads to disaster.

Americans are big eaters, big spenders, and big wasters. Our combo meals are super-sized. Many of our vehicles are gas-guzzlers. Our home entertainment systems require a room of their own. Our bigger-is-better mentality has created monumental problems. Our souls suffer the poverty of abundance, and our planet suffers the collateral damage. Landfills are brimming over, the air is thick with carbon emissions, and many rivers are polluted.

Maybe in the current economic crisis it is time to make our lives less hectic, less cluttered, less selfish, and less toxic. Maybe now is the time to simplify, to live with less. Maybe in choosing alternatives we can regain sanity and make the world better for all people.

Where to begin? Here are ten suggestions gleaned from a variety of sources:

1. Make a list of five things you want to accomplish in the next five years. Make sure the list squares with your personal sense of integrity and with your faith. Coordinate your list with your family members so that you are in agreement.

2. Take a hard look at your calendar and your checkbook. Eliminate any expenditure of time or money that does not move you toward one of your five goals. Avoid over-commitment and debt. Mismanagement of time and money causes stress.

3. Remove clutter from your office and your home. Begin with one drawer. Then another. Then clean a closet. Finally remove clutter from your basement, your attic, and your garage.

4. Discard any clothing you have not worn in the last three years. Other people can surely use unwanted and unneeded items from your home. Give away to charitable agencies household items that can be used by others. Turn trash into cash. Have a family yard sale and give the proceeds to a good cause.

5. Handle every piece of paper only once. Open the mail and make a decision about what is junk and what needs your attention. Read newspapers and magazines as they come into your home.

6. Recycle paper, glass, metal cans, and plastics. Compost your vegetable scraps.

7. Have a set time to perform routine tasks. Checking e-mail, paying bills, cleaning house, and feeding the pet will all be less tedious if they are a part of a routine.

8. Prepare nutritious food in your own kitchen. Eat out less often.

9. Set aside time for your spouse, children, and

friends. People are more important than things.

10. Take care of yourself. Regular exercise,
 adequate sleep, time for laughter, and
 Sabbath time are all important.

Let us ask the key question, "Do we really need this in our lives?" That one question may lead us to choose a push lawn mower rather than a power mower, to get rid of an extra television, and to experiment with line-drying laundry. As we simplify we may discover the joy of having fewer bills to pay, fewer errands to run, and fewer agendas to manage.

My friend and teacher Dr. Wayne Oates survived the Great Depression in the hills of Pickens County in the Upstate of South Carolina. Wayne's father died when Wayne was only four years old. His mother worked in the weaving room in a cotton mill, so he was raised by his grandmother. He told a story about living with less:

> A young pastor was invited to preach a revival
> at a rural church in the mountains of Kentucky.
> An elderly couple who lived in a log cabin
> provided lodging for the pastor and his wife.
> On their first evening the young couple sat
> near the fireplace with the older couple. Before
> glowing embers the elderly gentleman said,
> "Me and my wife are going to bed now. You
> young folks can sit here by the fire as long as
> you like. If you need something, make yourself
> at home, and get whatever you need. If you
> need something, and you can't find it, wake
> us up, and we'll get it for you. If you need
> something, and you can't find it, and you wake
> us up, and we don't have it, well, then, we'll
> teach you how to get along without it."

NOT YOUR MAMA'S GINGER ALE

I remember my mother having morning sickness. As the oldest of eight children, I was sometimes the person who tended to Mama when she was expecting another of my younger siblings. Enduring those early days of pregnancy with an unsettled stomach called for frequent sips of something soothing. Mama's preference was Canada Dry Ginger Ale.

Southern Living magazine featured an article on soft drinks in the South in June 2002. "Southerners love fizz. What France is to wine, the South is to soft drinks. Like our personalities, our drinks are sweet, bubbly, and explosive if shaken up. ... In most of the South, Coke is the word used when referring to anything cold and fizzy."

A number of carbonated soft drinks were developed in the South. Coca-Cola originated in Atlanta, Georgia. Dr. Pepper hails from Waco, Texas. Pepsi-Cola is the drink from New Bern, North Carolina. Some of the South's finest fizzy drinks have a distinctly local flavor. Sundrop, an intense lemonade, is made in McMinnville, Tennessee. In the

Volunteer State it outsells Coca-Cola five to one. In Salisbury, North Carolina, if you ask which wine goes best with a barbeque sandwich, the answer will surely be Cheerwine. Royal Crown Cola originated in Columbus, Georgia, a product of the Nehi Corporation. Affectionately known as RC, it is still being coupled with Moon Pies all over Dixie. NuGrape and Grapette continue to wash down hot dogs in many venues below the Mason-Dixon Line.

Ginger ale occupies a unique niche in the soft drink market. While vending machines and soda fountains rarely contain ginger ale, the drink is a staple on supermarket shelves and on airplanes. Ginger ale is a standard tonic to prevent or alleviate motion sickness. The bubbly drink is a home remedy to relieve upset stomachs and to soothe coughs and sore throats. And, in Mama's case, it was the treatment of choice for morning sickness.

Ginger beer, a strongly flavored fermented product appeared in the British Isles in the 1700s. Ginger ale is a refinement of ginger beer and comes in two varieties—dry and golden. Golden ginger ale retains the strong flavor of ginger beer. Dry ginger ale was developed during Prohibition when ginger ale was used as a mixer for bootlegged alcoholic beverages. Dry ginger ale quickly surpassed golden ginger ale in popularity. Canada Dry, Schweppes, and Seagram's are major brands of dry ginger ale.

Golden ginger ale is less common. Originating in 1866, Vernors Ginger Ale was designed to resemble imported Irish ginger beers. In 1862 James Vernor, a Detroit pharmacist, was called to serve in the Civil War. The story goes that he left a mixture of ginger, vanilla, and spices in an oak cask in his pharmacy. After returning from the war four years later he opened the keg and found the aging process in the oak wood had changed the drink inside. It was like nothing else he had ever tasted. It was golden ginger ale. Vernor declared it "Deliciously different," which remains the drink's motto to this day. Along with Hires Root Beer, Vernors ginger ale shares the title of America's oldest surviving soft drink.

In South Carolina we have our own golden ginger ale. Blenheim Ginger Ale is an amber delight that has been around for more than one hundred years. It is manufactured in Hamer, South Carolina, in the oldest and smallest independent bottling company in America. Many folks in our neck of the woods would argue that it is also the

best. The bottling plant is located next to the Blenheim Artesian Mineral Springs and has changed little since it began production in 1903.

James Spears, a patriot who was trying to escape Tory troops, discovered the mineral springs in 1781 when he lost a shoe in a water hole. The story is that, when he returned to fetch his shoe, he sampled the water. The water was cool and refreshing, but the strong mineral taste was overpowering. Soon local people came to the springs believing the water had healing properties.

In the late 1800s Dr. C. R. May prescribed the mineral water to his patients with digestive problems. Dr. May added ginger to the water when his patients complained about the taste. Their positive reaction gave him the idea to bottle the pleasing concoction. Dr. May and his business partner, A. J. Matheson, opened the bottling works in 1903. Blenheim Bottling Company is housed today in the same building that was constructed in 1920.

In the Carolinas Blenheim Ginger Ale has attained legendary status, partly because it is hard to find. You won't see a Blenheim machine standing next to those of other soft drinks. If you're looking for a fizzy non-alcoholic drink that will warm your soul, look no further than Blenheim Ginger Ale. The fiery elixir is bottled only in glass, never in cans, assuring that it never has a metallic taste. It comes in four varieties: Old #3 Hot, #5 Not as Hot, #9 Diet, and #11 Ginger Beer.

Many health claims have been made for this ginger ale. In addition to the original prescription for stomach problems, some say it will cure sinus problems, clear vision, or remove tattoos. The spicy ginger ale is used by some small Southern town jails to sober up drunks.

Whenever I pop the top off of a #9 Diet Blenheim, Clare begins sneezing. Pour this golden drink over ice and swill or sip slowly. You too will probably experience the most refreshing sneeze you have had in a long time.

The Old #3 is so hot and spicy that many gag and cough at the first sip. One fellow described it as being like a cold drink of kerosene or turpentine.

"The taste is hotter than the hinges of hell," exclaimed another.

Admittedly, it is an acquired taste.

It's definitely not your mama's ginger ale.

BROTHER TO A DRAGONFLY

I enjoy the writings of Will Campbell. He has authored numerous books. Two are favorites of mine, and both are autobiographical. *Forty Acres and a Goat* was published in 1986. *Brother to a Dragonfly*, his best known work, was a finalist for the National Book Award in 1978. In *Brother to a Dragonfly* he tells about an experiment his brother, Joe, conducted with a dragonfly. The two Mississippi farm boys followed a path across a field through the woods down to the river. Three days earlier, Joe had buried a dragonfly in an aspirin box. In the soft mud Joe dug up the box. When he opened it, the dragonfly flew out.

Joe turned to Will and said, "He's just like Jesus. He was buried in the ground for three days. He's still alive."

Like the butterfly, the dragonfly is considered a symbol of immortality. The life cycle of the dragonfly leads to this assumption. Dragonflies mate in mid-air—quite a feat! Eggs are deposited in the water. Eventually a larva crawls out of the water and attaches to a reed. Its skin becomes hardened, creating a cocoon.

Then a transformation takes place. Before long the chrysalis splits. A brand new body emerges from the dead shell. The gauze-like wings unfold, and a colorful and sleek dragonfly takes to the air.

A few years ago, I conducted a graveside funeral service. The widow of the deceased wore on her black dress a silver pin crafted in the likeness of a dragonfly.

"My husband gave this to me. It is a symbol of hope."

This small insect is one of nature's most fascinating creatures. To any observer the dragonfly is an aviation marvel. The Boeing Corporation in Seattle, Washington, has filmed dragonflies in flight. After taking a close look at this small insect, engineers were amazed at their aerodynamics. They concluded that the dragonfly is a highly perfected flying machine.

Some dragonflies fly at speeds up to sixty miles an hour. The average cruising speed for a dragonfly is about ten miles an hour. They can fly backwards. They can dart from side to side. They can stop in mid-flight and hover.

The secret is the two pairs of wings that work independently of each other. The front two wings simply churn the air, creating disturbance. The back two wings provide the stability.

Researchers say that the dragonfly creates turbulence, whereas aircraft try to avoid it. Engineers acknowledge that it is impossible to approximate this mechanically. Their conclusion is that the flying ability of the dragonfly is superior to anything the Boeing Corporation can manufacture.

I saw a pair of blue dragonflies stalking prey above the pond in my garden. The predatory insects are always welcome guests in our yard. In half an hour's time they can consume their own weight in mosquitoes.

Dragonflies have also been called horse stingers. People thought that they were doing the stinging. In fact, they were pursuing horseflies, the real pests. Sometimes they have been called mosquito hawks, a name that really fits because of their preference for the little bloodsuckers. It is the combination of their aerobatic maneuvers in flight and their voracious appetite that led to international acclaim.

The entire island of Japan was at one time called the Island of the Dragonfly. Legend has it that a pesky horsefly bit a Japanese emperor. No sooner had he been bitten than a dragonfly ate the horsefly. The emperor saw that a friend, the dragonfly, had attacked the one who accosted him. From that day forward he decreed that the whole island of Japan be called the Island of the Dragonfly. Samurai warriors adopted the insect as their symbol. The dragonfly was such a ferocious fighter that they etched the symbol on the front of their leather helmets.

On the North American continent, Lakota Indians of the northern Great Plains considered the dragonfly to be a fierce hunter. A dragonfly motif is common in Native American beadwork. The Navaho people of the Desert Southwest regarded the presence of a dragonfly as an indication of pure water, something very important to people who live in arid conditions. They often incorporated the image of the dragonfly into their sand paintings.

There are 6,000 varieties of dragonflies, each one unique. Sometimes they are called snake doctors and darners. People in Old England believed that falling asleep during the daytime was dangerous. They thought this insect with a body like a darning needle would sew your eyes shut as the penalty for laziness. It's enough to scare you out of an afternoon nap!

As a boy, I was fishing with my grandfather. I had not had even a nibble on my fishing line. Dragonflies were darting all around. One hovered close to me, and I was afraid. The thing looked like it had a killer stinger on its tail. Then, it disappeared from my sight.

My grandfather could still see it. "He is on the brim of your hat. Hold really still."

I did just as Pappy instructed. In a few minutes the insect flew away.

"Don't worry. They don't sting," Pappy said, "Now you'll catch fish."

Within just a short time I had a bass on the bank. Before the afternoon was over I had also caught several bream.

Appalachian folklore says that if dragonflies are about when you are fishing and one does not stop close by, you might as well pack up and go home. You are not going to catch any fish. But, if a dragonfly lights nearby while you are fishing, you are going to have good luck.

On that day it was the truth.

PLEASE PASS
THE BOILED PEANUTS

Clare and I hosted a passel of guests over the Labor Day weekend. Most of our visitors came from places north of the Mason-Dixon Line. Other than a family member from Nashville, Tennessee, and Clare's brother, Ben, who lives in Maine, we had a house full of Yankees.

Ben has deep roots in South Carolina. When he returns to this part of the world, he starts drooling for Southern cuisine. By the time he arrives in the Palmetto State he is ready for delicious, hot, salty boiled peanuts.

We placed a bowl overflowing with the delicacy on the coffee table in our den. Ben helped himself. So too did several of the others who were completely unfamiliar with boiled peanuts. Bless their hearts! Ben gave a demonstration to the uninitiated, showing them the fine art of sucking goober peas. It's a little like eating raw oysters on the half shell. You just let them slide around in your mouth a second before gulping them down.

Some of our guests enjoyed them; some turned away in disgust. "Those things are so gross!" By bedtime the bowl was empty.

Peanuts have long been a Southern staple. A handful of salted peanuts funneled into a glass bottle of RC Cola, Pepsi, or Coca-Cola makes a concoction my Uncle Will called Dixie Drizzle. A paper bag of parched or roasted peanuts is just right at a baseball or football game. But hot peanuts, boiled to perfection, are the crème de la crème of Southern snacks.

Edgar Allen, a long-time resident of the Upstate, originally hailed from southeastern Virginia. He was determined to grow peanuts in his Spartanburg vegetable garden. He tilled wheelbarrow loads of sand into the red clay of his backyard to create a suitable soil for raising peanuts. Year after year Edgar harvested his crop. "These things are

thumb-size," he would brag, "and I've got big thumbs!"

My father-in-law, Mr. Jack, had great success raising peanuts in his spacious garden in Leesville, South Carolina. My mother-in-law, Miz Lib, parched a good many to serve as snacks. She also kept a good supply of boiled peanuts in her freezer for those times when Ben returned home from places too far north and too far away.

Peanuts require a long, hot growing season. They need a well-drained, light, sandy soil with plenty of organic matter. The soil should be loose, not clayish and hard. Soils in the Sandhills and Lowcountry area are excellent.

The peanut is a legume. The flowering plant produces underground pods that contain the delicious seeds. Peanut plants have been in continuous cultivation for over 3,500 years. They originated in South America and were carried to Africa by early explorers. Traders took them to Spain and North America. In the Colonial period peanuts were used as food aboard ship because they were cheap and of high nutritional value.

The peanut comes in four varieties.

Virginia peanuts have been grown in the eastern region of the United States since the establishment of the Jamestown colony. Virginias, also called big whites, have the largest kernels and are the most commonly sold snack peanut.

Spanish peanuts have a smaller kernel with red skin. My grandfather had a peanut machine at the lumberyard. Deposit one penny in the slot, turn the knob, and, magically, a handful of red Spanish peanuts would drop from the glass globe into your waiting hand. A nickel would buy an ice cold Coca-Cola, the perfect companion for the salty redskins.

Because of their high yields, Runners are the most dominant variety in the United States. Most Runners are used for peanut butter and peanut oil. They are grown commercially throughout the Deep South.

The Valencia variety features bright red skin and small kernels. Valencia peanuts are sweet. Though excellent when roasted in the shell, they are even better when boiled.

When I was in the fourth grade, my teacher, Mrs. Pearl Fairbetter, assigned each of her students to do a report on a scientist. I went by the lumberyard on my way home from school. There was a paper bag

of soggy boiled peanuts on the counter. While my grandfather and I ate goobers, I told him about the assignment Mrs. Fairbetter had given. Pappy said, "Kirk, you ought to do a report on George Washington Carver. He's a fellow who did more with peanuts than anybody."

I found a biography of George Washington Carver in the school library. He was a former slave who became a scientist and discovered 300 uses for peanuts. A teacher with Booker T. Washington at Tuskegee Institute, Carver devoted his life to research projects connected with Southern agriculture. His work revolutionized the economy of the South by liberating it from dependence on cotton. Carver suggested that peanut derivatives could be used as adhesives, axle grease, bleach, buttermilk, chili sauce, fuel briquettes, ink, instant coffee, linoleum, mayonnaise, meat tenderizer, metal polish, paper, plastic, pavement, shaving cream, shoe polish, synthetic rubber, talcum powder, and wood stain, to name a few.

So many uses, but the best use is to boil them and eat them!

No one knows just why southerners started boiling peanuts. Boiling peanuts has been a folk practice in the south since the nineteenth century. In late August, when the peanut crop came in, surplus peanuts were boiled. Extended family and neighbors gathered 'round to share the feast of goober peas, a name that is a derivative of the African word for peanut, *nguba*.

At one point they became a necessity. After Union General William Tecumseh Sherman marched through Georgia the Confederacy was split in two. Rebel soldiers were deprived of much needed supplies. In order to feed the Army the Confederate government provided peanuts, which the soldiers boiled over their campfires. A well-known folk song tells the story.

Sitting by the roadside on a summer's day
Chatting with my mess-mates, passing time away
Lying in the shadows underneath the trees
Goodness, how delicious, eating goober peas.

Just before the battle, the General hears a row
He says "The Yanks are coming, I hear their rifles now."
He looks down the roadway, and what d'ya think he sees?
The Georgia Militia cracking goober peas.

I think my song has lasted just about enough.
The subject is interesting, but the rhymes are mighty rough.
I wish the war was over, so free from rags and fleas
We'd kiss our wives and sweethearts, and gobble goober peas.

Late summer into early fall is prime time for boiled peanuts. In the Southern clime, roadside stands or pickup truck peddlers offer bags of tasty boiled peanuts. For the last twenty-seven years the town of Pelion has thrown a Peanut Party every August. The local Ruritan Club boils nearly 130 bushels of peanuts.

My friend, Carl Bostick, worked for a time with James and J. D. Cromer. The slogan of their store in downtown Columbia boasts "the worst peanuts in town." It was simply a way to call attention to what most people believe are the best peanuts in the capital city. Though Cromer's sells both parched and boiled peanuts, Carl swears by the boiled ones.

While most people start with green peanuts, Carl does not. He shared his recipe with me. "Always begin with dry, not green, peanuts.

Get those red kind. Soak them for twelve hours. Stir in the salt, about one cup for each pound of peanuts. Boil them for one hour, then start tasting. Take them off the heat after about fifteen more minutes and taste, taste, taste. When they are exactly right, crisp and salty, drain off all the water and enjoy!"

Problem is, after Carl gets through tasting, there are not many boiled peanuts left.

Like okra, black-eyed peas, collard greens, grits, and pork barbecue, boiled peanuts are indigenous to our Southern culture. Much like a fish fry, a pig picking, or a Lowcountry shrimp boil, a peanut boil became a social occasion.

My family has often congregated around the chopping block in my mother's kitchen to shuck and suck boiled peanuts. Inevitably, somebody's eyes were bigger than their stomach. They gobbled enough goobers to make themselves ill. My sister Mamie was moaning and groaning after eating a double ration of boiled peanuts. "Sorry you're feeling bad," someone sympathized.

"It's okay. It's kinda' like having a baby. The joy of the experience more than makes the pain worth it."

She should know. She's the mother of eight. Mamie really likes boiled peanuts!

GUITARS AND GRATITUDE

When I was in the ninth grade my left knee became my Achilles heel. I tore the cartilage playing junior varsity basketball. My aspirations to play college basketball were shattered, adding insult to injury.

In those days arthroscopic surgery was not an option. I spent weeks walking on crutches and having the knee drained. Now, instead of staying after school for basketball practice, I had to go home to sit around doing schoolwork. I was miserable.

About a week into my convalescence, my dad did a remarkable thing. He brought home a secondhand Stella guitar. Handing it to me, he said, "As long as you are so unhappy, you might as well learn to play the blues."

The guitar was an unexpected but welcome gift.

With my knee propped up on a pillow, ice bag strapped on with an Ace bandage, I started trying to learn to play a few chords.

The steel strings on the guitar cut deep into my fingertips. I developed blisters. They eventually became calluses. I spent hours strumming that old Stella, long since gone.

These days, I enjoy playing and singing with our children and our grandchildren. I will be forever grateful to my dad for that first guitar.

My dad suggested I take lessons from a fellow he knew through the lumberyard. My teacher was Jerome Fowler, a resident of Clifton Mill #2. Mr. Fowler was one of the most unique people I have ever known. He had been the Minister of Music at a Methodist Church. He not only worked in the mill, but he also served as the band director at the mill. His language was salty. His teeth were usually in a glass on top of the piano. He smoked cigars.

An accident left Mr. Fowler with a broken arm that healed improperly. He could not hold a guitar. But he understood the

instrument as if he had invented it. He could hold a mandolin, which he played while I played the guitar. He stopped often to press my fingers into the right places on the fret board. He used the Gibson Guitar Course, teaching scales and runs, bar chords and harmonics. Again, the guitar inspires a sense of gratitude. I am thankful for Mr. Fowler.

Joe Bennett and three buddies started a band, The Sparkletones, in 1956 at Cowpens High School. Joe Bennett, originally from Glendale, had also taken guitar lessons from Jerome Fowler.

In January 1957 Bob Cox, a talent scout for The Columbia Broadcasting System, held auditions at the Spartanburg Memorial Auditorium. The Sparkletones took first prize at the event. Convinced they would be a success, Cox quit CBS to manage the group and flew them out to New York City to sign with Paramount.

At their first recording session they sang "Black Slacks." Released as a single soon after, "Black Slacks" became a hit and built up national recognition. The Sparkletones toured the nation doing numerous concerts and performing on *The Nat King Cole Show*, *American Bandstand*, and *The Ed Sullivan Show*. "Black Slacks" remained on the record charts for over four months, peaking at number seventeen on the Billboard Hot 100 late in 1957.

Joe and I get together occasionally. I took a few lessons from him to renew some of my guitar skills. We sometimes eat breakfast together at Dolline's and talk about what life has been like for both of us. We are two old codgers now.

Joe served in the Air Force in Vietnam. He was an air traffic controller. Maybe his most important job was to play his guitar at the Non-Commissioned Officers Club. The commander was trying to keep the soldiers on base instead of having them go into Saigon where they could get in trouble.

Joe said, "Every day, somebody there got a Dear John letter. I played every broken-hearted song there is to play. I bet I played 'Your Cheating Heart' five hundred times."

Joe shared a remarkable story. Years ago, The Sparkletones were playing a concert in Hartford, Connecticut. They were opening for Bo Diddley and Chuck Berry. The place was packed out.

Just before the show, two kids from Brooklyn, Tom and Jerry, were to make their first appearance ever. The promoter had asked them

to sing one song. Joe explained that the two young men were scared to death.

Joe told them, "You guys need to know that this is probably your best chance. You have a great audience here. They have come to hear good music. The promoter thinks you have the talent to do this. Just go out there and give it your best shot."

The two singers, Tom and Jerry, were a knockout! People loved them. Later, they changed their names to Simon and Garfunkel.

Several years ago, Paul Simon and Art Garfunkel did a reunion concert in Central Park before thousands of people. About halfway through that concert, Paul Simon said to Art Garfunkel, "Why don't we play 'Black Slacks'?" They broke into the old song. Joe said, "We have gotten more royalties off of their recording of that song than we ever made off of our recordings."

What were Simon and Garfunkel doing? They were using the guitar to express their gratitude.

When I hear Chet Atkins, Tommy Emmanuel, or Joe Bennett play the guitar I could feel envious of their remarkable musical ability, but I know that the best medicine for envy is gratitude.

I listen, and I am thankful.

Apple Cider
Sweet and Sour

My grandmother Mammy knew what to do with apples. I grew up on applesauce, apple juice, apple cobbler, and apple butter. Mammy could take the ugliest, knottiest apples and make the best lattice-crust apple pies ever. Now my Aunt Ann makes sugar-free apple pies for me using apple juice as the sweetener. I contend that apples were meant to be sweet. That's why they are associated with love.

Apples have long been connected with romance and affection. Though the forbidden fruit mentioned in the book of Genesis is not identified, popular tradition holds that it was with an apple that Eve coaxed Adam to disobey the Almighty. The larynx in the human throat is called the Adam's Apple. The name came from the notion that there was a chunk of the fruit sticking in the throat of Adam.

The phrase from the Bible "Keep me as the apple of thine eye" makes the lasting link between apples and love. In ancient Greece a man throwing an apple to a woman was a proposal of marriage. If she caught the fruit, it meant she accepted the proposal. In Roman mythology Venus, the goddess of love, was depicted holding an apple as a symbol of passion. The connection carries into the present time when an apple is presented to a beloved teacher as an expression of affection. According to Irish folklore, an apple peel, pared into one long continuous ribbon and thrown behind a woman's shoulder, will land in the shape of her future husband's initials. Both my grandfather and Clare's grandfather could peel an apple in this way. The long strip of apple peel was presented as a gift to a grandchild. Clare and I now find ourselves doing this for our grandchildren.

When I was a boy there was an old apple tree in the yard of an abandoned farmhouse down a dirt road beyond our house. In the autumn of the year the ground was littered with rotten apples. Apple fights, spontaneous frays, were great fun. Late one September

afternoon, beneath the old apple tree, the battle was joined. All went well until a buddy of mine threw a rotten apple at me. I ducked.

The apple sailed over my head and toward his girlfriend. The rotten apple hit her in the face! He was no longer the apple of her eye! She ditched him.

Apples have also played an important role in science and in technology. Sir Isaac Newton, upon witnessing an apple fall from its tree, was inspired to postulate the law of gravity. A leader in the development of cyber technology, Apple Computers adopted the fruit as a logo for their company.

Apples also have found prominence in history and in fiction. Swiss folklore holds that William Tell courageously used his crossbow to shoot an apple from his son's head, defying a tyrannical ruler and bringing freedom to his people. Snow White, the fairytale princess, slept in a deep coma induced by a poisoned apple, a gift from her wicked stepmother.

Beyond romance, science, and folklore, apples have also been linked to good health. An old proverb attests to the health benefits of the fruit: an apple a day keeps the doctor away.

Research suggests that apples may reduce the risk of colon cancer, prostate cancer, and lung cancer. Like many fruits, apples contain vitamin C, as well as a host of other antioxidant compounds. They also may assist with heart health, weight loss, and cholesterol control. The chemicals in apples may protect us from the brain damage that results from Alzheimer's disease and Parkinson's disease.

In the mountains of North Carolina the expression, "Let's talk about apples," means, let's forget about our troubles and think about something pleasant. Before the American Revolution William Mills became the first apple grower in Henderson County, North Carolina. In 1782 Asa and Samuel Edney married the Mills' daughters. Their community, Edneyville, was soon known as the core of the North Carolina apple industry. Now, each year in early September, the town of Hendersonville hosts the North Carolina Apple Festival.

Clare and I enjoy driving to the mountains in the fall to buy fresh apples from our favorite roadside stand. The display features more than thirty varieties of the fruit and other apple products—bread, jellies, and beverages. Juice made from sweet apples is filtered and pasteurized. Apple cider is unfiltered and unpasteurized juice. Apple

wine is fermented sweet apple juice. Apple brandy is a distilled derivative.

Many old apple cultivars have excellent flavor and are still grown by home gardeners and farmers whose conservation efforts continue in the tradition of John Chapman. An American pioneer, he roamed the Midwest for more than fifty years. He earned his nickname, Johnny Appleseed, by planting apple trees across Ohio, Indiana, and Illinois.

The apples planted by Johnny Appleseed were the bitter variety. Henry David Thoreau wrote that the apples were "sour enough to set a squirrel's teeth on edge and make a jay scream." Unknowingly, John Chapman provided a source for the most easily produced alcoholic beverage of early American times. Hard cider is fermented sour juice. Apple Jack is concentrated hard cider. President John Adams held that a tankard of cider a day kept the doctor away.

Jean and Ronnie Crossley operate the New Method Laundry and Dry Cleaning business in Spartanburg. We took clothes by to be laundered and pressed one day. In the course of the conversation, Clare said, "When I iron, my shoulder hurts."

Jean asked, "Do you take cider vinegar?"

Clare said, "No! I tried it, but it's just so nasty!"

Jean explained that she takes cider vinegar every day. Jean is so energetic, even given her strenuous job and her long work hours, that Clare has become a convert. She mixes a quarter of a cup of cider vinegar in a tall glass of water and sips on it all day long.

Unfiltered apple cider vinegar has long been regarded as a home remedy. Check the label. The vinegar must be unfiltered! Two tablespoons of the sour elixir, mixed in a glass of water as a daily tonic, is said to relieve

or cure a number of ailments. The long list includes allergies, sinus infections, acne, high cholesterol, flu, chronic fatigue, acid reflux, sore throats, contact dermatitis, arthritis, and gout. Apple cider vinegar breaks down fat and promotes weight loss. A daily dose of apple cider vinegar in water is said to reduce high blood pressure and help control diabetes.

Clare's aunt and uncle were true believers in the powers of apple cider vinegar. Mitch and Helen imbibed the remedy every day. Once, they were traveling on a nostalgic steam locomotive trip. Box lunches were served to all the passengers. Every person aboard the train developed food poisoning except for Mitch and Helen. To this day family lore holds that the apple cider vinegar protected them.

Members of Clare's family are so enamored with the medicinal effects of drinking sour cider vinegar that it frequently becomes the topic of conversation at family gatherings. Clare is convinced that we too should drink our daily ration of sour unfiltered apple cider vinegar.

I have not acquired a taste for sour apple cider. Still, Clare insists. Every single day she pours a quarter cup of Apple cider vinegar in a glass for me as well as for herself. I mix mine with vegetable juice and chug it as fast as I can. I agree with Clare. It does taste nasty!

"I am giving this to you because I love you," she says.

"I am drinking it because I love you," I say.

So, I guess it does have something to do with love and maybe with science and good health. It certainly has something to do with family lore.

"You know," she will say, "Mitch and Helen drank cider vinegar every day."

"Yes, I know, and Mitch and Helen both died years ago."

Peace like a River

With tears in her eyes and her mascara running, Betsy asked, "Daddy, will you take me camping? I need to get out of town." Betsy had completed her junior year of high school. She had the summer ahead of her, and she had broken up with her boyfriend right after exams. Though she initiated the breakup, she was heartbroken.

The answer to her question was a no-brainer for me. I would make the time to take her away. I could use the break myself. I was about to begin my fourth year as senior pastor of a growing church. The demands on my time were intense. But a day or two away with my daughter would be good for both of us. As far as I was concerned, there was only one place to go for this camping getaway. Betsy and I would camp at my favorite trout fishing spot, Burrells Ford on the Chattooga River.

Under the shadow of Whiteside Mountain, the highest sheer cliffs in the Blue Ridge Mountains, the Chattooga River headwaters spill over small ledges and waterfalls. The mountain stream enters a narrow and treacherous gorge. Gathering momentum with sharp drops in elevation, the river follows a twisting route over continuous rapids and around massive boulders.

The Chattooga is one of the few remaining free-flowing mountain streams in the Southeast. Dense forests characterize the primitive area. In 1974 Congress designated the Chattooga a Wild and Scenic River.

In 1811 Andrew Ellicott, a surveyor, settled a boundary dispute between Georgia and North Carolina. He marked a large rock in the Chattooga River. Ellicott Rock is the point where the boundary lines of South Carolina, North Carolina, and Georgia join.

As the river leaves the gorge it flattens, flowing wide and smooth between Georgia and South Carolina. At a shallow place an old rutted road once crossed the rocky bed of the river, allowing wagons drawn

by oxen, mules, or draft horses to travel across the state line. The crossing is called Burrells Ford.

I love this area of Northwestern South Carolina! It was here, in the early spring of 1985, that I landed my largest rainbow trout, a nineteen-inch male sporting the distinctive hooked jaw or kype. I am sure the fish had been a breeder released in the fall from the fish hatchery upstream.

It was here that I had previously experienced a dramatic confrontation with a large black snake. The serpent swam from the Georgia side across the swift current of the river to the place I was fishing on the South Carolina bank. I doubt that snake had ever before encountered a human. He was completely unafraid of me. He gave me quite a pause and a sharp, bloody bite on the thumb.

Before the Chattooga was declared a Wild and Scenic River, campers could drive all the way to Burrells Ford Campground. But now a protective corridor has been established, cutting off all direct motorized access. The short hike may deter some tent campers, but there will never be a recreational vehicle at Burrells Ford!

On Friday morning Betsy and I drove west on Highway 11 through the area known as the Dark Corner of South Carolina. We stopped at a store in Cleveland. The place is a service station, a grocery, and a grill. We filled my truck with gasoline. Inside we had breakfast for lunch at a table in the back. Betsy was in one of her vegetarian phases then, so she had a veggie omelet. I had bacon and eggs with grits. Out of the window at the rear of the building we could see a fenced in lot. Two ostriches and several emus walked back and forth along the fence. Before we left the store we bought a fishing license for Betsy, her first one and a small can of Niblets corn to use as trout bait.

We drove over the Saluda River, past Caesar's Head and Table Rock, and across the high bridge over the Toxaway River just south of Jocassee dam. Turning up Highway 130, we ascended the Blue Ridge escarpment and stopped at a lookout above Jocassee Gorges. Mountain streams feed beautiful Lake Jocassee, the best kept secret in South Carolina. The water is deep and clear. It is so clear it is the only place I have ever fished where, in water twenty-feet deep, I was able to see a largemouth bass pick up the plastic worm on the end of my fishing line.

After taking in the magnificent view of the lake Betsy and I drove

just across the state line into North Carolina. A short walk from a parking area took us to another overlook and a spectacular view of Whitewater Falls.

We made our way back down Highway 107 to the Walhalla State Fish Hatchery. Nothing whets a fisherman's appetite more than seeing concrete tanks teeming with rainbow trout, the very fish that will eventually stock the streams and rivers of the Upstate. Gazing at the vats filled with fish, Betsy said, "I want to catch one!"

We continued our journey to the Burrells Ford turnoff. Several miles down a dusty gravel road, we crossed a bridge over the Chattooga River on the Burrells Ford Bridge marking the border between Sumter National Forest in South Carolina and Chattahoochee National Forest in Georgia. This section of the whitewater stream has almost always been a spot where I could be sure to catch a trout.

On this day I wanted Betsy to see the beauty of the river. Here in the Upper Chattooga, below the headwater falls, the river is as close to pristine as any in our state.

Fifty-seven miles downstream is Section IV, made famous by James Dickey's book and film *Deliverance*. Section IV is the classic Southeastern whitewater rafting run, including some of the most heart-pounding rapids to be found anywhere. Through the famous Five Falls the river is tumultuous, spilling over five back-to-back Class IV-V rapids in quick succession. With names like Jawbone and Sock 'em Dog a raft trip on the lower Chattooga is a memorable experience. The joke is, "If you hear banjo music, keep paddling!" I ran that section with three good friends in 1983. Betsy, only a year old then, was at home with Clare.

On this warm June day Betsy and I sat on a rock below the bridge for a little while and enjoyed the sun. We took off our boots and dabbled our feet in the cold water. We saw a pair of belted kingfishers swoop down, plucking fish from the water. "Let's go fishing," Betsy urged.

Back in the truck, we drove to the parking lot nearest the campground. We hoisted our backpacks on our shoulders. Betsy carried a small cooler. I carried the fishing tackle. We walked down the Forest Service road toward the campground. Judging from the vehicles in the parking lot, I knew that the area might be crowded.

Betsy and I walked into the campground to pay the one-night fee. I

showed her where the pit toilets were. Neither of us opted to use those. Most campsites are bunched together beneath the shady canopy of hardwood and hemlock trees, but some are further down the Foothills Trail in glades near the river. We walked past the other campers down the trail to an isolated place on a rise near the river. I have pitched a tent here numerous times. I prefer to be within earshot of the whitewater. Sleeping beside a mountain stream and waking up in fresh mountain air is exhilarating.

We prepared our campsite. I put up the tarp tent, though I knew if the sky was clear we would sleep under the stars. We gathered plenty of firewood and secured our food in a bear bag hung on a metal post provided by the Forest Service for that purpose.

The largest trout thrive in deep pools in the Chattooga downstream from the campground. I rigged up the two lightweight spinning rods. I put a spinner bait on mine and a small hook and a lead shot on Betsy's. We walked to the river and found a likely spot. I showed Betsy how to load her hook with corn and reminded her to spit on her bait for good luck.

Betsy caught the first trout. "Some people are just better at fishing than others," she quipped.

"I guess so," I conceded.

Her fish was a nice rainbow exactly the right size for supper. Even as a vegetarian she will eat fish. I soon caught a trout on my spinner about the same size as hers. Using my Buck knife, I showed Betsy how to clean fresh trout.

As I was doing so, we heard a thumping sound. We looked up to see a great blue heron winging its way past us headed downstream. The heron landed beside a pool below gentle rapids on the Georgia side. She folded her wings, preened her feathers, took one step with her long legs, and speared a fish. She lifted the silver wiggling fish on her sharp beak and swallowed him in one gulp.

"Some are just better at fishing than others," I reminded Betsy.

"You got that right!" she agreed.

Moments later we saw a fuzzy head bob up in the water. I wasn't sure what kind of critter it was. It disappeared quickly. I knew it would pop up downstream. Sure enough, the head resurfaced, this time with two companions. They were river otters, frolicking as river otters are wont to do.

Back at the campsite, I selected a large flat rock and put it under the fire bed. I would need it for breakfast the next morning. Then I built a fire using oak from a deadfall and dry white pine sticks gathered from beneath a nearby tree. Soon we had an inviting blaze. We dipped water from the river and purified it by boiling for ten minutes. When we had a good bed of hot coals, we were ready to cook. We had prepared vegetarian hobo dinners at home and transported them in the cooler. The aluminum foil pouches contained diced potatoes, carrots, onions, green peppers, sugar snap peas, mushrooms, and corn oil. I took a roll of foil from my backpack and prepared the trout with salt, pepper, and butter. We folded each fish into a foil pouch and placed it in the hot coals. Before long our supper was sizzling. We enjoyed a cup of hot tea. After each pouch cooked for ten minutes per side the meal was ready. It was a tasty dinner.

After supper we talked. Betsy had just completed an Environmental Science class. She had much to say about taking care of rivers like the Chattooga and mountains like the Blue Ridge. She thanked me for spending time with her and bringing her to such a peaceful place. I paraphrased a favorite psalm, "He makes me lie down in a green forest, He leads me beside whitewaters, He restores my soul."

We piled the remaining hot coals on top of the big flat rock, unrolled our sleeping bags on a ground cloth in the open, and slept under the stars. To our left, in the grassy glade across the trail, a whip-poor-will serenaded us with her song. To our right, the river hummed a lullaby throughout the night.

The next morning, I rekindled the fire and boiled more water. Betsy and I had early morning cups of hot tea. Then I cleared the coals from the big flat rock with my pocketknife. I poured boiling water on the stone to sterilize it. The rock was still so hot the water continued to boil on its surface. I took three pieces of precooked soy bacon from the cooler and placed them in a triangle on the rock. At home I had cracked eggs into a Tupperware container and mixed in a little cream and corn oil. Now, by the river, I shook the container to scramble the eggs and poured half of them into the triangle of faux bacon. They cooked quickly on the hot stone surface. Using my knife, I scraped the food onto a paper plate for Betsy. Then I repeated the process for myself using real bacon, also precooked. Betsy has enjoyed talking about her breakfast on the rocks ever since.

Before we left for home I wanted to take Betsy to a favorite spot. The northwest corner of South Carolina has more than thirty spectacular waterfalls. One of them was nearby. We packed up our campsite, making sure the fire was drenched with water and all the trash was stowed in a plastic bag to be packed out. We walked back up the foothills trail to the campground. I secured our gear under a concrete picnic table. Then we hiked up a mountain path, about two miles, following King Creek. The trail crossed the small stream on footbridges several times. We paused at one to admire the rhododendron beginning to bloom. At another we saw a blue-tail lizard basking in the sun. There were deer tracks in a muddy area and a tree bearing evidence of a black bear scratching for insects. As we crested the hill after a steep ascent we came to King Creek Falls, a stunning waterfall about seventy feet high. We sat on a log, watching water spill from the top of the mountain into a pool below. Perhaps it is the backward slant of the rocks, but the drop appears to be higher. Sometime in the past a massive tree fell from the top of the cascade, stabbing its top into the basin at the foot of the waterfall. As long as I have been visiting the place the huge log has remained unmoved. Betsy and I cooled our feet in the cold water before making our way back down the creek, returning to the Chattooga River.

We hoisted our packs and hiked up the mountain on our way back to the truck. A man walking up the Forest Service road passed us, carrying a small ice chest much like the cooler Betsy was carrying.

I asked him, "How was the fishing?"

"Didn't catch enough to keep." His euphemism for didn't catch anything.

Others coming down the trail inquired of us, "How's the fishing?"

"Didn't catch enough to keep," Betsy answered. A good line, so she made it her own.

On the way home we stopped for lunch at The Dutch Plate, a Mennonite restaurant in Campobello. We talked about our trip. Betsy thanked me again. I also thanked her. The truth is that both of us needed this trip. She needed a break, some perspective, and some time with her dad. I needed a change of pace, time to refocus on the big picture, and a special time with my daughter whom I love very much.

Two days and one night by the whitewater of the Chattooga gave

us both peace like a river. After we were back at home that sense of serenity lingered for awhile.

Betsy is now a grown woman living far away from the Chattooga. We were talking on the phone recently about some of the stresses in her life. She said, "You know what, Daddy? I'm ready to go camping and trout fishing again. I need to sleep by a river under the stars and eat breakfast on the rocks."

I'm ready for that too.

A SOUTHERN SNOWFALL

During an especially severe ice storm a friend called to add his unique brand of humor.

"This is the devil," he announced. "It's frozen over down here too!"

The beginning of every January intensifies the prospect of inclement weather across the South. Meteorologists know that forecasting weather for Upstate South Carolina is always a challenge. Accuracy in prognostication is high risk in winter.

With advanced technology at their fingertips, most weather professionals agree that the tool that would be most helpful is one usually absent in their weather room. A window! Given a portal to the outside, they could at least see what was actually happening.

Southern folks have their time-honored ways of determining the long-range forecast. The length of hair on a horse's back or the colors of the fuzz on a wooly worm are indicators of what is to come. The relative scarcity or plenty of acorns, pecans, hickory nuts, and beechnuts are portents of the severity of winter.

Sleet and freezing rain are the most dreaded forms of precipitation. While ice-covered trees have a crystalline beauty, the pop of breaking branches and the crack of splitting trunks are sounds of nature's agony. Frozen roads, sidewalks, and ice-laden power lines contribute to the human misery, resulting in broken limbs and splitting headaches.

Several years ago, I was visiting the hospital during an ice storm. I came upon a homeless man sleeping in the stairwell. I was reminded that those of us who have food and warmth must share with organizations that provide services to our most needy citizens.

Northern transplants are baffled by the enthusiasm of some Southerners to a prediction of snow. Enough is enough for them! They are annoyed when a light dusting of snow brings traffic to a halt in Dixie. Clare, who learned to drive in Macon, Georgia, is afraid to drive

in snow and hesitant to travel even in a heavy frost.

Some people must work through the difficult conditions. Medical personnel, paramedics, firefighters, law enforcement officers, utility employees, road crews, and tow truck drivers are but a few examples of those who labor long hours in the cold and damp.

For some, a snow day is a holiday!

Some people in the South greet the prospect of snow with excitement. School children, and maybe their teachers, wear their pajamas inside out and backwards if snow is predicted. It's rumored to give greater assurance that the snow will stick. Accumulation creates a delightful playground of snow angels, snowmen, snowball fights, and sledding.

My mother always fixed a big kettle of vegetable soup on snow days. Though the roads were too bad to go to school, Mama's children and grandchildren always found a way to travel "over the river and through the woods to grandmother's house." Now, at our house during winter weather, Clare has a crock pot filled with simmering soup. Yum!

When snow is impending, grocery shelves are quickly depleted of milk and bread. Do people really sit in their homes eating bread and drinking milk during icy weather?

With a wintry mix in the forecast, I posed the question while standing in the express line at the grocery store. The woman ahead of me explained, "If my power goes out, I give my children peanut butter and jelly sandwiches and a glass of milk. The peanut butter and milk give them complete protein."

Glad for a reasonable answer, I stepped forward to purchase my own bread and milk.

ACKNOWLEDGEMENTS

I am thankful to Michael Smith and his predecessor Carl Beck, editors of the Spartanburg *Herald-Journal*, for giving me the opportunity to write these columns and the permission to publish them in book form. In a time when hometown newspapers are stressed and in transition, it is gratifying that there is still a place in print for a weekly column like "By the Way."

I am grateful to Jeff Zehr and his predecessor Landy Timms, editors of *H-J Weekly*, for their trust and their competence. Jeff and Landy are evidence of the friendships that can develop between editor and writer, even in cyberspace.

I appreciate the privilege of working again with Betsy Teter and the board of directors of Hub City Writers Project. They have become a model for a new way of publishing. They set the standard for excellence. Hub City Writers Project is a national treasure.

Working with Kari Jackson on this project has been a delight. Kari is a bright and shining star as an editor. Kari not only knows how to write a good essay, she knows how to teach an old codger to improve. This is a far better book because of her keen eye, her skillful suggestions, and her sixth sense for what I am trying to say.

Krista Jones has provided the stunning illustrations for *Banjos, Barbecue and Boiled Peanuts*. As a lifelong doodler, I am amazed when an artistic talent like Krista, using simple pen and ink, can be so creative. Krista's illustrations bring these stories to life.

Thank you also to *Sandlapper* magazine for their permission to include "The Boykin Spaniel" and "Hiking Jocassee Gorges," articles that originally appeared in the magazine.

I am thankful everyday for Kathy Green, a secretary and colleague who is simply the best.

I am indebted to the people of Morningside Baptist Church. As a pastor, I could not write without the encouragement and support of a congregation that understands writing as an extension of ministry.

I cannot write without Clare, my wife and my companion in all

things. Her beautiful green eyes can spot a misspelled word or a punctuation error at twenty paces. After I write "By the Way" each week, Clare is my first and most incisive reader. In a very real sense, to have my name on a piece of writing is to have her name on it too. She pushes me to do my best.

My children have been my first audience and have served as a sounding board around the family table for most of these stories. I appreciate their patient listening and loving advice.

Finally, I am deeply indebted to those who read what I write. Without you, these words would fall silent. Through you they carry the ring of truth far beyond my keyboard.

Thank you. Thank you. Thank you. Thank you, all.

Faithfully,
Kirk H. Neely

BIOGRAPHIES

KIRK H. NEELY

Kirk H. Neely is senior pastor of Morningside
Baptist Church in Spartanburg, South Carolina.
He holds a doctor of ministry degree in pastoral
counseling and psychology of religion from the
Southern Baptist Theological Seminary. He received a Merrill
Fellowship to the Divinity School of Harvard University in 1980.
Neely has been a pastor and counselor for over forty-five years.

KRISTA JONES

A native South Carolinian, Krista Jones is a
Wofford College graduate, where she earned
a Bachelor of Arts degree in Environmental
Studies and Spanish. She has pursued her love
of art from her early Montessori days and enjoys working in many
mediums, including pen and ink, watercolor, oils, colored pencils,
and photography.

OTHER BOOKS BY KIRK H. NEELY

*Santa Almost Got Caught: Stories for Thanksgiving,
Christmas, and the New Year*
(Our Home Place, 2011)

A Good Mule is Hard to Find
(Hub City Press, 2009)

When Grief Comes: Strength for Today, Hope for Tomorrow
(Baker Publishing Group, 2007)

Comfort & Joy: Nine Stories for Christmas
(Hub City Writers Project, 2006)

Hub City Press is an independent press in Spartanburg, South Carolina, that publishes well-crafted, high-quality works by new and established authors, with an emphasis on the Southern experience. We are committed to high-caliber novels, short stories, poetry, plays, memoir, and works emphasizing regional culture and history. We are particularly interested in books with a strong sense of place.

Hub City Press is an imprint of the non-profit Hub City Writers Project, founded in 1995 to foster a sense of community through the literary arts. Our metaphor of organization purposely looks backward to the nineteenth century when Spartanburg was known as the "hub city," a place where railroads converged and departed.